The COMPLETE BOOK OF MARITIME DESIGN

A Compendium of Naval Art and Painting

La Fortezza Gibilterra, Affediata dalla Flotta Confederata dell'Amiraglio Rooke, l'Anno 1704. l'ultº Luglio, fotto 'l Comando dell Collonello Gallouai, Inglese, accordata, e reffasi li 5. Agosto con honorabili patti, esclusi però li Francesi. Dererito l Comando di questa Piazza al Principe d'Hassia Darmstatt e presidiata con 3000. Soldati, fecero grand Danno alla Nemici. L'Anno seguente 1705. volsero ricuperare essa Fortezza li Francesi, sotto il Comando del Marchese Villadarias, e Marescallo de Thessè, ma doppo valorosa difesa p) 6. mesi, erano astretti di levare l'Assedio, per Mare e per Terra con notabile loro danno

The COMPLETE BOOK OF MARITIME DESIGN

A Compendium of Naval Art and Painting

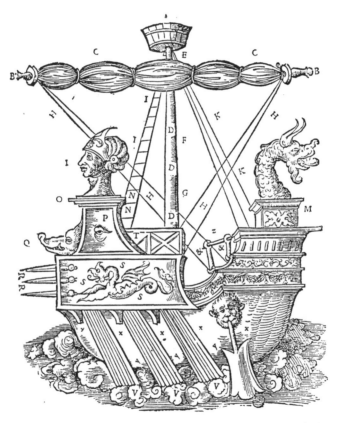

WITH AN INTRODUCTION BY

DAVID CORDINGLY

GRAMERCY BOOKS

New York

Acknowledgements and picture credits
The publishers would like to thank the following for their help with the research and collation of
this title: Andrew Brown, John Green, Alison Moss and Antony Preston. We are extremely
grateful to the Warwick Leadlay Gallery and The Parker Gallery for allowing us to use images
from their archives. We would also like to thank the vast array of artists, both past and present,
whose works are included on these pages, in particular Przemyslaw Budzbon, Brian Lavery,
Mark Myers, and John Roberts for many of the twentieth-century drawings and ship plans, and
Geoff Hunt, John Stewart and Ross Watton for their original paintings.

This edition is published by Gramercy Books,®
a division of Random House Value Publishing, Inc.,
201 East 50th Street, New York, New York, 10022
by arrangement with Conway Maritime Press, London, England.

Gramercy Books® and colophon are registered trademarks of Random House Value Publishing, Inc.

Random House
New York • London • Sydney • Auckland
http://www.randomhouse.com/

Library of Congress CIP Data
The complete book of maritime design : a compendium of naval art and
 painting / with an introduction by David Cordingly.
 p. cm.
Simultaneously published in Great Britain under title : The
maritime compendium.
 ISBN 0-517-16072-2
 1. Naval art and science–History–Pictorial words. 2. Marine
art–Pictorial works. I. Cordingly, David.
V27.C65 1998
623.8'2'00222–dc21 98-2753
 CIP

Printed and Bound in Singapore under the supervision of
M.R.M Graphics Ltd, Winslow, Buckinghamshire

Edited by Nicki Marshall
Picture research by Suzanne Green
Designed by Digital Artworks Partnership Limited
Designer – Pauline Hoyle

Contents

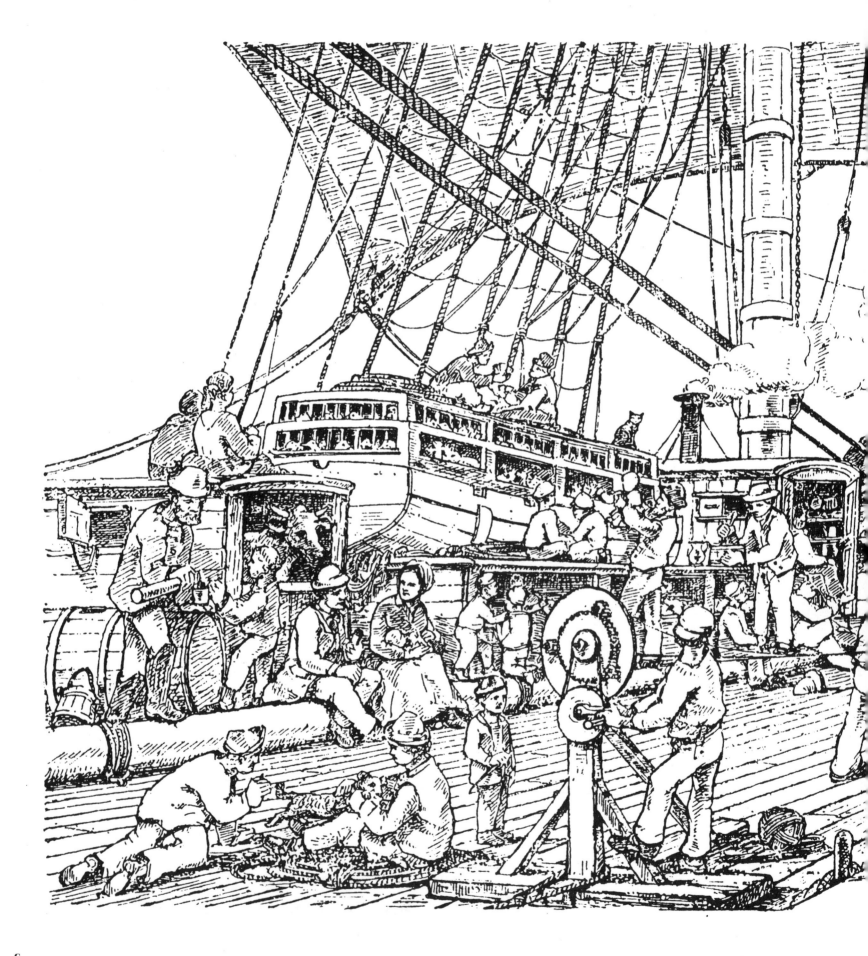

Introduction

It is easy to ignore the sea nowadays. Most of us live in towns and cities far from the sound of waves breaking on the shore. If we travel overseas on business or pleasure we usually fly; the air stewards will remind us that there are life-jackets under our seats but there is an air of unreality about the safety measures and only the most pessimistic passengers ever imagine they are likely to ditch into the sea. Indeed it is surprising how few air travellers even bother to look out of the cabin windows.

Newspapers and television sometimes bring us reports of maritime disasters: the sinking of a passenger ferry; the flooding of villages in low-lying areas by monsoon rains; the pollution of beaches by oil from a shipwrecked tanker; the loss of a fishing boat and her crew during a storm. But unless we are directly involved in some way, such reports have the same remoteness from most of our lives as stories of famines and earthquakes and other natural disasters.

If we think of the sea at all it is more likely to be in connection with holidays. For many families the seaside holiday is, and always has been, an essential feature of the year. For British people this used to mean a trip to Brighton, Blackpool, Southend-on-Sea, and other coastal resorts, but today is more likely to mean the sun and sand of the Costa Brava, the Greek islands or Majorca. For Americans there are the beaches of California or Miami, or the more distant delights of Acapulco, the Bahamas or Hawaii. For Scandinavians there is the holiday home on the banks of the Baltic. In these and other places the sea provides a ready-made playground for small children, and a pleasant backdrop for sun-bathing and for barbecues on the beach. It is in no way threatening.

The pictures in this book are a graphic reminder that the sea has not always been regarded as a place for relaxation. A quick glance through the pages will reveal pictures of ships of all shapes and sizes from earliest times to the present day: merchant ships, warships, fishing boats, lifeboats, ocean liners, yachts, ferries and hovercraft. They remind us of the crucial importance of the sea as a highway for exploration, conquest and trade. Sea battles decided the fate of nations. Islands and colonies changed hands as a direct result of naval action. It was the ocean voyages of explorers like Columbus, Vasco da Gama, Abel Tasman and Captain Cook which led to the discovery of new lands overseas. North America, the home of numerous tribes of native Indians and roaming herds of buffalo, was settled on its eastern shores by the British and the French, and later by immigrants from all over Europe. In the beginning the settlers eked out a living in the coastal towns of Virginia, Carolina and New England, but as the populations grew the more adventurous headed west, driving out the Indians and building towns and cities across the vast continent. In the Caribbean the arrival of the white men resulted in the wiping out of the native peoples and their replacement by a relatively small number of Europeans and the transportation across the Atlantic of millions of Africans to

work as slaves on the plantations. In Central and South America the explorers were followed by the Spanish conquistadors who marched inland, conquered the ancient civilisations of the Aztecs and the Incas and plundered the country of gold and silver. The Dutch, for whom trade appears to have been more important than conquest, sent their ships to the east, and the astonishing rise of the Dutch republic in the seventeenth century was due to the activities of Dutch merchants whose ships sailed from Amsterdam to the trading stations established in India and Indonesia. The British took Canada from the French, settled Australia and New Zealand, established colonies in Africa and the West Indies, lost the American colonies but succeeded in building up an empire overseas which was founded on, and depended on, sea power.

The crucial importance of seaborne trade is underlined by the fact that most of the great cities of the world owe their foundation, growth and wealth to their position as ports. Some of these cities were built on the banks of great rivers: London grew up on two low hills at the lowest crossing point on the Thames; Boston at the mouth of the Charles River; Quebec beside the St Lawrence River. Some cities such as Sydney, Vancouver, and Hong Kong flourished because they enjoyed the benefit of great natural harbours. Others like Cape Town, Copenhagen and Singapore owed their growth and prosperity to their strategic position on major trade routes. All of them at different times in their history attracted fleets of merchant ships carrying goods from overseas. The pattern has changed in the last twenty or thirty years. Many types of cargoes are now carried in containers and the successful ports are those like Rotterdam which have adapted to the container revolution. The building of giant supertankers has meant that many ports which are sited on rivers some way upstream no longer have the depth of water to take large ships. But though many ports which were once prosperous have now gone into decline, the carrying of goods by sea continues to keep the world's industrialised nations going. Many people assume that most goods today, like most of the travelling public, are carried by aeroplane. Nothing could be further from the truth. More than eighty-five per cent of the world's trade still travels by sea, and anyone who has observed the vista of merchant ships of all sizes waiting outside the port of Singapore will appreciate the reality of this.

Ships and the sea have played a defining role in shaping many of the civilisations of the world, but the sea has also played another role. More than seventy per cent of the earth's surface is covered by water and it has been calculated that there are sixty billion gallons of it for every single inhabitant of the earth. The oceans have a profound effect on our climate. Warmed by the heat of the sun they are largely responsible for the ridges of high pressure and troughs of low pressure which sweep across the continents and bring fair weather or rain and thunderstorms. The oceans provide the motivating force for the hurricanes and typhoons which build up in the Atlantic and the Indian ocean and cause such devastation every year. Equally devastating are the tidal surges and tidal waves, the most dramatic of which are the tsunamis which have their origin in the Pacific Ocean and cause catastrophic damage and loss of life in the islands and coastal regions of the East.

It is little wonder that for centuries people have regarded the sea with fear and awe. Adventurous sailors brought back tales of sea monsters which gave rise to fantastic stories about sea serpents, leviathans and giant squids. The more scientifically-minded landsmen may have had doubts about some of the sailors' stories but there was enough evidence to show that much of what they said was true. After all, there really were flying fish, swordfish and giant whales, and though the dugong may not look much like a mermaid when viewed at close quarters, it could perhaps be mistaken for a woman at a distance. Pliny the elder, a former commander of the roman fleet, recorded two sightings of mermaids off the Spanish coast. He published an account in his Natural History of 80 AD and noted that they looked very much like the pictures he had seen of them except that scales covered their entire bodies and not just their fish tails. Christopher Columbus reported seeing three mermaids off the coast of Haiti; like Pliny he was disappointed because they were not as pretty as they were usually depicted. One of the most detailed of the early descriptions of mermaids appears in the log kept by the explorer Henry Hudson during his expedition to find a route to the east. Two members of his crew saw a mermaid on 13 June 1608. 'From the navel upward, her back and breasts were like a womans (as they say who saw her) her body as big as one of us; her skin very white; and long hair hanging down behind, of colour black; in her going down they saw her tail which was like the tail of a porpoise and speckled like a mackerel.'

By the nineteenth century, mermaids had been relegated to the realm of fiction and to stories such as Hans Anderson's Little Mermaid. Sightings of sea monsters likewise became rare. Everybody knew that Jules Verne's story Twenty thousand leagues under the sea was fiction but there was increasing evidence from fishermen, divers and underwater explorers to show that giant squid, huge eels and monstrous looking fish lurked in the ocean depths.

Many ancient civilisations have stories and legends about great floods. What is interesting about some of these stories is that historians and archaeologists have found evidence to suggest that they really happened. The biblical story of Noah and the Flood (which is echoed in the Assyrian story known as the Epic of Gilgamesh) received some confirmation when the archaeologist Leonard Woolley was excavating the ancient city of Ur in the 1920s. In the cross-section of a deep trench he discovered layers of clay which indicated a major flooding of the region. It is now generally accepted that there was a great flood or series of floods in the Euphrates region in the years around 4000 BC. Less credible is the theory of several Americans that they have located the remains of Noah's ark on Mount Arawak.

The Lost City of Atlantis has been the subject of much speculation ever since Plato described in detail a vast island which was the home of a mighty civilisation. According to his account there was a violent earthquake and floods, 'and in a single day of misfortune the island of Atlantis disappeared into the depths of the sea'. There have been numerous theories about Atlantis. One is that the lost city was on the island of Thera, north of Crete, which was destroyed by a volcanic explosion around 1450 BC. Another suggests that Crete itself

was Atlantis because it is believed that the Minoan empire was brought to an end by a natural catastrophe.

Islands have always had a strong hold on people's imagination. In Greek mythology they are places where the traveller may encounter the Cyclops, or the Sirens, or the goddess Circe who could turn men into beasts. There has always been a tendency to regard islands as special places, as places to get away from it all. They fall broadly into two distinct categories: the islands of the northern latitudes and the tropical islands.

The northern islands have their own mysterious attraction. There are the remote islands in the mist: the Scottish isles of Skye and the Shetlands and the outer Hebrides, places which inspired the stories of Sir Walter Scott and Robert Louis Stevenson. There are the islands like Lindisfarne which were refuges for monks in the dark ages. There are the beautiful islands off the coast of Nova Scotia, the hundreds of islands in the Baltic sea and around the coasts of Finland. These are the islands of pine woods, and rocky shores and beaches of pebbles lapped by cold, clear water which have inspired some of the films of Ingmar Bergman and have their own legends: the Finnish Kalemara, and the sea gods and monsters of Nordic legend.

By contrast there are the tropical islands, epitomised by the islands of the Caribbean and the Pacific islands of Tahiti and Hawaii. Pictures of tropical islands reproduced in thousands of travel agents brochures have made a cliché of these places. We are all familiar with those pictures of dazzling white beaches, fringed by coconut palms, and sparkling blue water sheltered by coral reefs. For many people who live in cold, grey northern climates these islands have an almost irresistible attraction. There is the sunshine, the warm sea, the brilliant tropical flowers and vegetation, the abundance of fruit, and the relaxed and easygoing attitude of the inhabitants. It is little wonder that so many film stars and successful businessmen purchase properties in the Bahamas or the Cayman islands, and sometimes buy entire islands.

It is tropical islands (or desert islands) which have inspired the stories of castaways and pirates. The most famous castaway is the hero of Daniel Defoe's Robinson Crusoe. He was shipwrecked off the coast of south America, was washed ashore and 'lived eight and twenty years all alone in an uninhabited island'. Defoe based the story on the true adventures of the Scottish seaman Alexander Selkirk who was marooned on the island of Juan Fernandez off the coast of Chile in 1704. He lived on fish and goats for four years before he was picked up by a privateer ship commanded by Captain Woodes Rogers. On board Rogers' ship, acting as pilot, was the writer, explorer and former buccaneer William Dampier who had been present when Selkirk was originally marooned. Dampier's long brooding face appears among the portraits of famous seafarers in chapter 5.

The major part of this book is taken up with pictures of ships and ships' gear. A glance through the illustrations in the first chapter shows the astonishing variety of hull shapes and rig which have been devised during the evolution of the ship. The earliest of the various craft illustrated are those frail but elegant vessels used by the Egyptians, which never seemed real until archaeologists uncovered the remains of an entire ship in the sand near the pyramids. Then there are Greek galleys, the triremes and quinqueremes. We now know, from a replica which was constructed of a trireme, that these formidable vessels were highly manoeuvrable, capable of extraordinary acceleration from a standing start and, with a trained crew, could travel long distances at speed. The Viking ships with their light, clinker construction and low freeboard appear to be wholly unsuited for ocean voyages and yet they not only sailed across the North Sea but also crossed the North Atlantic to Greenland and beyond. And then there are those broad-beamed, round-hulled medieval ships, the cogs and hulks which carried the trade of northern Europe for centuries. They are followed by the carracks and caravels of the great age of exploration, and the galleons made familiar from depictions of the Spanish Armada. By the eighteenth century the shipbuilders of northern Europe had developed and refined a range of sailing ships of all sizes which were perfectly adapted for particular purposes: the ships of the line for battle; the big three-masted Indiamen and the smaller brigs and snows for carrying cargoes across the oceans; the schooners and ketches and specialised local craft for fishing; and a host of sloops and barges for coastal and inland trade.

Equally seaworthy, but very different in form, were the vessels developed for fishing and trading in the Indian and Pacific Oceans: the artists on Cook's voyages brought back pictures of the war canoes of Tahiti and fishing craft with strangely-shaped sails and outriggers; travellers in the East described the numerous forms of Chinese junks; and then there were Arab dhows with lateen sails and the many ingenious forms of craft evolved by the fishermen of Indonesia.

With the introduction of steam power in the nineteenth century the picture slowly changed. Tall, black funnels appeared on the decks of western ships but the shipbuilders retained the masts and sails in case of engine failure. As steam power became reliable, the sails were abandoned and the very different profiles of iron and steel ships began to appear. These ranged from the towering forms of ocean liners, aircraft carriers and battleships, through a range of cruisers, destroyers and frigates to the low streamlined shapes of the submarines.

In chapters 2 and 3 we see in more detail the extraordinary complexity of ship design. Ship plans and cross-sections reveal the arrangements below deck, the position of the gun decks, the galley and the quarters for officers and men. Images include ships in course of construction, and the specialised tools used by the shipwrights, notably the adze and the two-handed saw. There are fine illustrations of figureheads and stern decorations, the intricate carvings loaded with heraldry and symbolism – a reminder that the ship of war was not simply a fighting machine but was an ambassador of her country intended to impress onlookers when she sailed into a foreign port. And then there are drawings of masts, spars and rigging; details of shrouds and ratlines and deadeyes; and the ingenious systems of blocks and tackle designed to ease the burden of raising and lowering sails, and to give added purchase when hauling in sheets or heaving a ship's boat onto the deck. Among the most decorative illustrations in the book are the carefully-drawn pictures of the numerous knots and splices which seamen have devised to fasten one rope to another, a rope to a spar, or a rope to a hook or an anchor.

Introduction

Warfare at sea, which is the subject of chapter 4, was a favourite topic for artists throughout the ages. Monarchs, governments and individual naval officers wanted pictorial records of their warships and of notable victories at sea. The British defeat of the Spanish Armada inspired numerous pictures, several of which are illustrated here. The battles of the Nelson era were likewise the subject of dozens of marine paintings, notably by Nicholas Pocock whose work is represented by several engravings. Pocock was the heir to a tradition of marine painting which went back to medieval times. We find depictions of sea battles in illuminated manuscripts, on wall-hung tapestries, and occasionally among the paintings of renaissance artists. But it was the Anglo–Dutch wars of the late seventeenth century which gave the impetus to the detailed recording of naval actions. Dutch artists such as Hendrick Vroom and Adam Willaerts created a market for marine paintings among the seafaring people of Holland. They were followed by two generations of gifted marine artists including Simon de Vleiger, Ludolf Bakhuizen and Willem van de Velde and his son Willem van de Velde the younger. These artists painted and drew meticulously accurate portraits of ships and fleet actions as well as atmospheric seascapes and coastal views. British artists in the eighteenth century took their lead from the van de Veldes and established a flourishing school of marine art which lasted well into the nineteenth century.

At the heart of this book are the pictures of seafarers. These cover a wide sweep. There are the familiar images of naval heroes like Nelson and the great Dutch admiral De Ruyter alongside pictures of monarchs such as Alfred the Great who created a fleet to defend England from the Vikings, and King Louis XIV whose reign saw the massive expansion of the French fleet under the direction of Colbert, his naval minister. There is an idealised portrait of Henry the Navigator, and more lifelike representations of the notorious Captain Bligh and the female sailor Mary Anne Talbot. Scattered among the monarchs and naval officers are a surprising number of buccaneers and pirates. These include the masterful figure of Sir Henry Morgan, who sacked Portobello and burnt Panama City to the ground; the sinister Lolonais, who was renowned for the savage torture he inflicted on his victims; the two women pirates Mary Read and Anne Bonny who were condemned to death by a Jamaican court but escaped hanging because they were both pregnant; and the most colourful pirate of them all, Captain Teach, known as Blackbeard, who terrorised the east coast of America until he met a violent death at the hands of Lieutenant Maynard among the swamps off the coast of Carolina. The quality of these images vary greatly. Some are taken from crude woodcuts or copper engravings; some are engraved versions of oil painted portraits. The majority of the pictures reproduced here were originally made as book illustrations in the eighteenth and nineteenth centuries.

Perhaps the most decorative pictures in the book are those in the chapter on Navigation and Seamanship. The pictures of lighthouses are notable for the variety of designs, as are the fine diagrams which illustrate the machinery devised for operating the lantern and its revolving gear. Most elegant of the lighthouses is Winstanley's elaborate structure on the Eddystone Rock, with its wooden balconies, numerous cranes, and windvane. In marked contrast is the functional shape of the Bell Rock lighthouse on the Firth of Forth, typical of so many of the lighthouses built around the British coast during the nineteenth century. Equally decorative, but on a considerably smaller scale, are the pictures of navigational instruments. We can follow here the development of instruments for measuring latitude; the cross staff, the back staff, the quadrant and the sextant.

With the chapter on the New Worlds we are back with the seafarers again, those who are most well-known for their exploration. The chapter is appropriately headed by an engraved portrait of the celebrated geographer and mapmaker Gerard Mercator who made his name with the publication of a great atlas in 1585 and achieved lasting fame by devising a method for projecting the spherical world onto a flat page. The Mercator projection forms the basis for the admiralty charts which are used by professional seamen and cruising yachtsmen throughout the world. There follow portraits of the pioneering explorers who gave their names to seas, straits and continents: Humboldt, Magellan and Amerigo Vespucci. There are the resolute, bearded faces of the Elizabethan sea dogs such as Sir John Hawkins, and Sir Walter Raleigh. There are portraits of the explorers of the Pacific: Captain Byron, Louis Antoine de Bougainville, La Perouse, and Captain James Cook. Their exploits are commemorated here in a series of wood and copper engravings, which are at the other end of the illustrative scale from the delicate watercolours and fine paintings produced by John Webber, William Hodges and other artists who accompanied the expeditions. Also included are the charts and the pages from atlases which resulted from the travels, observations and soundings made by the seamen of many nations throughout the past three centuries.

The final chapter contains some graphic illustrations of the energy of the sea. Here are glimpses of storms and shipwrecks, vessels sinking among ice floes or smashed to smithereens on rocky shores. These powerful images are followed by various designs for lifeboats, and by curious pictures showing the ingenious early methods devised for salvaging the sunken remains of ships. The book concludes with pictures of mermaids and monsters, and some of the legends inspired by the sea, which provide a perfect contrast to the technical drawings of ships, guns and rigging which naturally occupy the greater part of the book. They are a reminder that, although the sea may be the domain of sailors and fishermen, it has throughout history played a major role in the development of civilisation, and the stories, legends, poetry and paintings it has inspired have, for centuries, stirred the imagination of many people who may have seldom, if ever, been to sea in a ship.

David Cordingly
July, 1997

Chapter 1

Sea-going Vessels

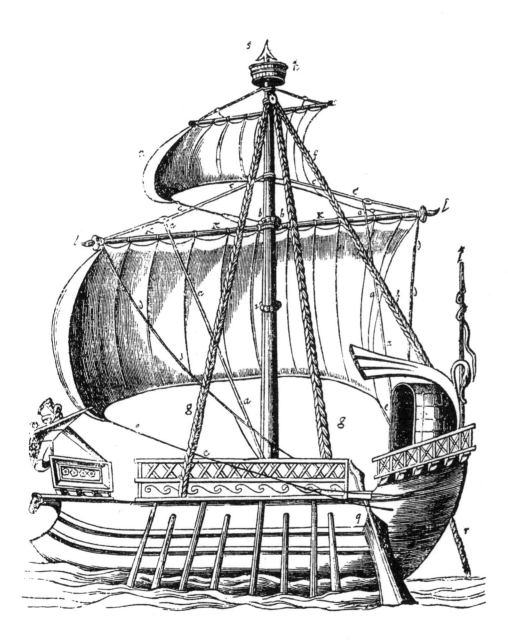

The boat was the earliest vehicle to improve mobility for travellers and traders because it enabled comparatively wide expanses of water to be crossed, cutting journey times and improving communications between different races and cultures. As a result of our overwhelming desire to travel across the oceans more quickly, safely and economically, water transport, whether for civil or military reasons, has been in a continuous state of development since the very earliest stages of civilisation.

From the primitive origins of boats in the shape of dugouts the ship has emerged in myriad form to excel as a tool of exploration and colonisation, expanding trade between countries, and determining supremacy at sea during wartime. Some, such as the graceful East Indiamen and the sleek tea clippers are remembered for their aesthetic qualities. In stark contrast there are the modern day destroyers and aircraft carriers, and the nuclear submarines that lurk beneath the surface, which are more noted for the armaments they carry and their position at the forefront of technological advancement.

It was not until the eighteenth century, pioneered by the work of Hendrik af Chapman in his folio of ship drawings *Architectura Navalis Mercatoria*, that highly detailed ship plans began to be used routinely in the production of specific ship-types. Early ship-types, therefore, such as the cog and the carrack can only be loosely defined, while later ones were subject to the application of scientific principles in overcoming design and construction issues. As such, in the following pages of this chapter, some pictures are simply artistic impressions of what might have been, whilst others can be viewed as detailed diagrams, which in themselves mark the progress of the most important invention in the world's social, economic and cultural history.

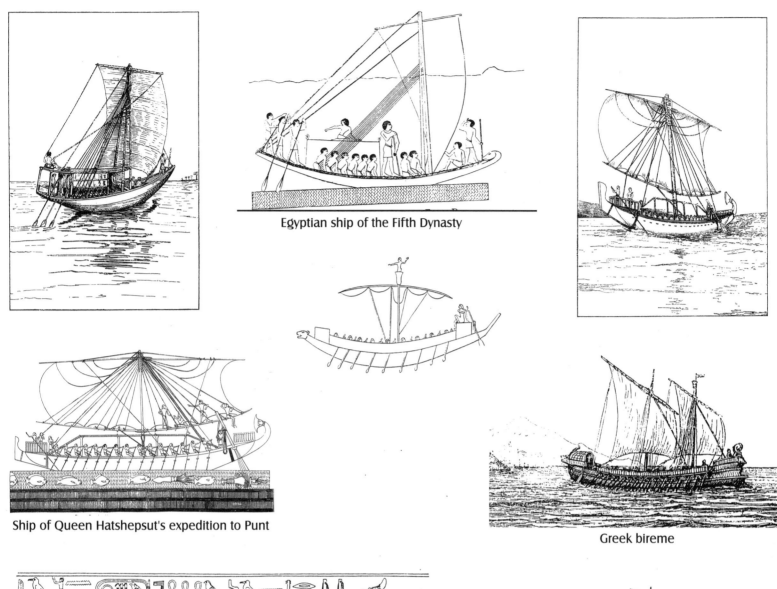

Egyptian ship of the Fifth Dynasty

Ship of Queen Hatshepsut's expedition to Punt

Galley from the temple of Sahure

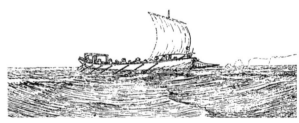

Greek bireme

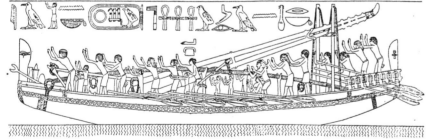

Phoenician ship

The Mediterranean galley was a formidable machine that relied on the muscle power of freeman, convicts and prisoners of war to propel the ship. The ultimate oared warship was the trireme (characterised by three files of oarsmen per side, rowing at three different levels) where the efficient disposition of over 100 oarsmen made this galley-type the fastest oared warship of all time.

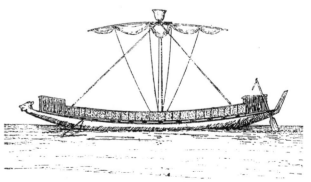

Egyptian warship

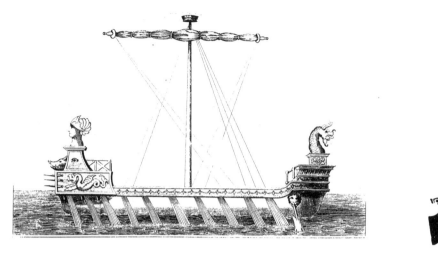

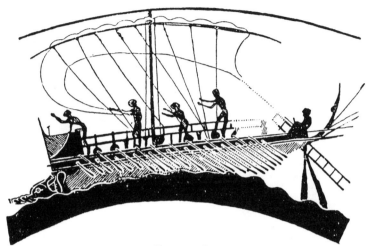

Greek war galley

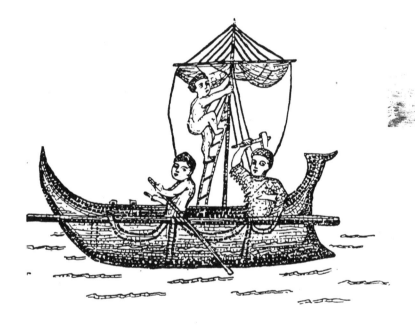

Greek bireme

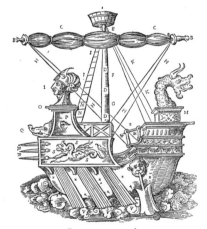

Roman warship

Greek bireme

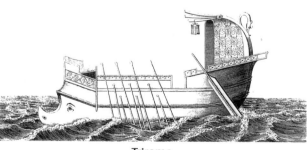

Trireme

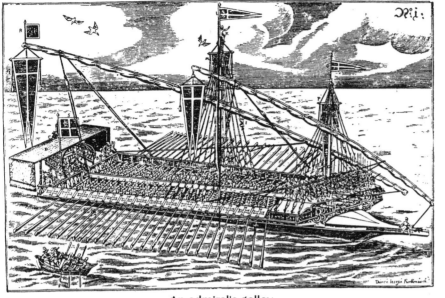

An admiral's galley

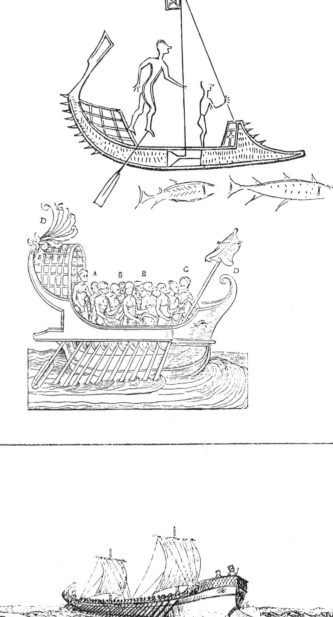

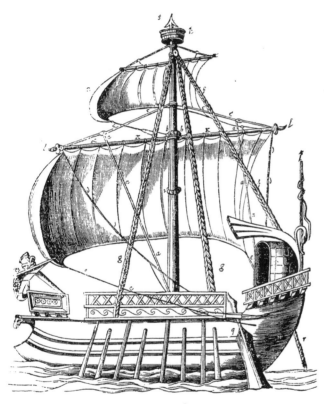

Roman warship

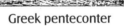

Greek penteconter

The galley was a successful and enduring ship-type. With a sail to harness a favourable wind and ease the burden of the oarsmen, these ships were able to cover large expanses of water. Further north, the dominant ship-type that evolved was the clinker-built longship, in which the Norse people set sail to settle in distant lands, such as Iceland, Greenland and even America.

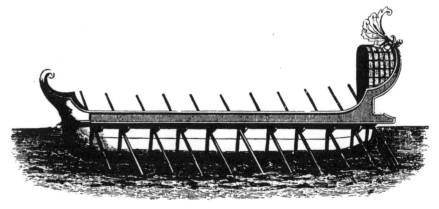

Norse merchantman

Norwegian ship ~

Anglo-Saxon ship

Russian ship

Norse longship

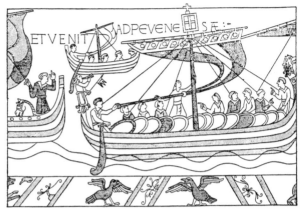

Scene from the Bayeux Tapestry

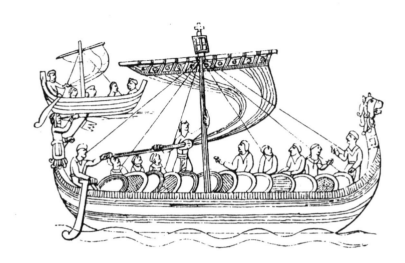

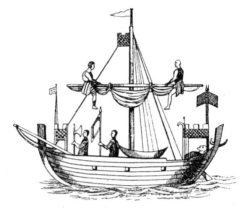

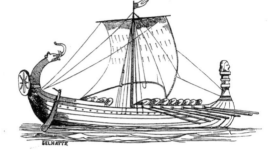

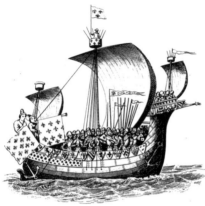

Ship of William the Conqueror

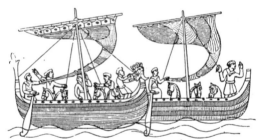

The horse boats, from the Bayeux Tapestry

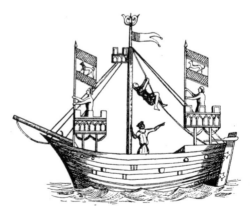

Illustrations, such as those in the Bayeux Tapestry give us many details as to the preparation and manoeuvrability of early medieval boats. Many northern European ship-types were derivatives of the Viking longship to which later additions, such as the forecastle and aftercastle were made. Later, however, the northern, clinker-built method was to merge with the southern carvel flush-planked construction, and the number of masts increased.

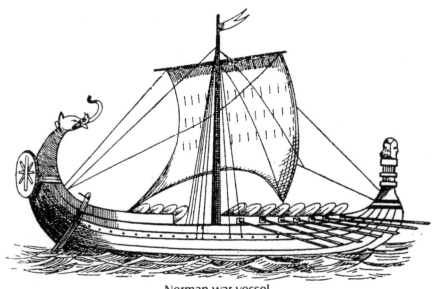

Norman war vessel

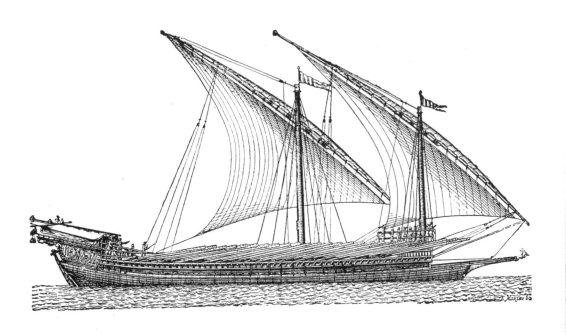

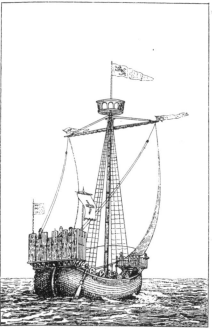

A Crusade ship

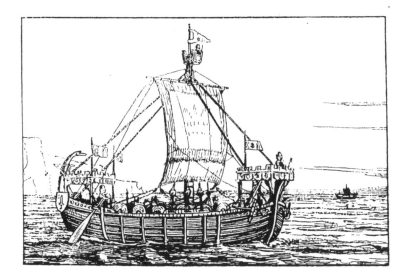

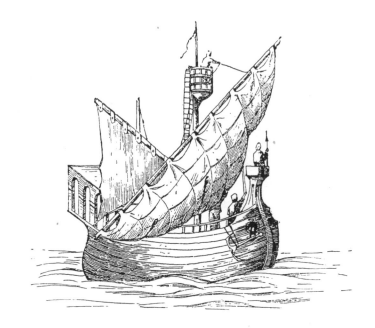

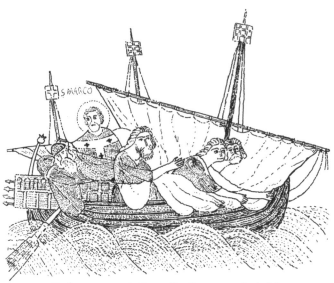

Early representation of a three-masted ship

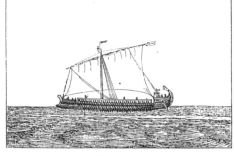

Dromon

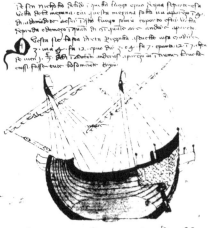

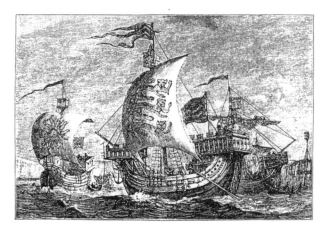

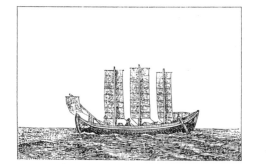

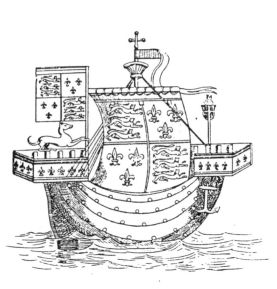

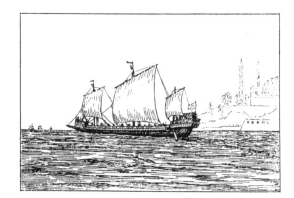

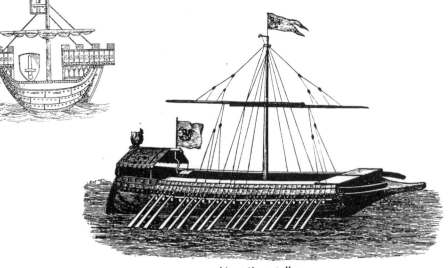

Ship design continued to develop during the Middle Ages to produce the first full-rigged ship – the carrack, which superseded other ship-types to become the capital ship of sixteenth-century navies. With the provision of mounted gunports in the carrack, warfare at sea was able to transcend the limitations of a land battle at sea, fought by archers positioned in the fore and aftercastles, or by soldiers boarding the enemy vessel and engaging in hand to hand combat.

Venetian galley

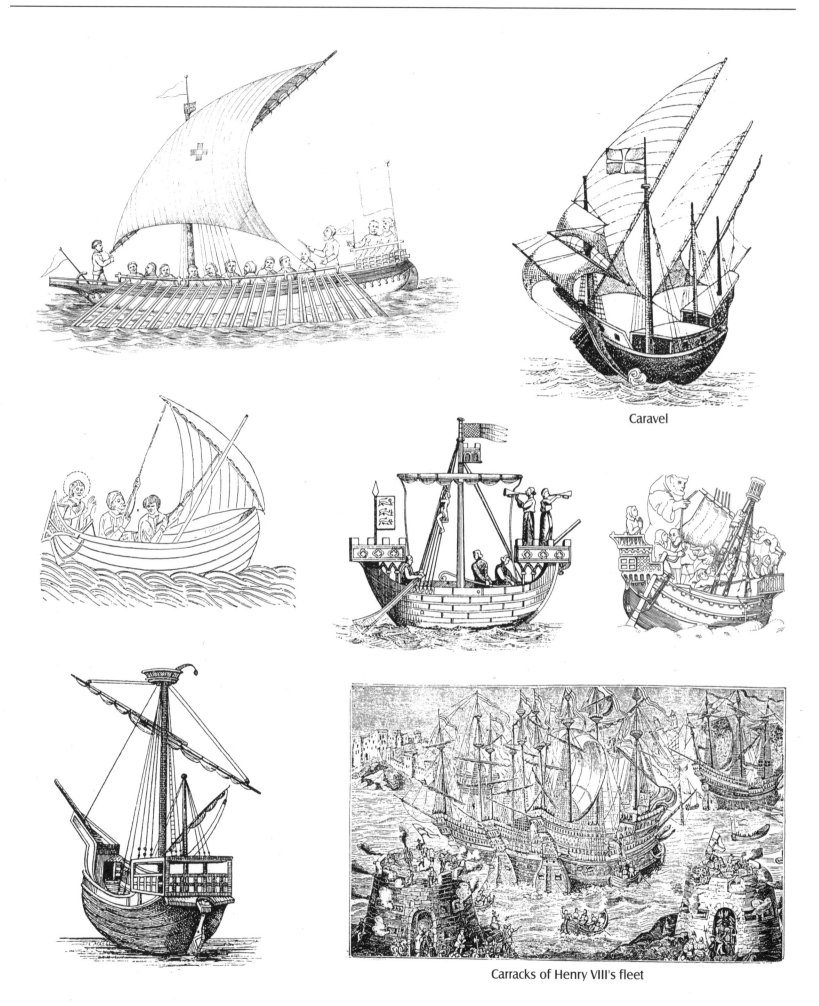

Caravel

Carracks of Henry VIII's fleet

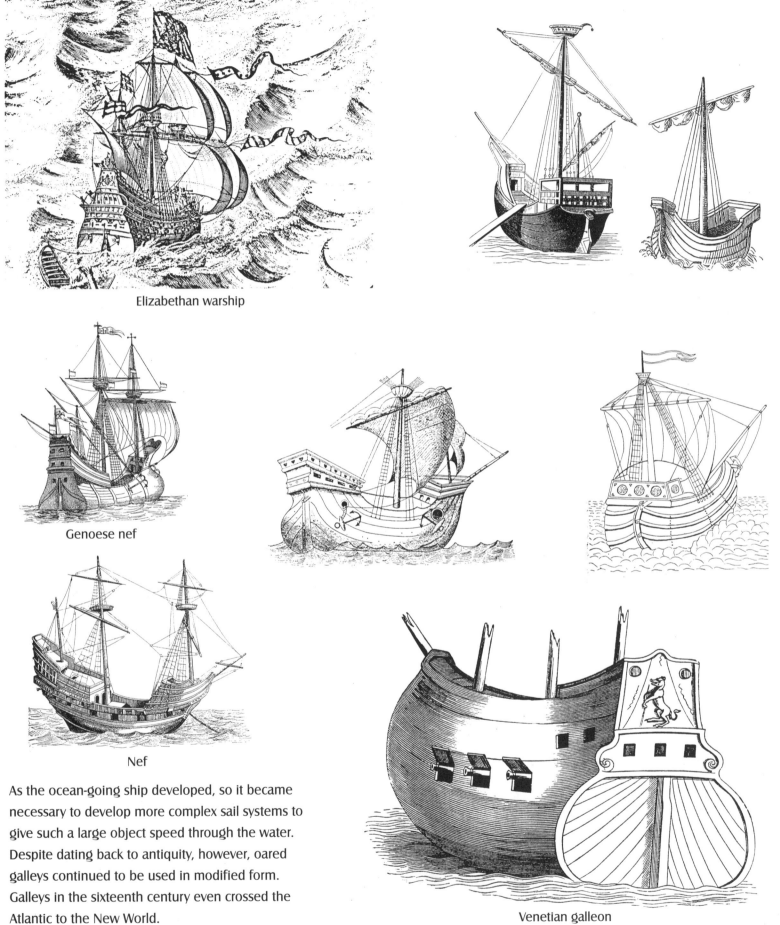

Elizabethan warship

Genoese nef

Nef

As the ocean-going ship developed, so it became necessary to develop more complex sail systems to give such a large object speed through the water. Despite dating back to antiquity, however, oared galleys continued to be used in modified form. Galleys in the sixteenth century even crossed the Atlantic to the New World.

Venetian galleon

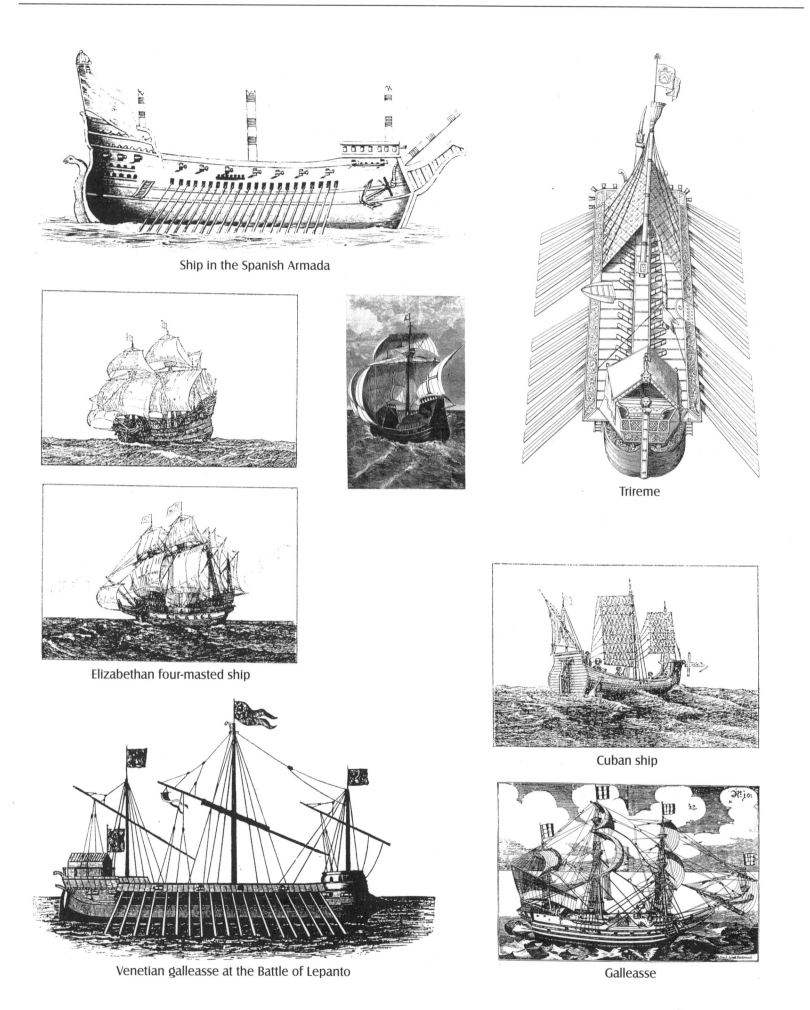

Ship in the Spanish Armada

Trireme

Elizabethan four-masted ship

Cuban ship

Venetian galleasse at the Battle of Lepanto

Galleasse

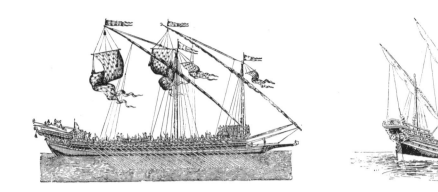

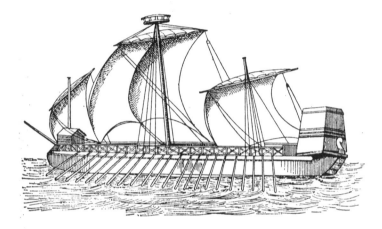

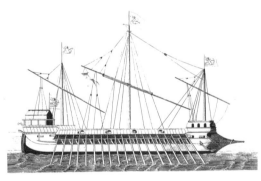

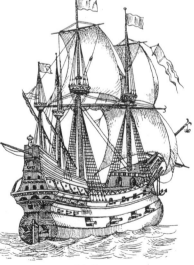

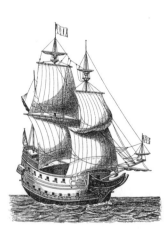

As the design of ships became more complicated, so the rudimentary skills of the shipwright had to evolve into a scientific shipbuilding process, although there were still many fatal experiments. Even good designs could be easily overwhelmed by the volatile nature of the world's oceans, and deaths at sea were common.

Nef

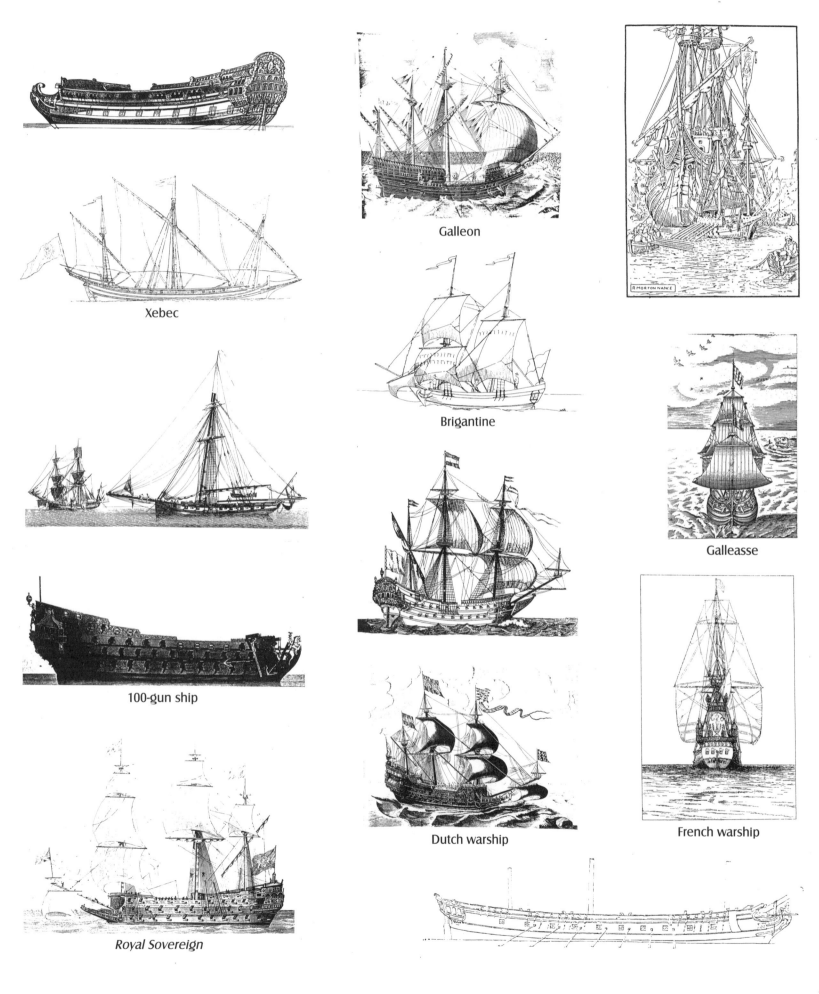

Xebec

Galleon

100-gun ship

Brigantine

Galleasse

Dutch warship

French warship

Royal Sovereign

Brig

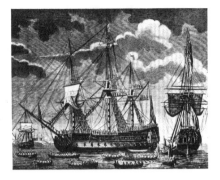

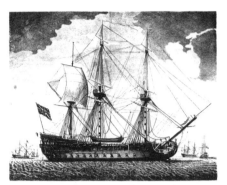

French 74-gun ship *Terrible*

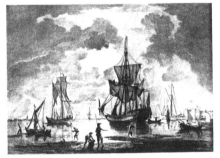

Early types of yachts

Corvette

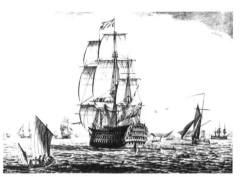

Second Rate ship of the line

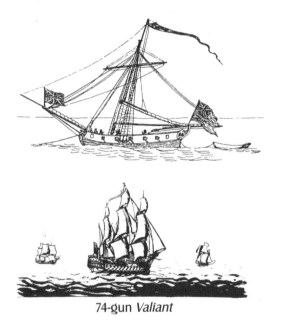

74-gun *Valiant*

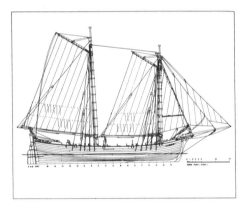

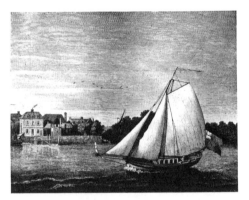

In the seventeenth and eighteenth centuries, ship types became much more distinct, with the huge number of small mercantile vessels distinguished by variations in rig. The rating system was developed to grade warships according to fighting capacity and ability to withstand punishment. The steam-powered vessel made its first appearance at the end of the eighteenth century but did not in any real capacity take on the roles carried out by sailing ships.

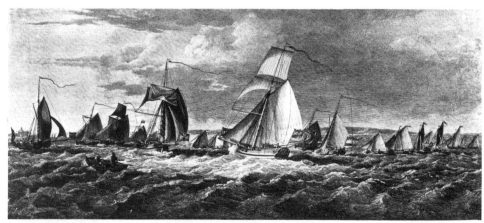

Yachts off Sheerness, 1778

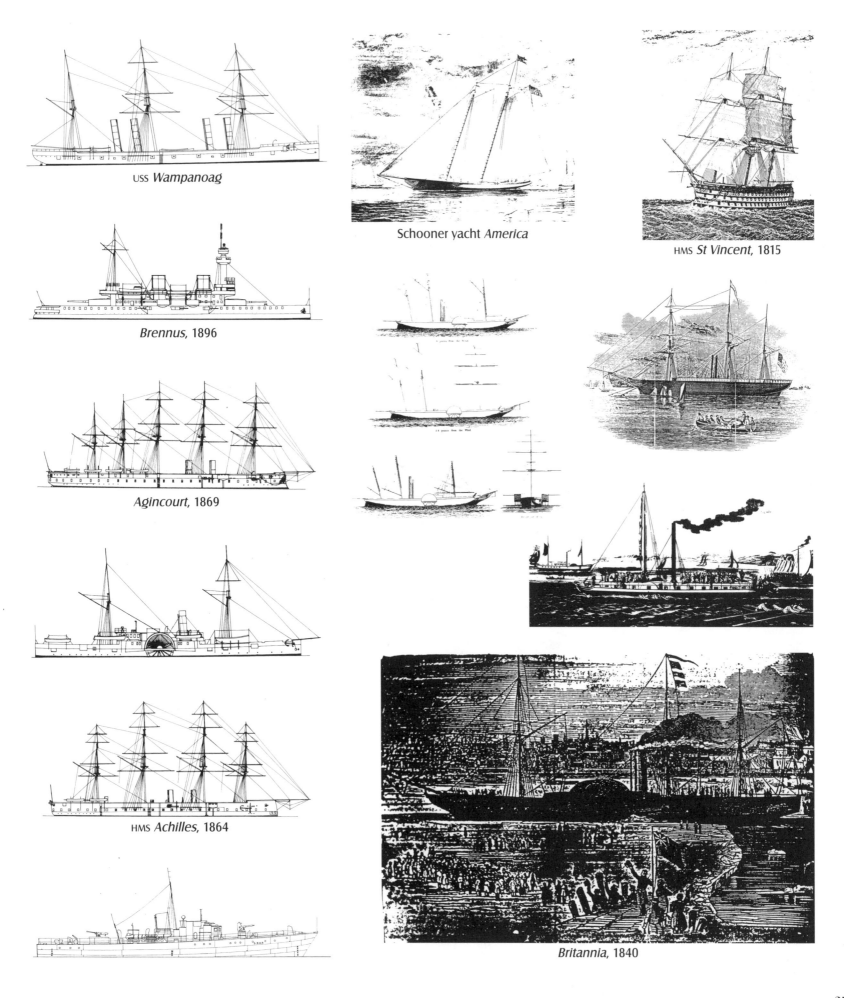

USS *Wampanoag*

Brennus, 1896

Agincourt, 1869

HMS *Achilles*, 1864

Schooner yacht *America*

HMS *St Vincent*, 1815

Britannia, 1840

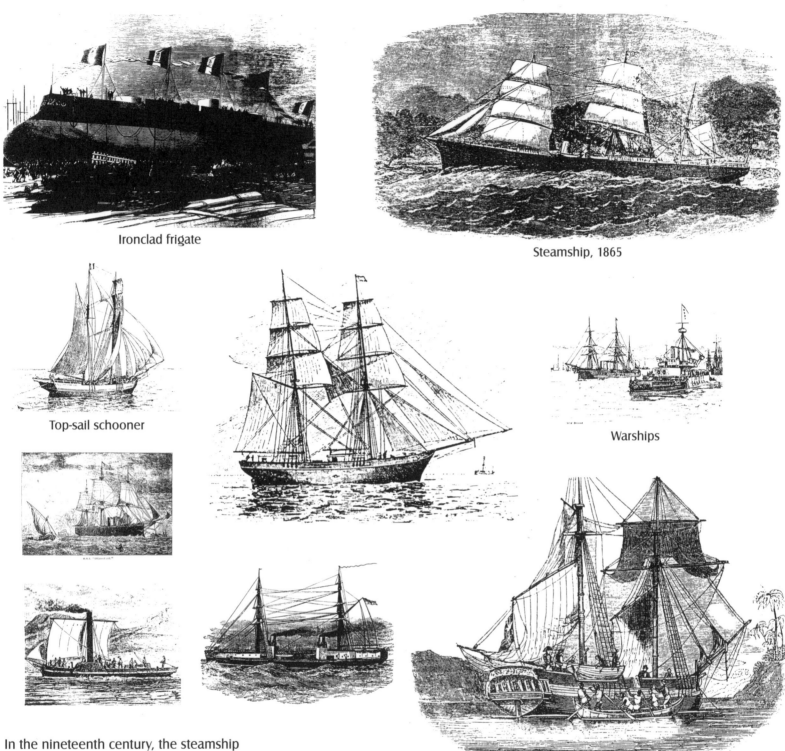

Ironclad frigate

Steamship, 1865

Top-sail schooner

Warships

In the nineteenth century, the steamship developed to the point where it became a viable alternative to the sailing ship as a carrier of goods. This did not, however, prevent the sailing ship from achieving dominance in trades such as tea from China. The speed required to fulfil demand, resulted in what is often considered to be the most beautiful ship ever built - the tea clipper, characterised by a very sharp-raked stern, three masts and square rig.

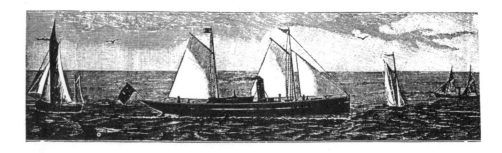

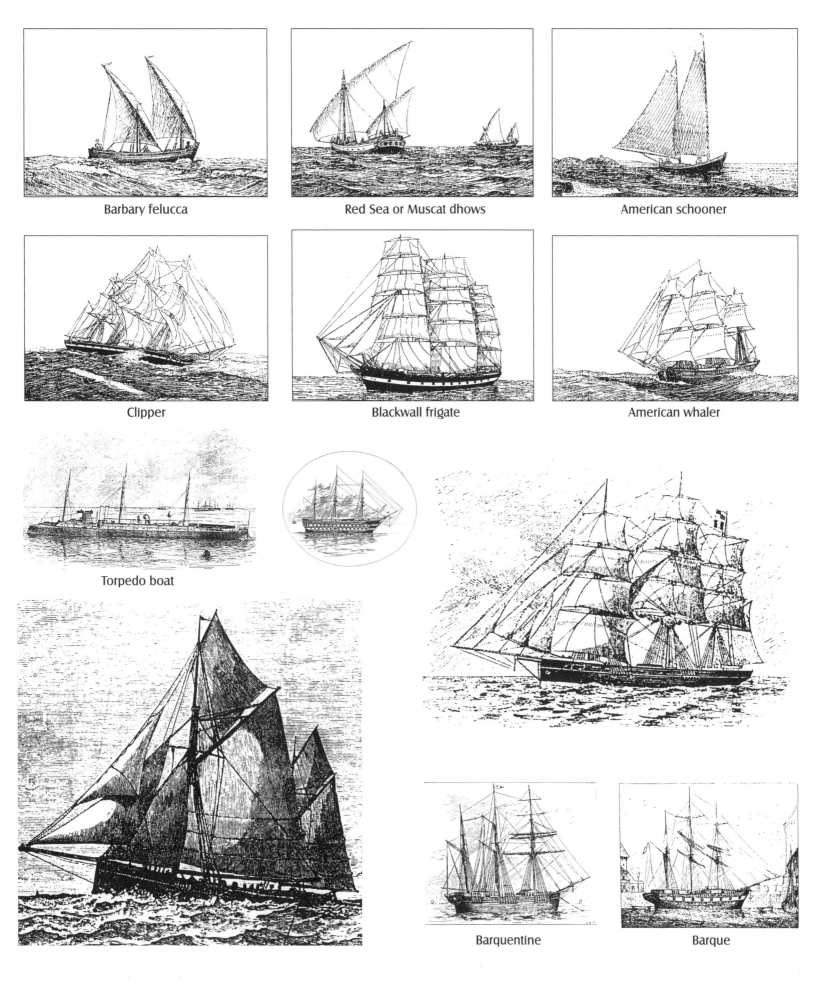

Barbary felucca

Red Sea or Muscat dhows

American schooner

Clipper

Blackwall frigate

American whaler

Torpedo boat

Barquentine

Barque

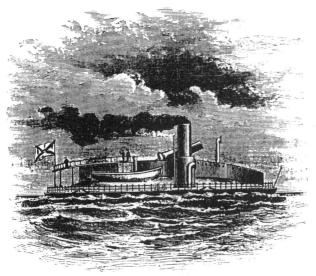

Russian ironclad

Federal steamer of the
American Civil War

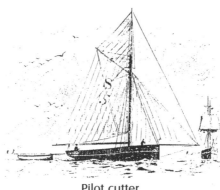

Pilot cutter

Warships underwent a gradual change during the
nineteenth century, as iron replaced wood to
become the primary material for shipbuilding. As
such, the ironclad usurped the position of the old
line-of-battle ship to become the capital ship. Later
improvements to the steam engine coupled with
the introduction of breech-loading guns, allowed
the modern battleship to emerge as a totally
separate ship-type.

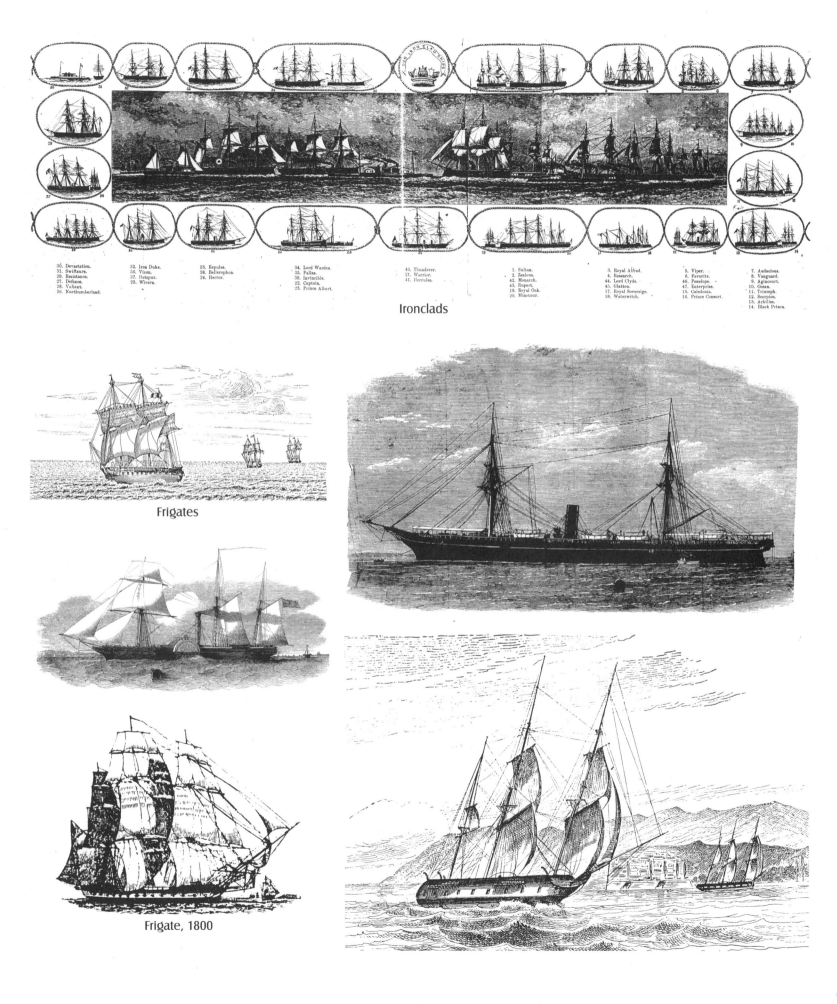

36. Devastation.	32. Iron Duke.	33. Repulse.	34. Lord Warden.
31. Swiftsure.	36. Vixen.	38. Bellerophon.	35. Pallas.
29. Resistance.	37. Hotspur.	24. Hector.	39. Invincible.
27. Defence.	25. Wivern.		22. Captain.
28. Valiant.			23. Prince Albert.
26. Northumberland.			

40. Thunderer.	1. Sultan.	3. Royal Alfred.	5. Viper.
21. Warrior.	2. Zealous.	4. Research.	6. Favorite.
41. Hercules.	42. Monarch.	44. Lord Clyde.	46. Penelope.
	43. Rupert.	45. Glatton.	47. Enterprise.
	19. Royal Oak.	17. Royal Sovereign.	15. Caledonia.
	20. Minotaur.	18. Waterwitch.	16. Prince Consort.

7. Audacious.
8. Vanguard.
9. Agincourt.
10. Ocean.
11. Triumph.
12. Scorpion.
13. Achilles.
14. Black Prince.

Ironclads

Frigates

Frigate, 1800

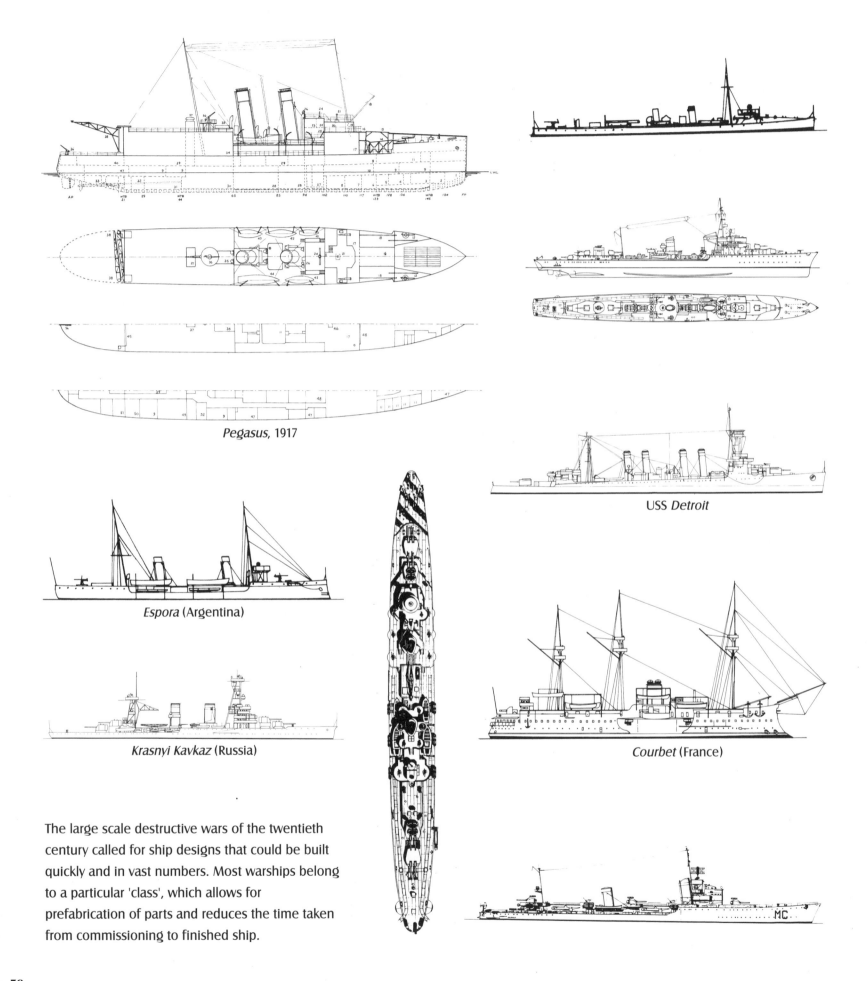

Pegasus, 1917

Espora (Argentina)

Krasnyi Kavkaz (Russia)

USS *Detroit*

Courbet (France)

The large scale destructive wars of the twentieth century called for ship designs that could be built quickly and in vast numbers. Most warships belong to a particular 'class', which allows for prefabrication of parts and reduces the time taken from commissioning to finished ship.

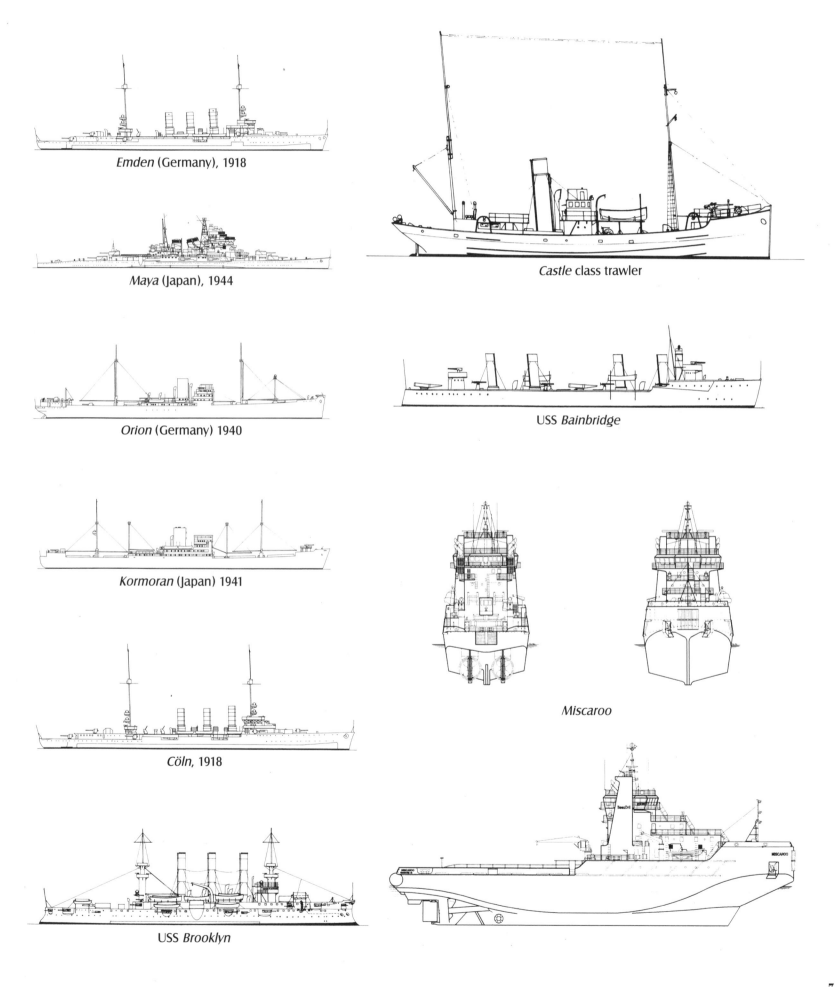

Emden (Germany), 1918

Maya (Japan), 1944

Orion (Germany) 1940

Kormoran (Japan) 1941

Cöln, 1918

USS *Brooklyn*

Castle class trawler

USS *Bainbridge*

Miscaroo

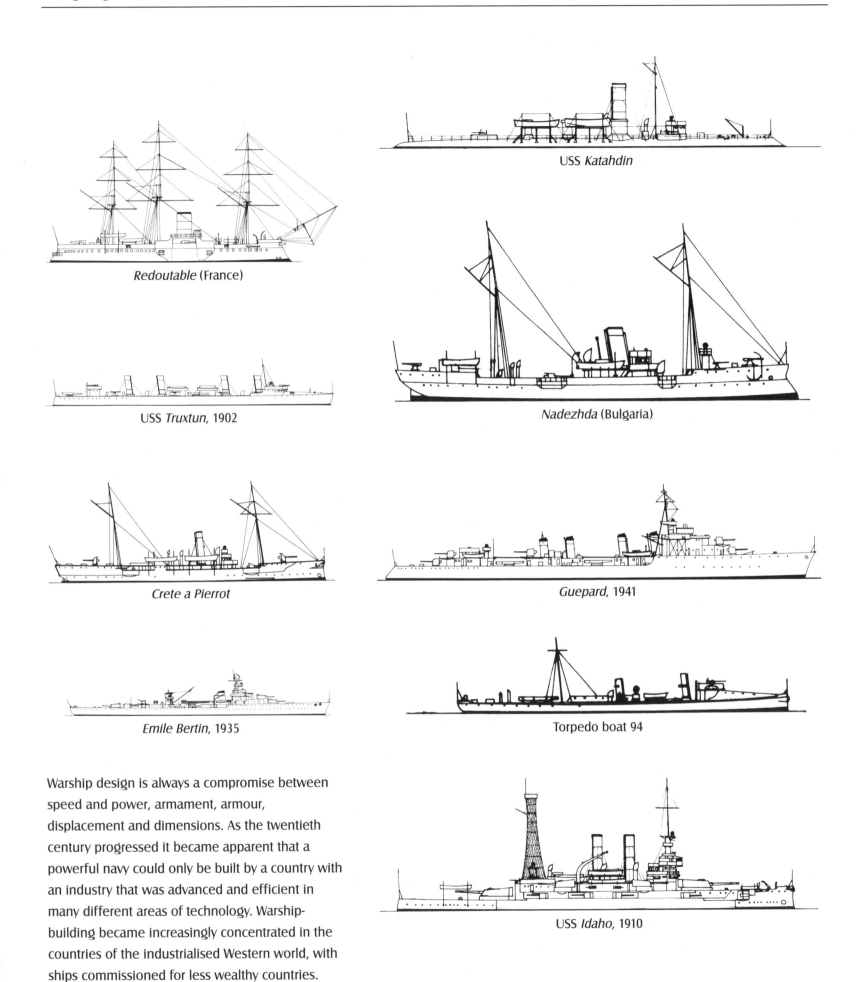

Redoutable (France)

USS *Katahdin*

USS *Truxtun*, 1902

Nadezhda (Bulgaria)

Crete a Pierrot

Guepard, 1941

Emile Bertin, 1935

Torpedo boat 94

Warship design is always a compromise between speed and power, armament, armour, displacement and dimensions. As the twentieth century progressed it became apparent that a powerful navy could only be built by a country with an industry that was advanced and efficient in many different areas of technology. Warship-building became increasingly concentrated in the countries of the industrialised Western world, with ships commissioned for less wealthy countries.

USS *Idaho*, 1910

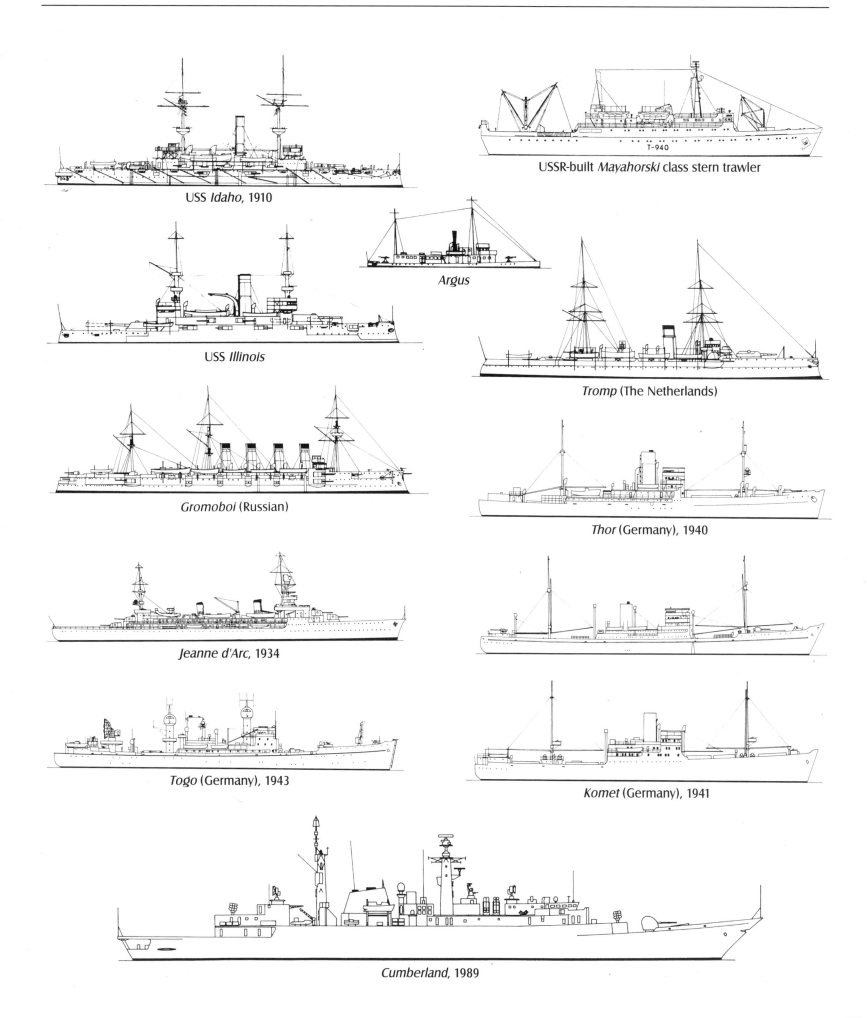

USS *Idaho*, 1910

USSR-built *Mayahorski* class stern trawler

Argus

USS *Illinois*

Tromp (The Netherlands)

Gromoboi (Russian)

Thor (Germany), 1940

Jeanne d'Arc, 1934

Togo (Germany), 1943

Komet (Germany), 1941

Cumberland, 1989

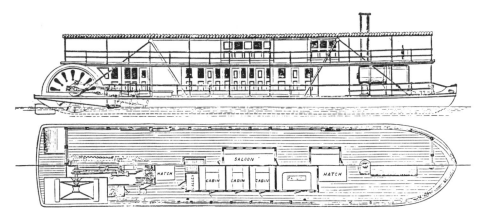

Stern-wheel paddle steamer - longitudinal view with upper and lower deck plans

East Indiaman, 1952

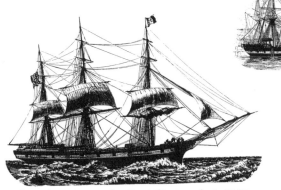

American transatlantic sailing packet, 1840

Early China tea clipper

Whale boat

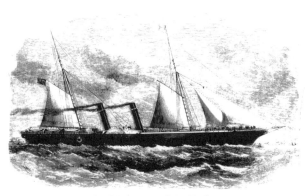

P&O's steamship *Delta*

The nineteenth century saw massive peaceful migrations particularly from Europe to North America and people became a valuable cargo in their own right. In North America the inexorable move westwards lead to the exploitation of rivers and lakes by entrepreneurs and the first steam-driven vessels such as the stern-wheeler became a common sight on those relatively calm waters.

Chinese tea-boat

Carrack

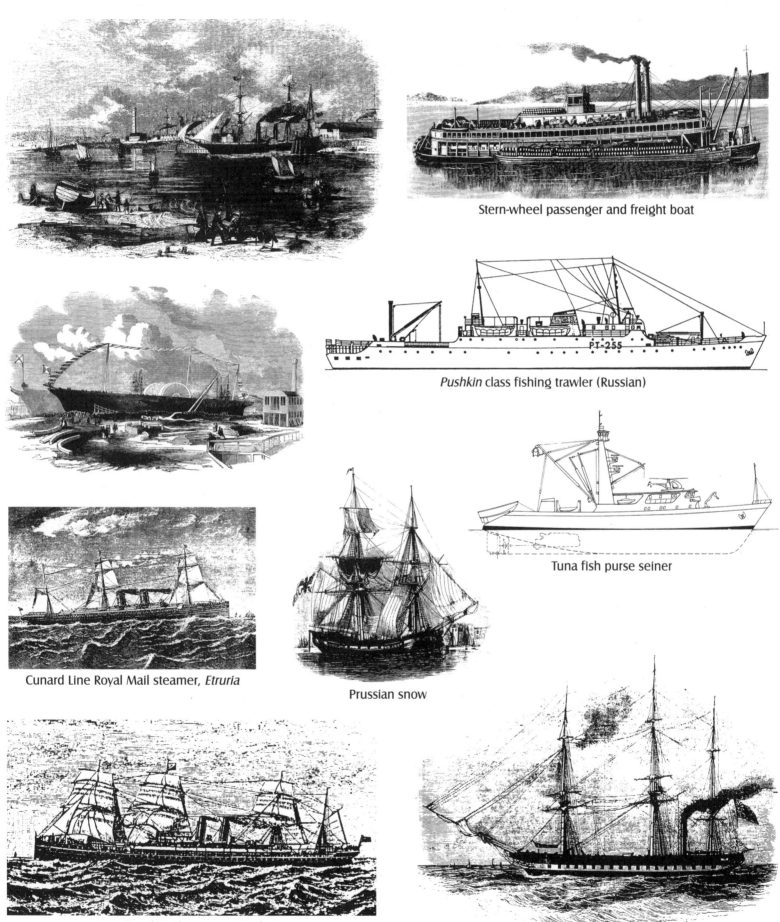

Stern-wheel passenger and freight boat

Pushkin class fishing trawler (Russian)

Tuna fish purse seiner

Cunard Line Royal Mail steamer, *Etruria*

Prussian snow

P&O Royal Mail steamer, *Carthage*

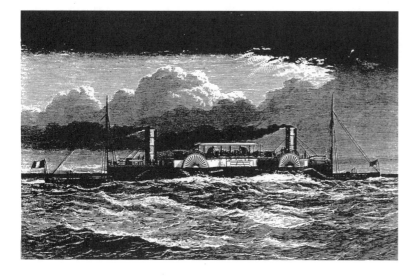

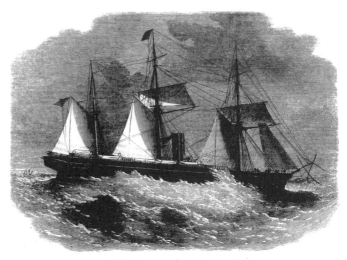

P&O steamship *Poonah*

American clipper, *The Great Republic*, 1853

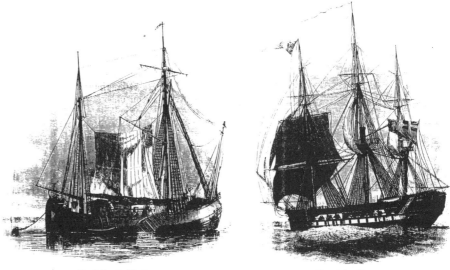

Dutch galliot

East Indiaman

As with the warship, the merchant ship proliferated into a multitude of functional designs according to its cargo. In some cases these designs were adapted as conditions changed, for example the whale-catcher which altered with the introduction of the factory ship and the fishing trawler, as advancing technology changed the way fish were caught and stored before the ship returned to shore.

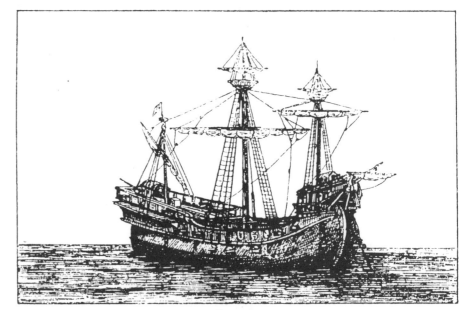

Carrack

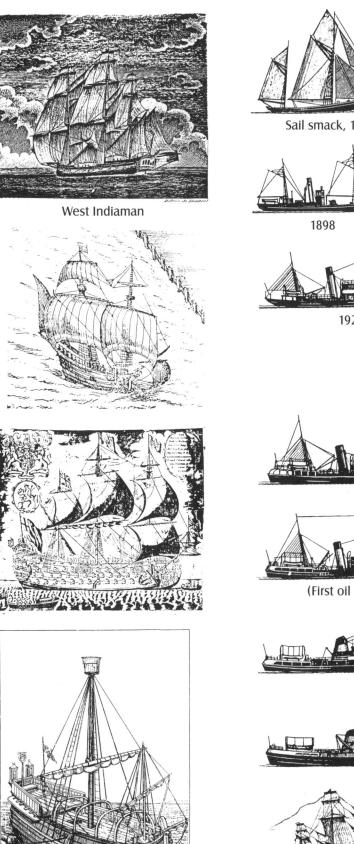

West Indiaman

Merchantman

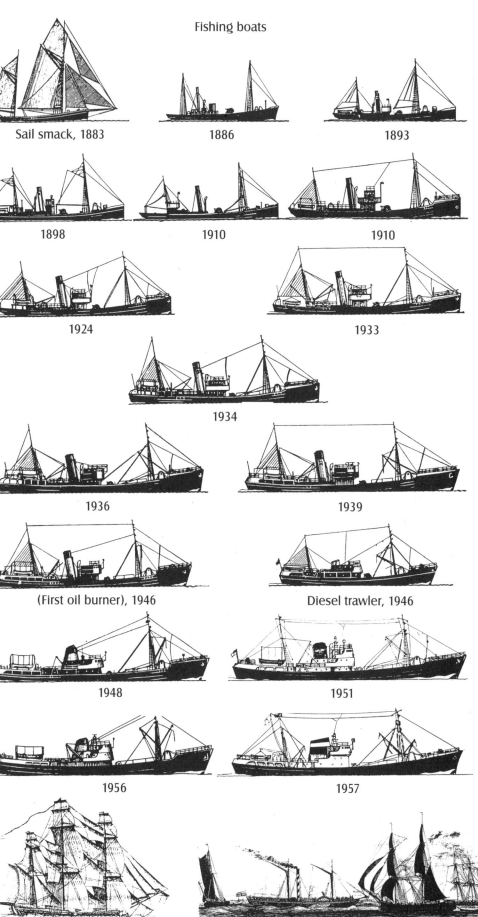

Fishing boats

Sail smack, 1883

1886

1893

1898

1910

1910

1924

1933

1934

1936

1939

(First oil burner), 1946

Diesel trawler, 1946

1948

1951

1956

1957

West Indiaman, 1783

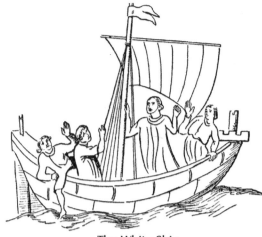

The White Ship

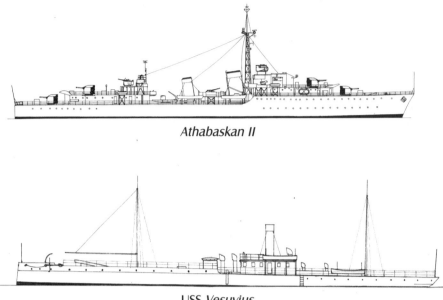

Athabaskan II

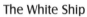
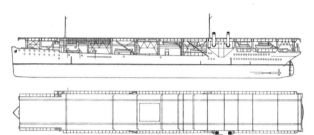

USS *Langley*

USS *Vesuvius*

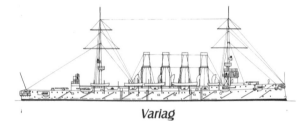

Variag

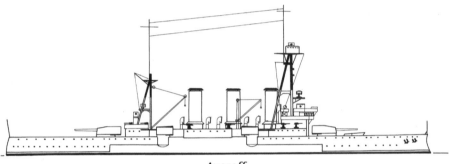

Averoff

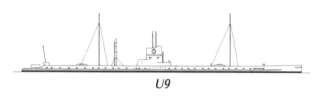

U9

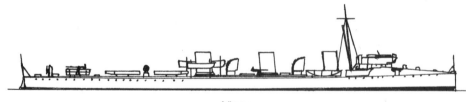

Viper

The names of certain ships linger in the public imagination long after others have vanished into obscurity. A selection are illustrated here and on the following four pages. Fame has often been achieved by these ships due to a catastrophe that befell them (*White Ship, Mary Rose*), their role during the age of exploration (*Santa Maria, Endeavour*), their association with a particular king (*Henri Grâce à Dieu* and *Sovereign of the Seas*), for being the first of their kind (*Warrior, U1*) or for taking part in great battles, (*Victory*).

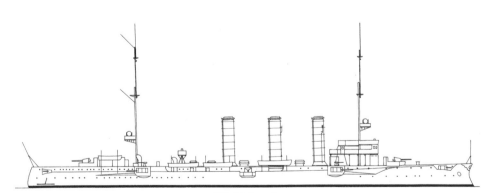

Königsberg

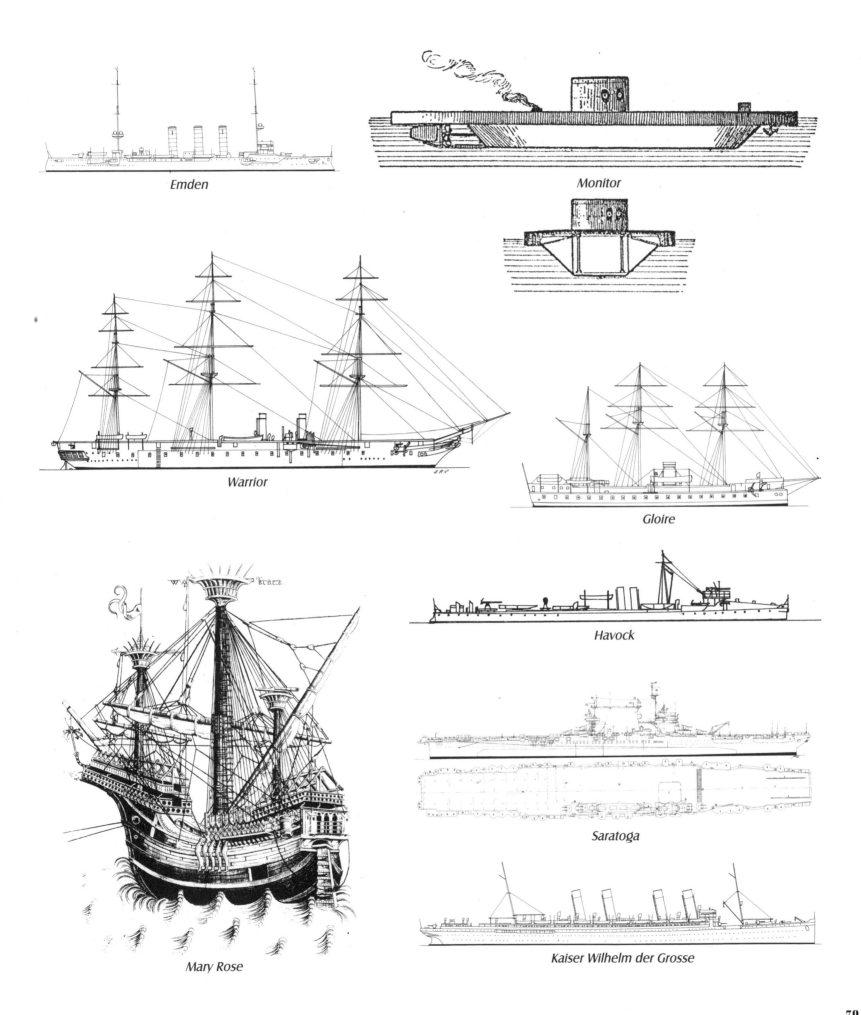

Emden

Monitor

Warrior

Gloire

Havock

Saratoga

Mary Rose

Kaiser Wilhelm der Grosse

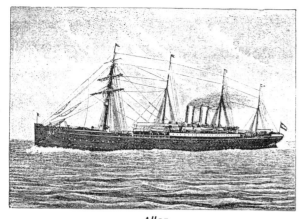

Aller

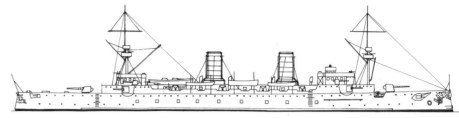

Esmeralda

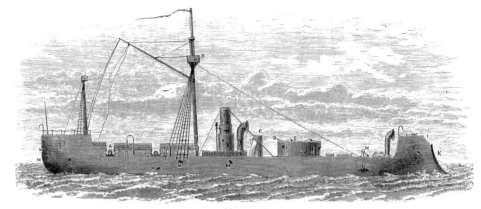

Huascar

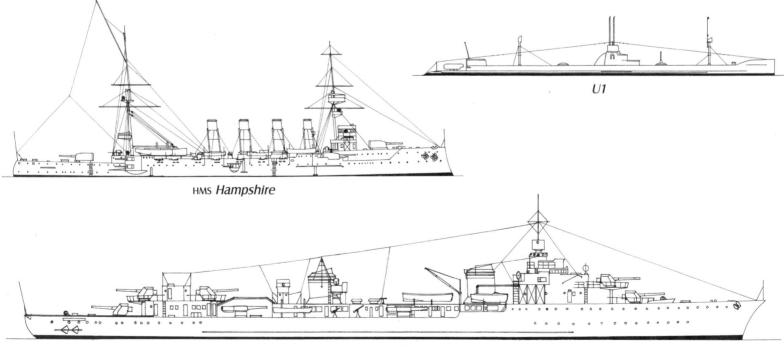

City of Rome

Borodino

U1

HMS Hampshire

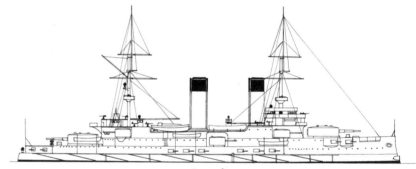

Le Fantasque

Sunbeam

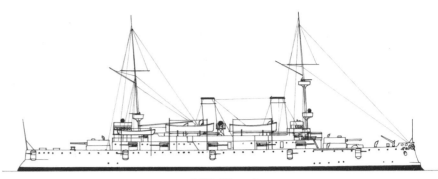

USS *Olympia*

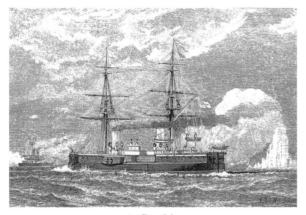

Inflexible

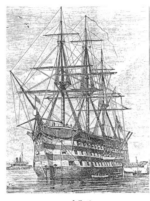

HMS *Victory*

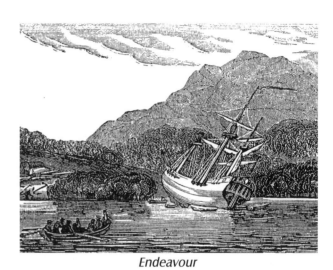

Endeavour

Sovereign of the Seas

Ark

Bounty

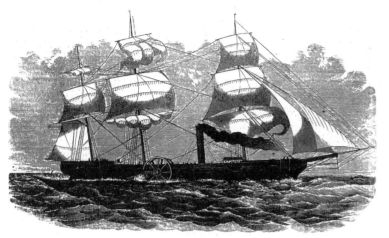

Savannah

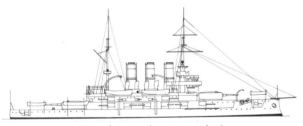

USS *Housatonic*

Cachalot

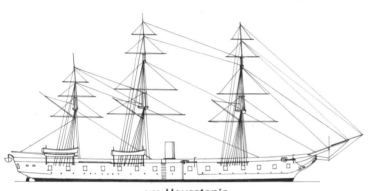

Panteleimon (ex-*Potemkin*)

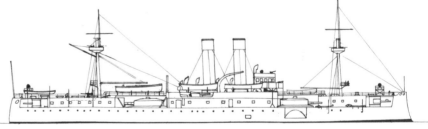

USS *Maine*

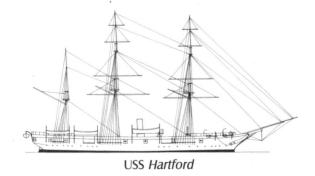

USS *Hartford*

Oriskany

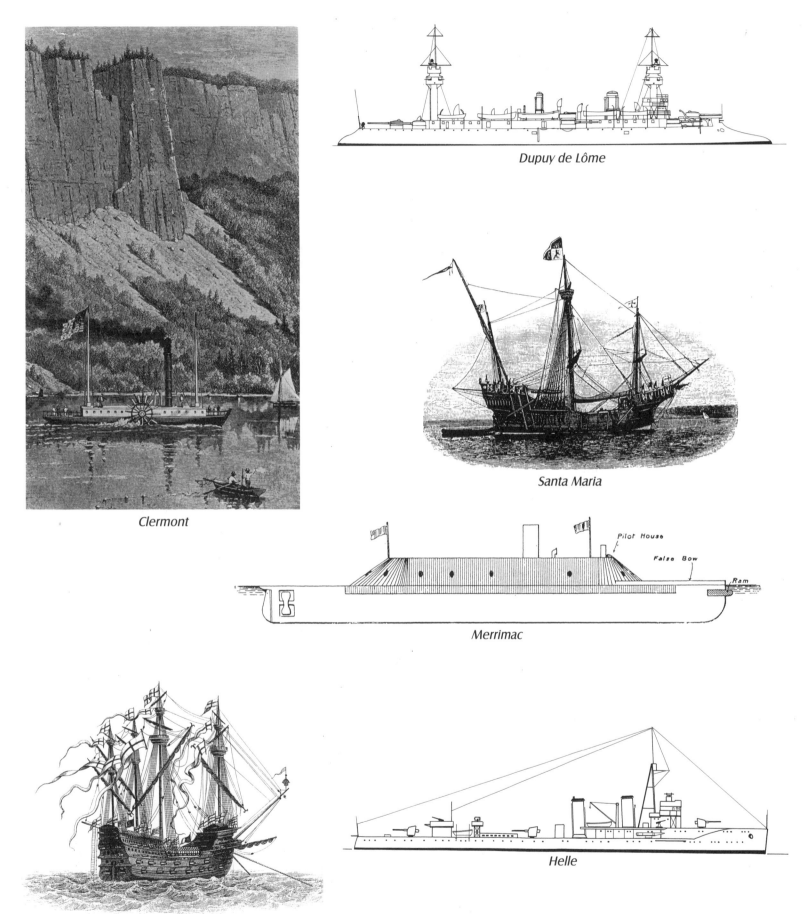

Dupuy de Lôme

Clermont

Santa Maria

Merrimac

Pilot House

False Bow

Ram

Henri Grâce à Dieu

Helle

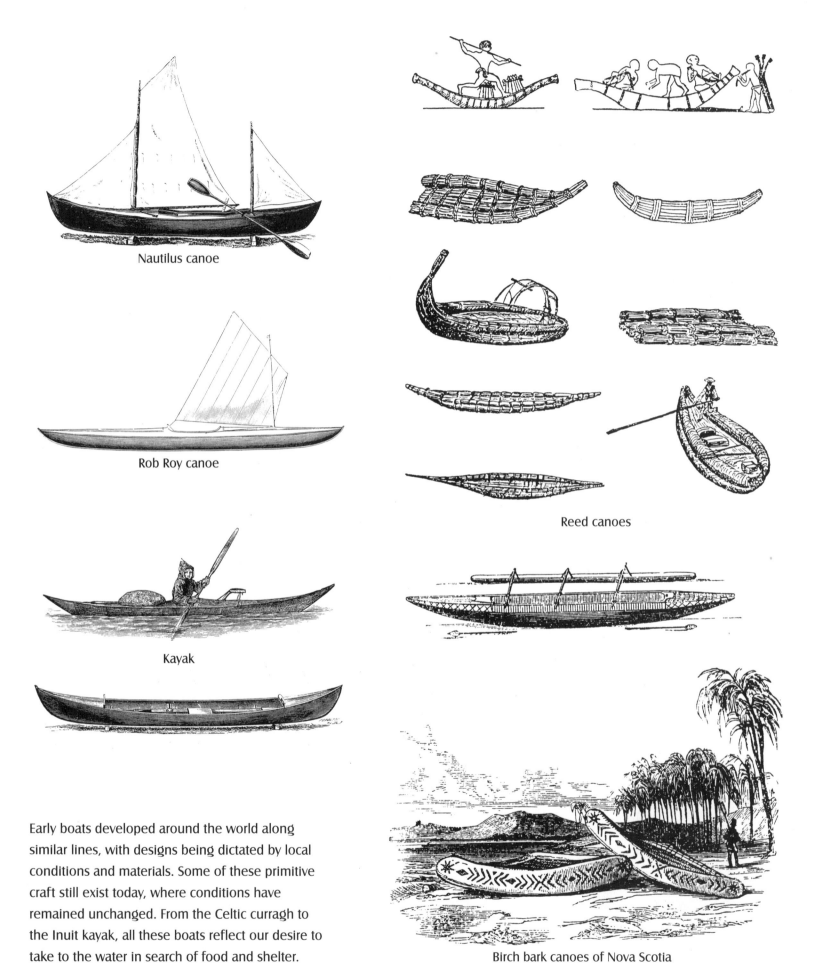

Nautilus canoe

Rob Roy canoe

Kayak

Reed canoes

Early boats developed around the world along similar lines, with designs being dictated by local conditions and materials. Some of these primitive craft still exist today, where conditions have remained unchanged. From the Celtic curragh to the Inuit kayak, all these boats reflect our desire to take to the water in search of food and shelter.

Birch bark canoes of Nova Scotia

Macao Tankaboat

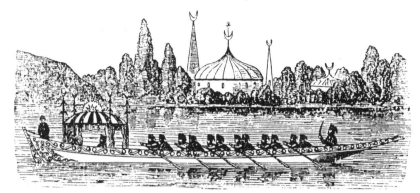

Turkish Caique

Manila banca

Coracles

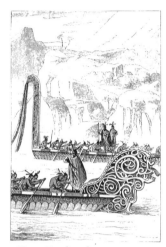

New Zealand war canoe

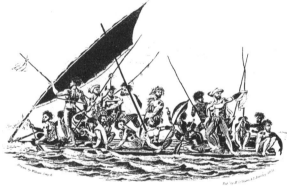

Ganges rowing boat

Raft of Gambier Island

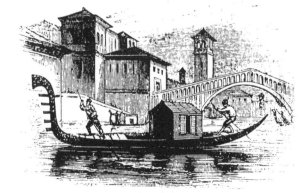

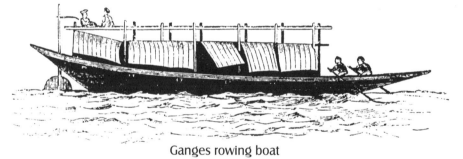

Gondola

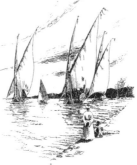

Bombay dinghy

Suez dhows

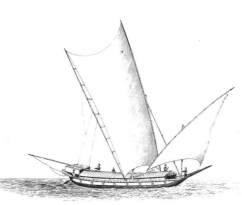

Tartar galley

Tahitian pahies

Thames barge

Penzance lugger

Bolivian reed boat

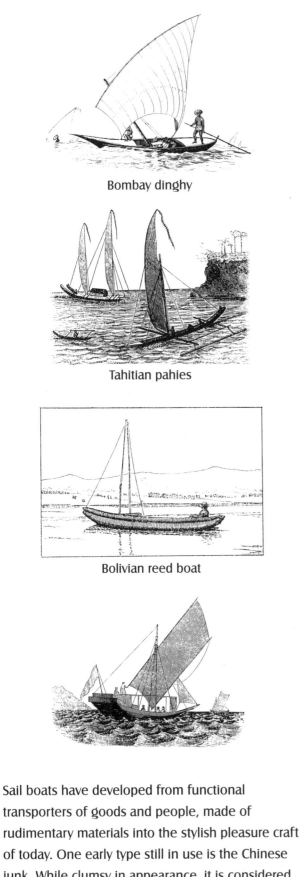

Chinese junk

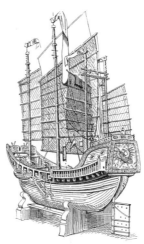

yacht

Sail boats have developed from functional transporters of goods and people, made of rudimentary materials into the stylish pleasure craft of today. One early type still in use is the Chinese junk. While clumsy in appearance, it is considered to be one of the most efficient and seaworthy of sailing ships. Variations of the type were used for trade on rivers and oceans and often as warships.

Mediterranean felucca

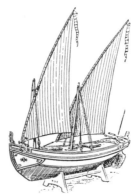

South American Balza

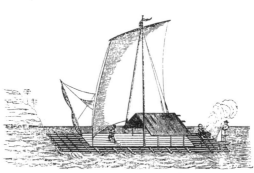

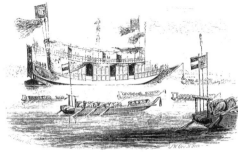

Imperial barge, Yokuhama

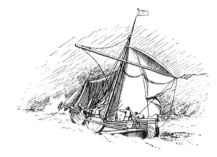

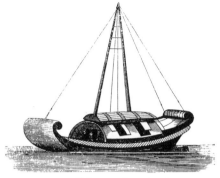

Chinese river junk

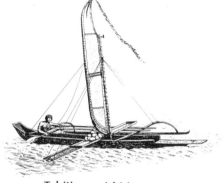

Tahitian outrigger canoe

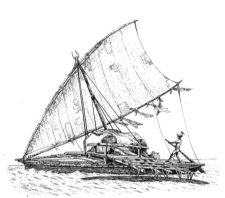

Fijian outrigger canoe

Scotch zulu

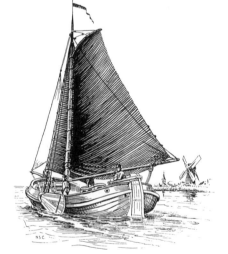

Dutch schuyt

Fijian sailing canoe

Norwegian jaegt

Japanese junk

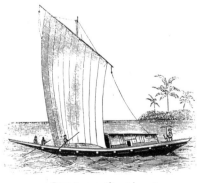

Ganges sailing boat

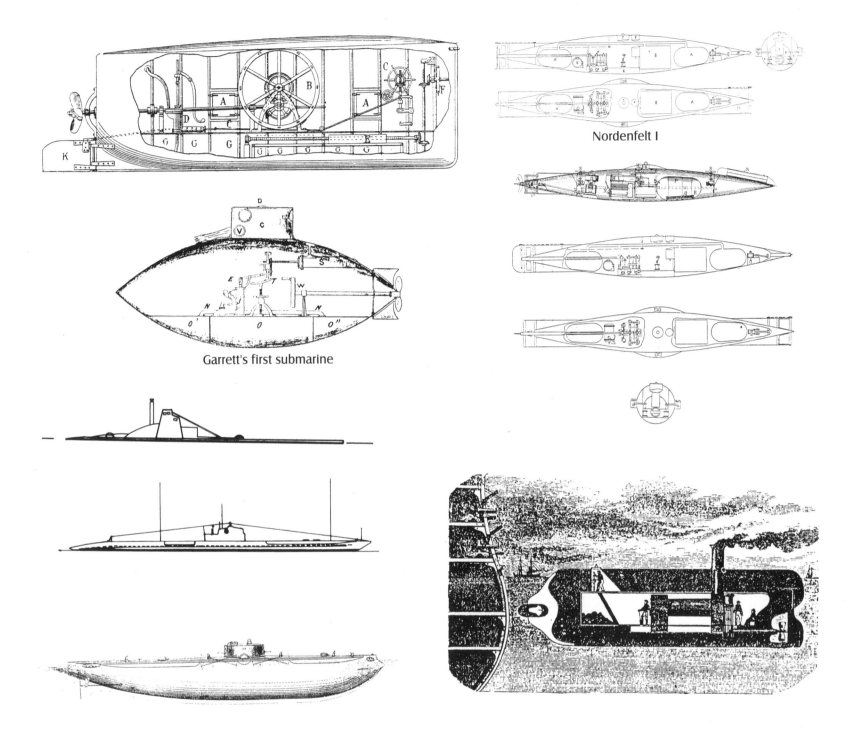

Nordenfelt I

Garrett's first submarine

The quest for dominance at sea during war was the driving force behind the creation of a vessel that could attack its target from beneath the ocean's surface. The success of the submarine owes much to the bravery and ingenuity of early pioneers. Many experiments were doomed to failure, but the submersibles of Fulton, Garrett and Holland turned the idea of a vessel that could swim below the surface of the sea into a reality.

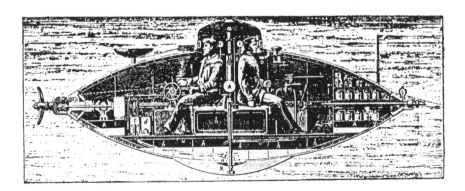

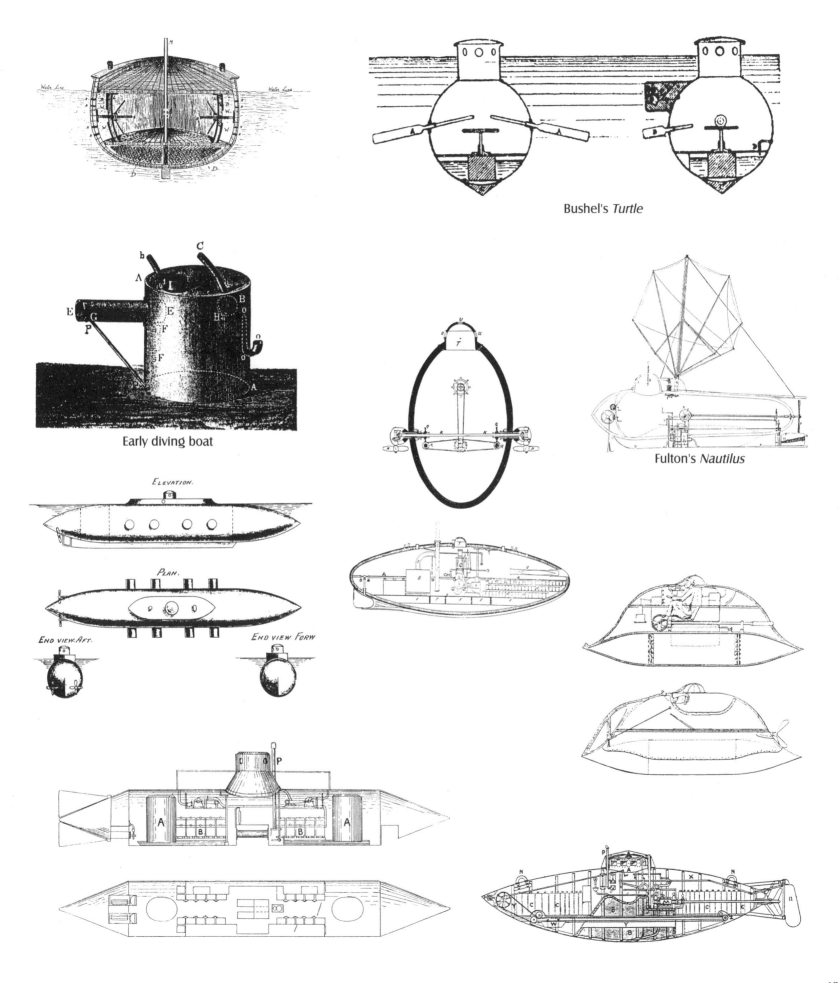

Bushel's *Turtle*

Early diving boat

Fulton's *Nautilus*

ELEVATION.

PLAN.

END VIEW. AFT. END VIEW. FORW.

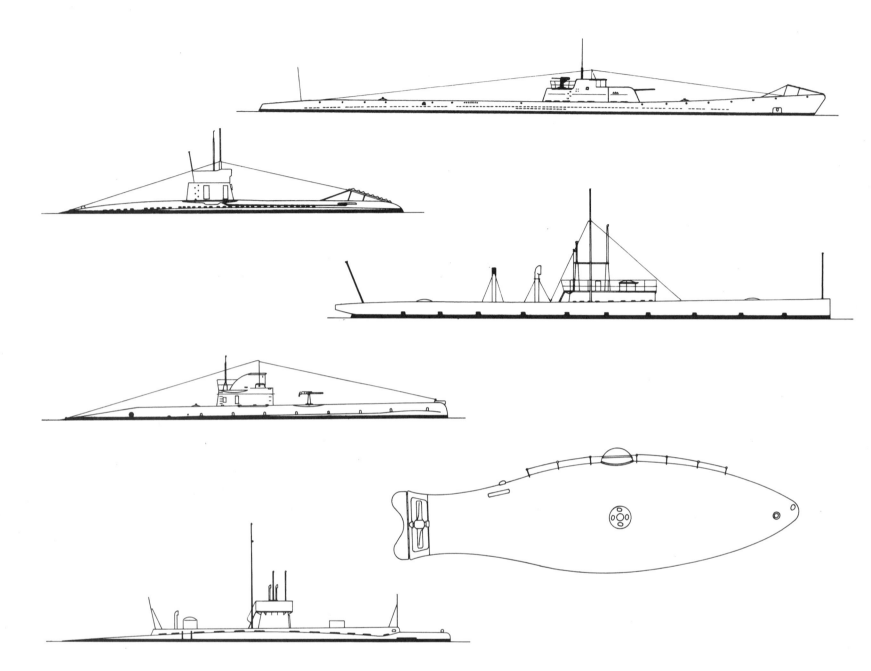

The structure of the submarine was of vital importance because it needed to be able to withstand the pressure of the water when submerged. Many hulls that looked adequate on paper imploded in practice when the submarine dived. The best cross section of the hull of a submarine was found to be circular and initially the vessels were cigar shaped, but later the tear drop shape was adopted.

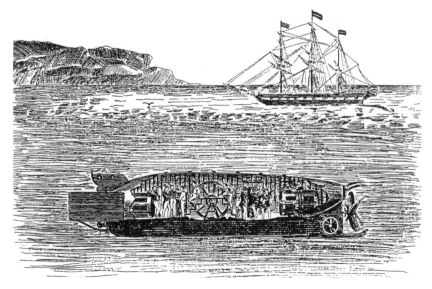

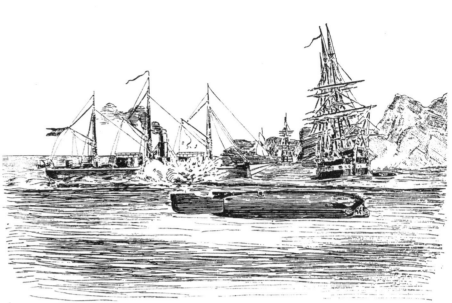

Bauer's *Brandtaucher*

Cross section of Nordenfelt

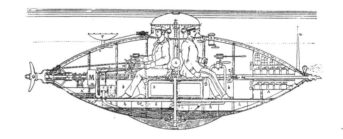

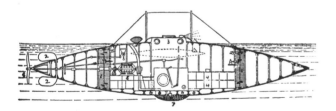

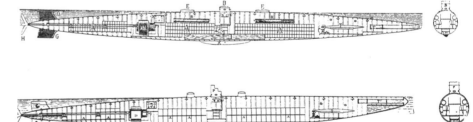

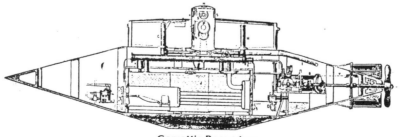

Garrett's Resurgam

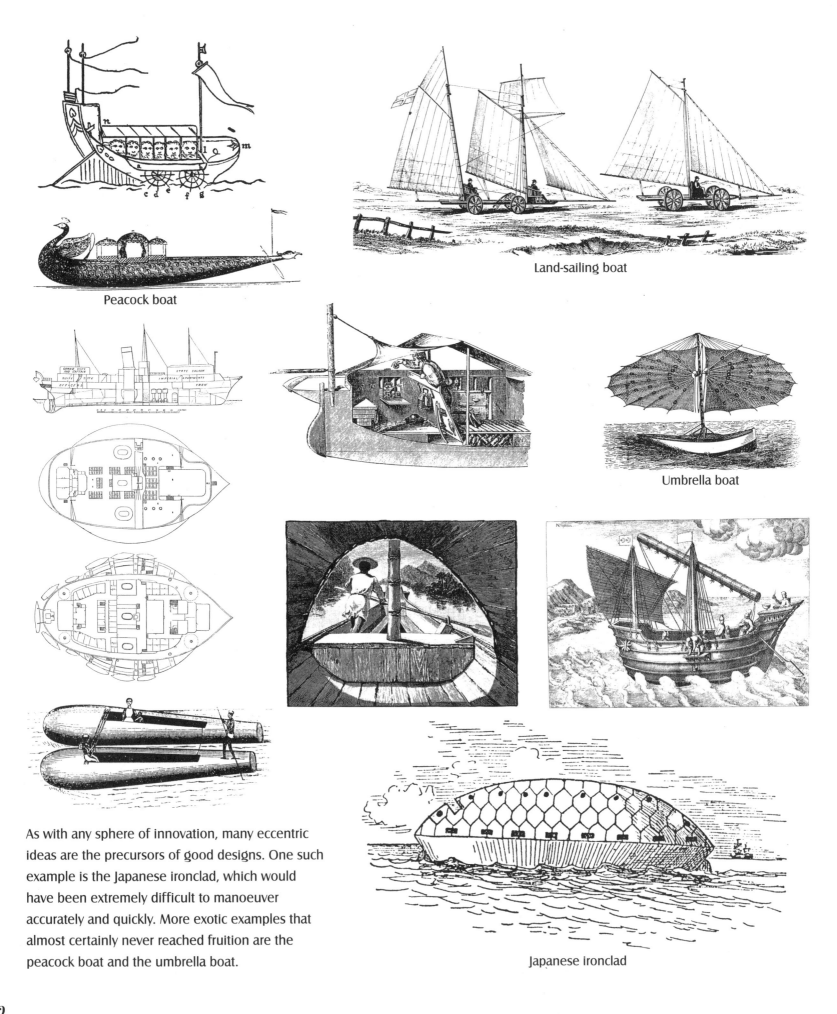

Peacock boat

Land-sailing boat

Umbrella boat

As with any sphere of innovation, many eccentric ideas are the precursors of good designs. One such example is the Japanese ironclad, which would have been extremely difficult to manoeuver accurately and quickly. More exotic examples that almost certainly never reached fruition are the peacock boat and the umbrella boat.

Japanese ironclad

Chapter 2

Naval Architecture and Construction

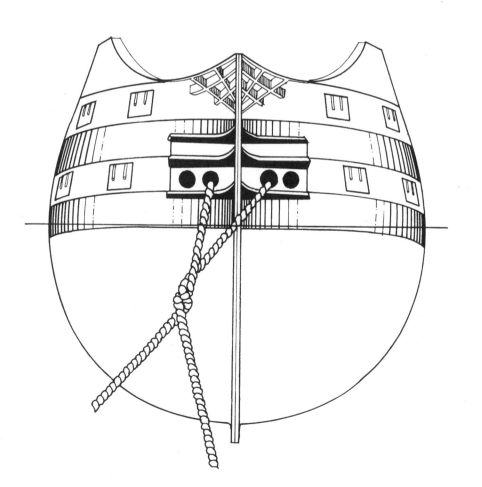

The art of naval architecture is the most important part of a ship's life; the architect is responsible for the vessel's strength, stability, internal workings and fittings, and for designing a ship suitable for its purpose. Shipbuilding techniques, from the earliest skin canoes and rafts, gradually progressed though the centuries with each culture adding its own ideas. The Egyptians developed techniques to make seams watertight, as their vessels, due to the available materials, were made of shorter lengths of plank attached together. They also initiated the use of oars in very light winds. Although the Phoenicians created their own trading vessels which were more stable, although no larger than the Egyptian ships, it was the Romans, in the first century AD, who influenced ship design during the following centuries. Due to the growth of the Roman Empire, vessels were required to transport armament and large quantities of cargo throughout the realm. The Romans' knowledge of engineering, and interest in the development of ideas, resulted in ships which were an improvement on all that had gone before.

By the twelfth century, the increase in sea-going trade had created a demand for more seaworthy vessels. The skills essential for successful ship design and construction developed through the following centuries into the highly-complex professions of today. Initially working only 'by eye' with traditional methods handed down through the years, ship designs gradually began to appear in formal plans. In the boom years of sea-faring on the world's oceans, in trade and war, ships were ambassadors for their nation and were therefore highly decorative and imposing. With the introduction of iron and then steel in the nineteenth century, the science of shipbuilding emerged, with increasingly accurate plans allowing the creation of complex, hard-wearing vessels tailored to specific uses.

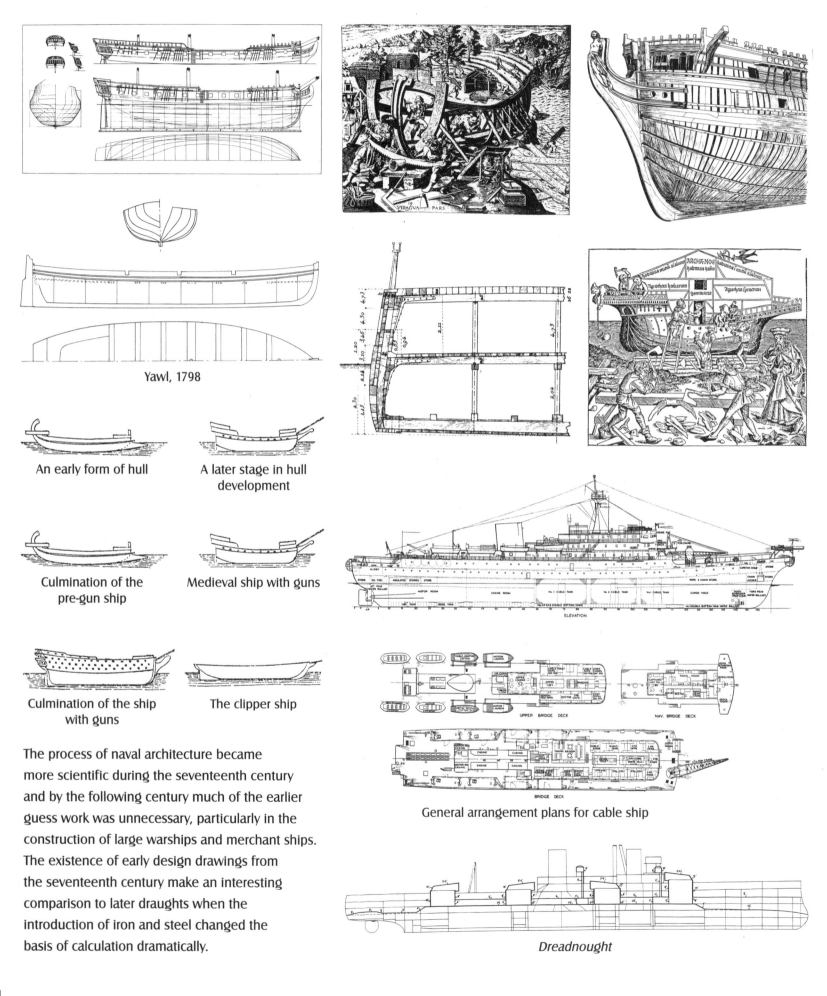

Yawl, 1798

An early form of hull

A later stage in hull development

Culmination of the pre-gun ship

Medieval ship with guns

Culmination of the ship with guns

The clipper ship

ELEVATION

UPPER BRIDGE DECK

NAV. BRIDGE DECK

BRIDGE DECK

General arrangement plans for cable ship

Dreadnought

The process of naval architecture became more scientific during the seventeenth century and by the following century much of the earlier guess work was unnecessary, particularly in the construction of large warships and merchant ships. The existence of early design drawings from the seventeenth century make an interesting comparison to later draughts when the introduction of iron and steel changed the basis of calculation dramatically.

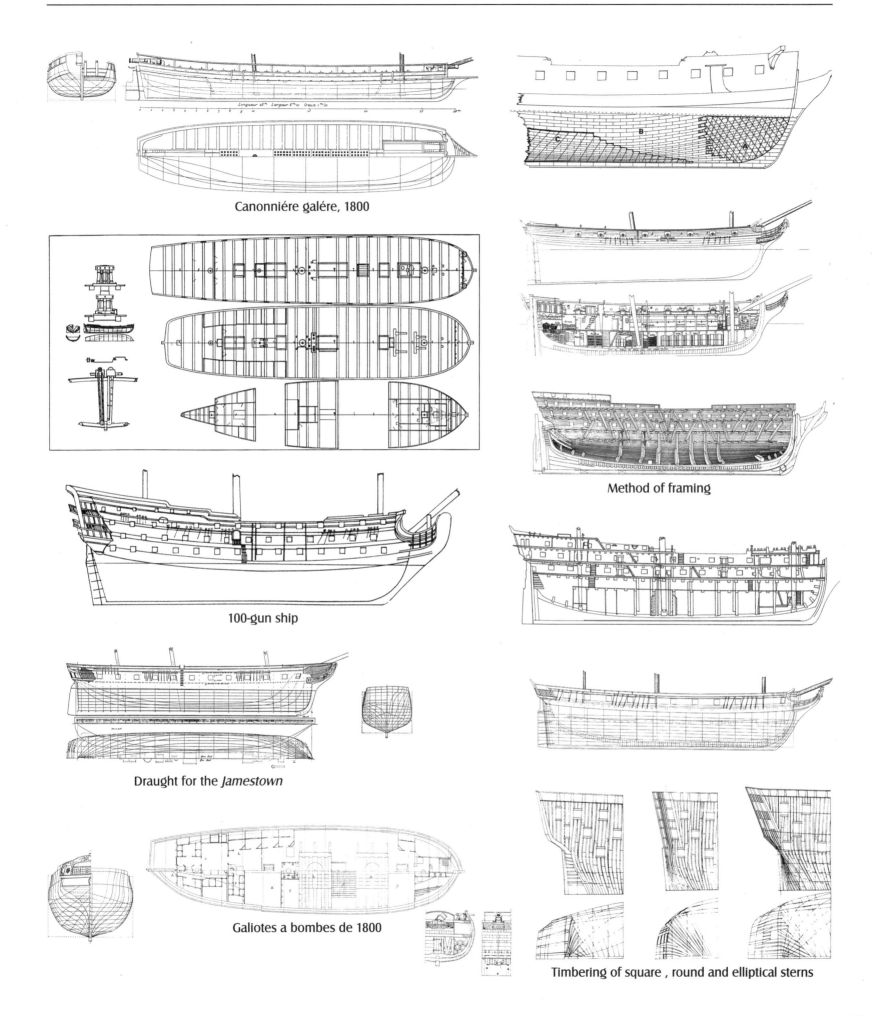

Canonnière galére, 1800

Method of framing

100-gun ship

Draught for the *Jamestown*

Galiotes a bombes de 1800

Timbering of square , round and elliptical sterns

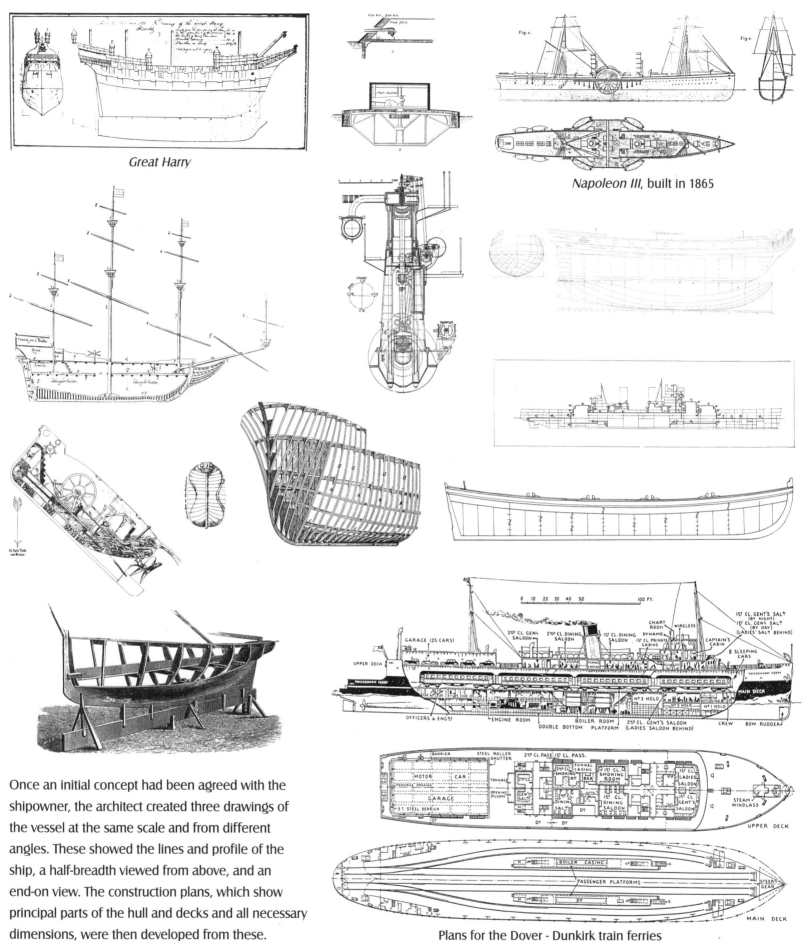

Great Harry

Napoleon III, built in 1865

Once an initial concept had been agreed with the shipowner, the architect created three drawings of the vessel at the same scale and from different angles. These showed the lines and profile of the ship, a half-breadth viewed from above, and an end-on view. The construction plans, which show principal parts of the hull and decks and all necessary dimensions, were then developed from these.

Plans for the Dover - Dunkirk train ferries

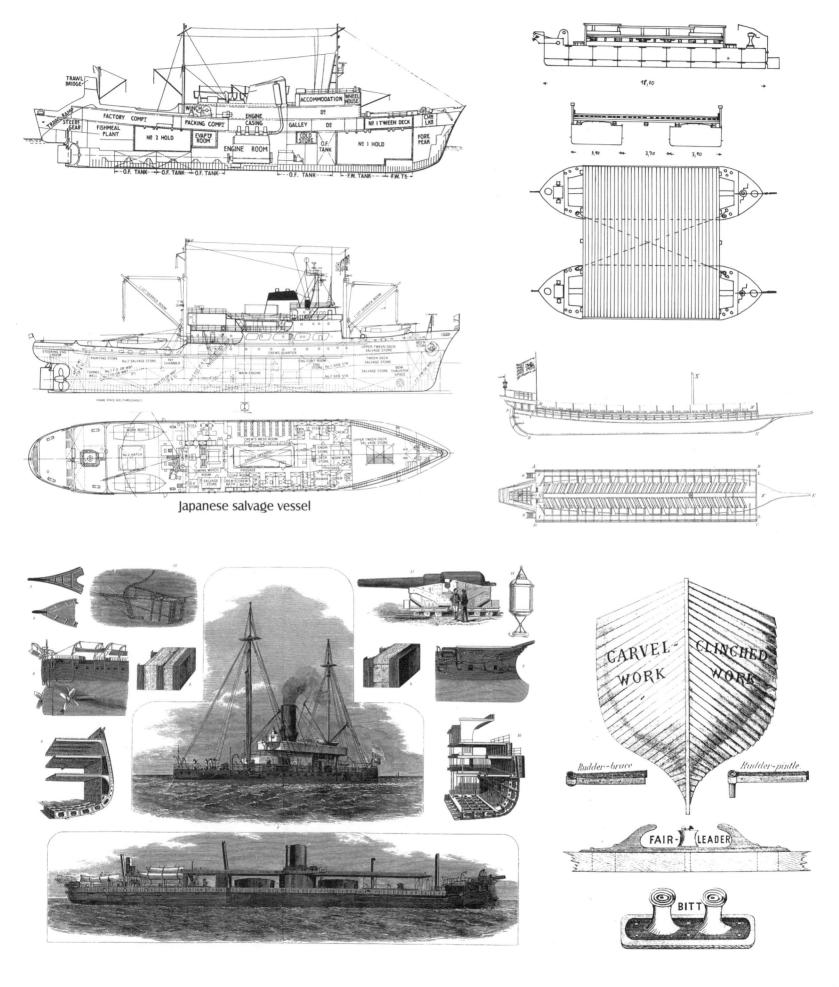

Japanese salvage vessel

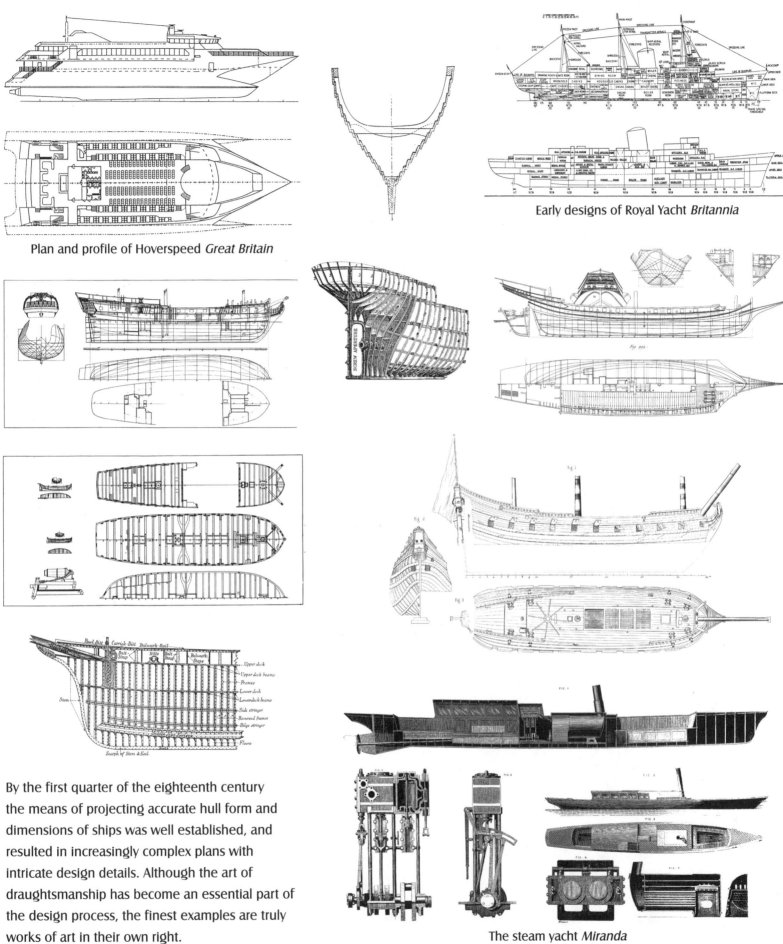

Plan and profile of Hoverspeed *Great Britain*

Early designs of Royal Yacht *Britannia*

By the first quarter of the eighteenth century the means of projecting accurate hull form and dimensions of ships was well established, and resulted in increasingly complex plans with intricate design details. Although the art of draughtsmanship has become an essential part of the design process, the finest examples are truly works of art in their own right.

The steam yacht *Miranda*

Benton, fore and aft section

Benton, broadside

(Emerson, Walker &C°)

1 Hand Power Levers
2 Cross-head
3 Warping Ends
4 Side Bitts
5 Side Bitt Keeps
6 Screw Brake Nut
7 Cable-lifter
8 Pawl Rack
9 Main Cone Driving Wheel
10 Cross-head Bracket
11 Centre Bitt
12 Centre Bitt Keep
13 Chain Pipes
14 Cable Relievers
15 Bed Plate
16 Chain Wheel for messenger from Steam Winch
17 Clutch for attached Steam Power
18 Gearing for Steam Power

The Gokstad ship; elevation and deck plan

Robert Seppings' iron rider plates

Early seventeenth-century Dutch shipyard

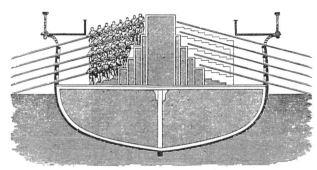

Transverse midship section of a quinqereme

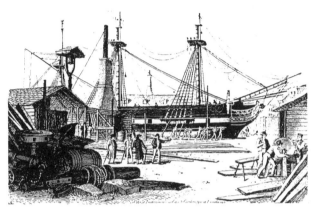

A West Indiaman under construction

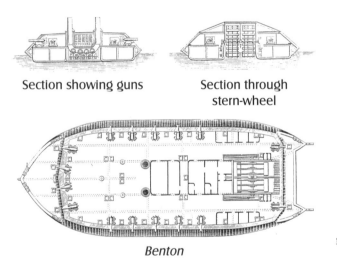

Section showing guns

Section through stern-wheel

Benton

Although details about a large number of important warships and merchant vessels from the eighteenth and nineteenth centuries have survived in plans, arguments about classical problems such as the method of rowing the quinquereme, have only recently been solved satisfactorily. Drawings of ships, including Egyptian paintings, play a major part, along with archaeological finds and contemporary literature, in understanding our maritime heritage.

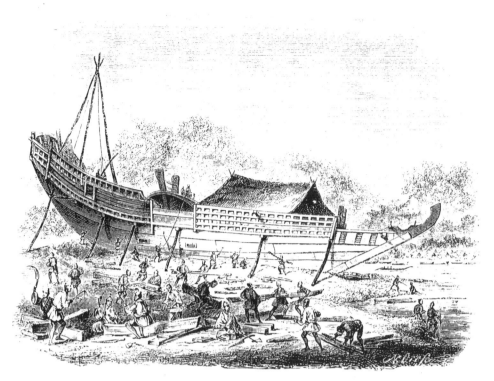

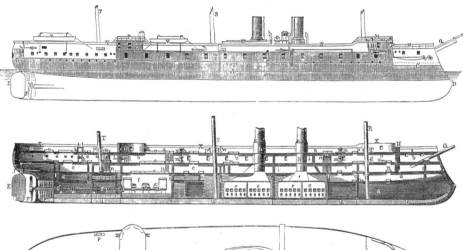

Plans of the *König Wilhelm*

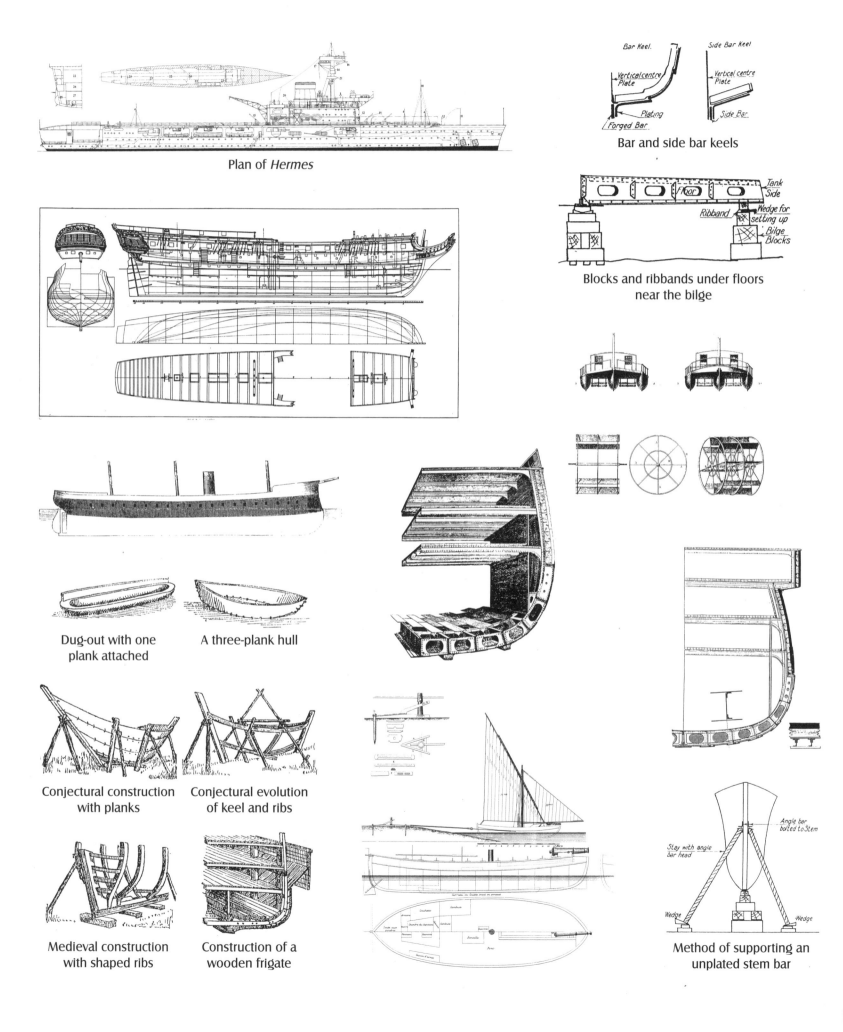

Plan of *Hermes*

Bar and side bar keels

Blocks and ribbands under floors
near the bilge

Dug-out with one
plank attached

A three-plank hull

Conjectural construction
with planks

Conjectural evolution
of keel and ribs

Medieval construction
with shaped ribs

Construction of a
wooden frigate

Method of supporting an
unplated stem bar

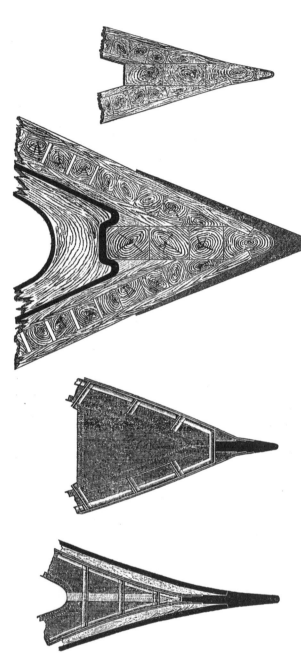

Ironclad rams

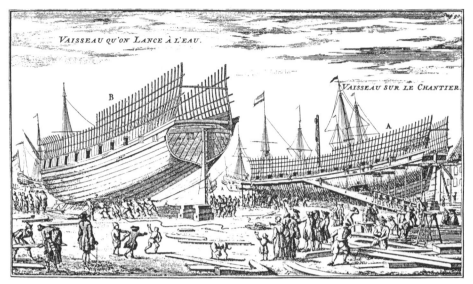

Dutch shipyard of the eighteenth century

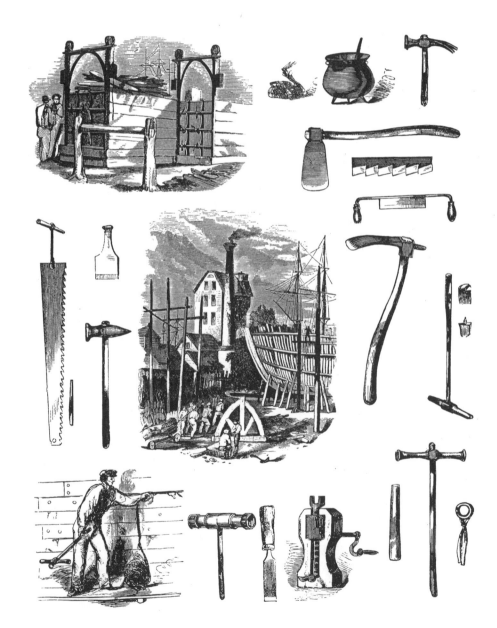

Shipbuilder's tools were adapted with the introduction of iron and steel, but modern wooden boats are often built with instruments very similar to these early examples. In addition to the construction of the hull to pre-prepared plans, the outfitting, or the provision of fixtures and fittings which turn the ship from a mass of wood or metal into a working machine, remains a very critical part of the production process.

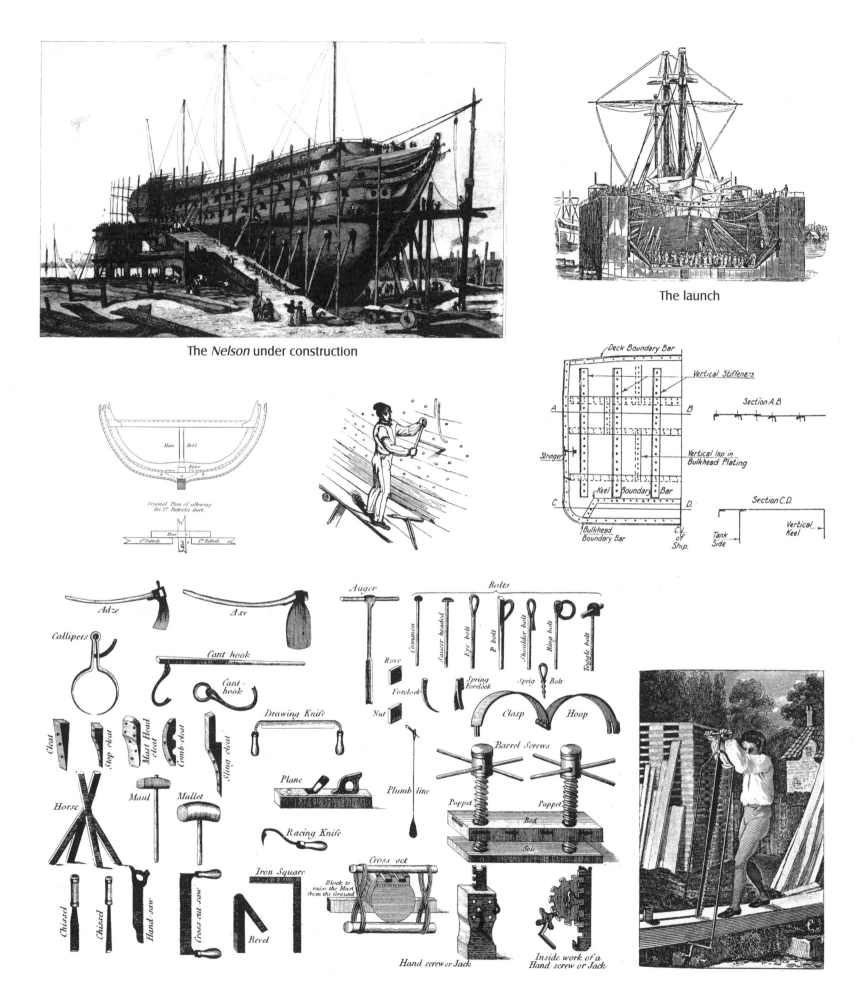

The *Nelson* under construction

The launch

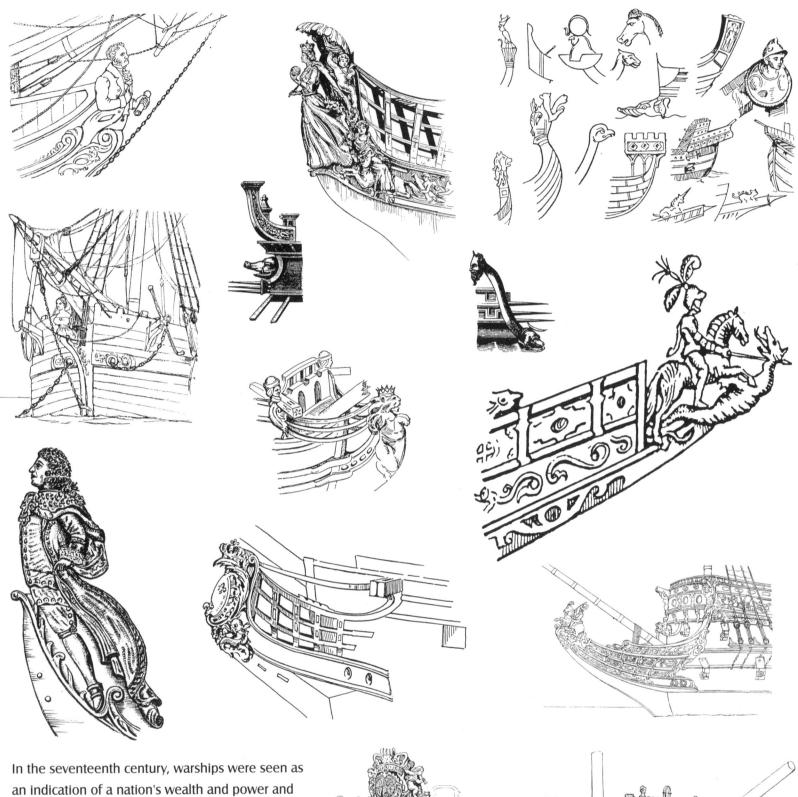

In the seventeenth century, warships were seen as an indication of a nation's wealth and power and were, therefore, very elaborately decorated. Although early figureheads were often religious symbols, as mariners hoped that the deities would protect the ship, those such as the lion or the representation of victory over an oppressor were popular powerful images with which to impress other nations.

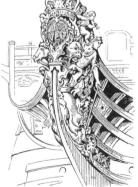

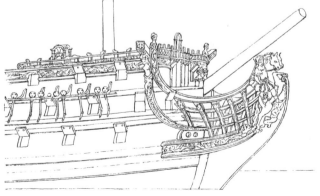

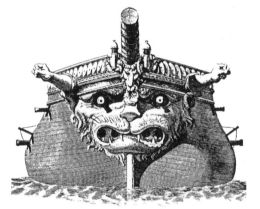

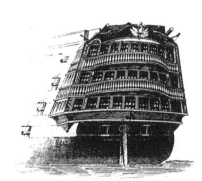

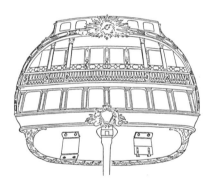

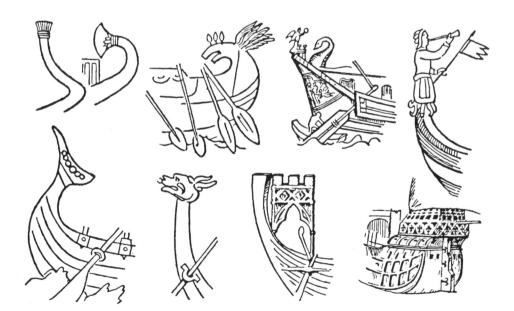

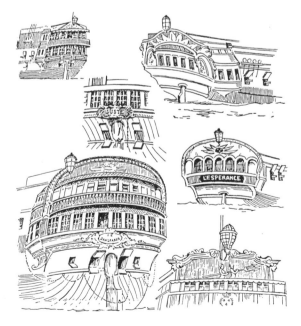

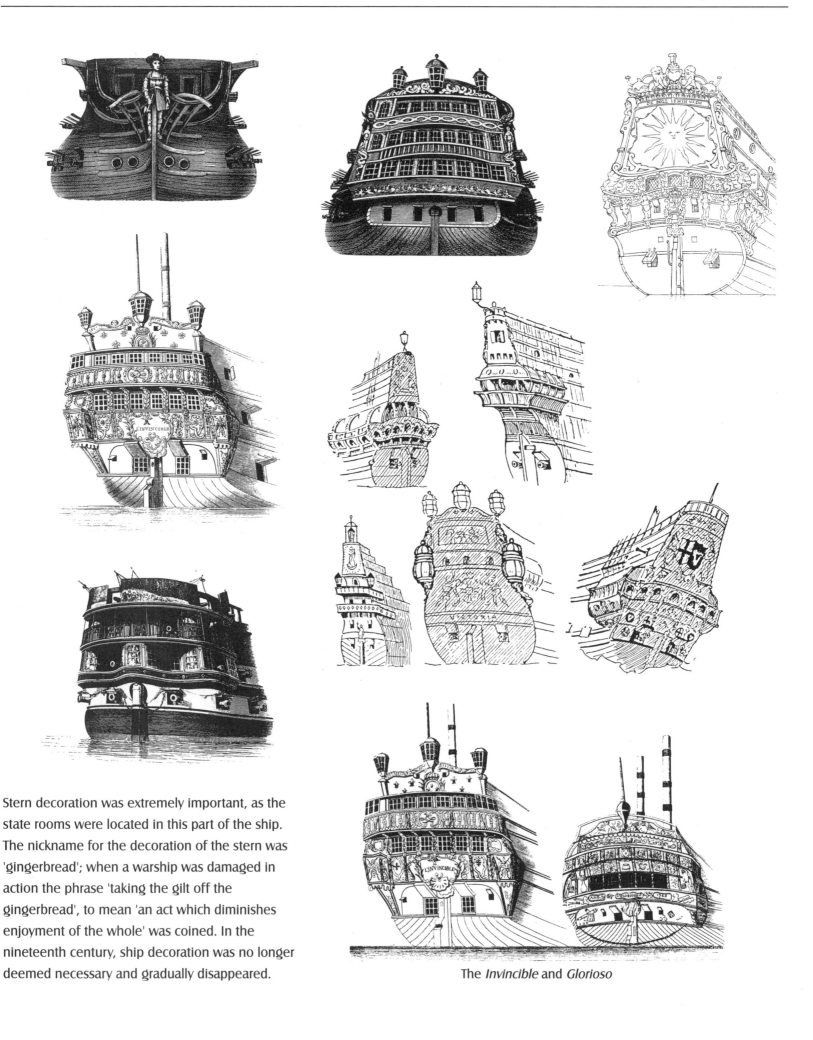

Stern decoration was extremely important, as the state rooms were located in this part of the ship. The nickname for the decoration of the stern was 'gingerbread'; when a warship was damaged in action the phrase 'taking the gilt off the gingerbread', to mean 'an act which diminishes enjoyment of the whole' was coined. In the nineteenth century, ship decoration was no longer deemed necessary and gradually disappeared.

The *Invincible* and *Glorioso*

Anatomy of the Ship

The fixtures and fittings of a ship are one of the most interesting areas of historical maritime research. As can be seen in the variety of ship designs and shipbuilding techniques, the development of these areas of maritime technology follow general cultural and scientific progress. The importance of sea domination and rise in sea-borne trade continually developed ideas for ship design as the maritime nations endeavoured to find unrivalled vessels for both naval and mercantile use. By studying evidence from underwater archaeology, contemporary documents, artworks, and of course any original plans, much of the progression of their scientific understanding can now be clearly ascertained.

Initially manpower was the only form of propulsion used, as discovered in the oared galleys of Ancient Egypt and Greece and the paddle canoes later found in the New World. When the sail was first introduced it immediately became indispensable. When sailing techniques and the importance of wind and current were recognised with the increase in trade and exploration voyages, sails on the individual ship grew in number and size. The rigging, which encompasses all ropes, chains and wires used to support masts and yards for the efficient operation of the sails, developed alongside. As they were continually open to the elements, the ropes were always wet and slippery to handle; to counteract this, and to make sure they were always working at optimum level, a variety of individual knots and splices were designed for specific parts of the rigging. The introduction of steam created a whole new concept of ship design, with the subsequent development of auxiliary machinery resulting in a smaller number of sailors needed to perform essential tasks. Although steam revolutionised merchant and naval shipping during the nineteenth century, it has gradually been overtaken by diesel propulsion in the last few decades.

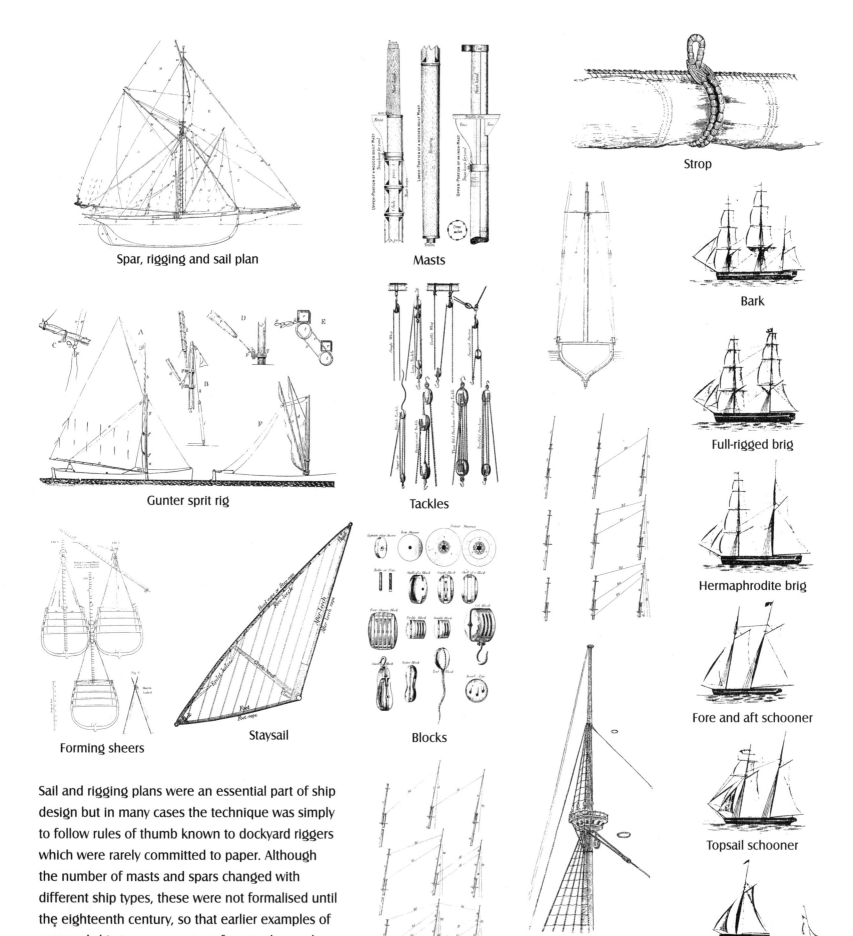

Spar, rigging and sail plan

Masts

Strop

Bark

Gunter sprit rig

Tackles

Full-rigged brig

Hermaphrodite brig

Forming sheers

Staysail

Blocks

Fore and aft schooner

Topsail schooner

Sail and rigging plans were an essential part of ship design but in many cases the technique was simply to follow rules of thumb known to dockyard riggers which were rarely committed to paper. Although the number of masts and spars changed with different ship types, these were not formalised until the eighteenth century, so that earlier examples of a named ship-type may not conform to the modern understanding of that type.

Foremast, top and garland

Sloop

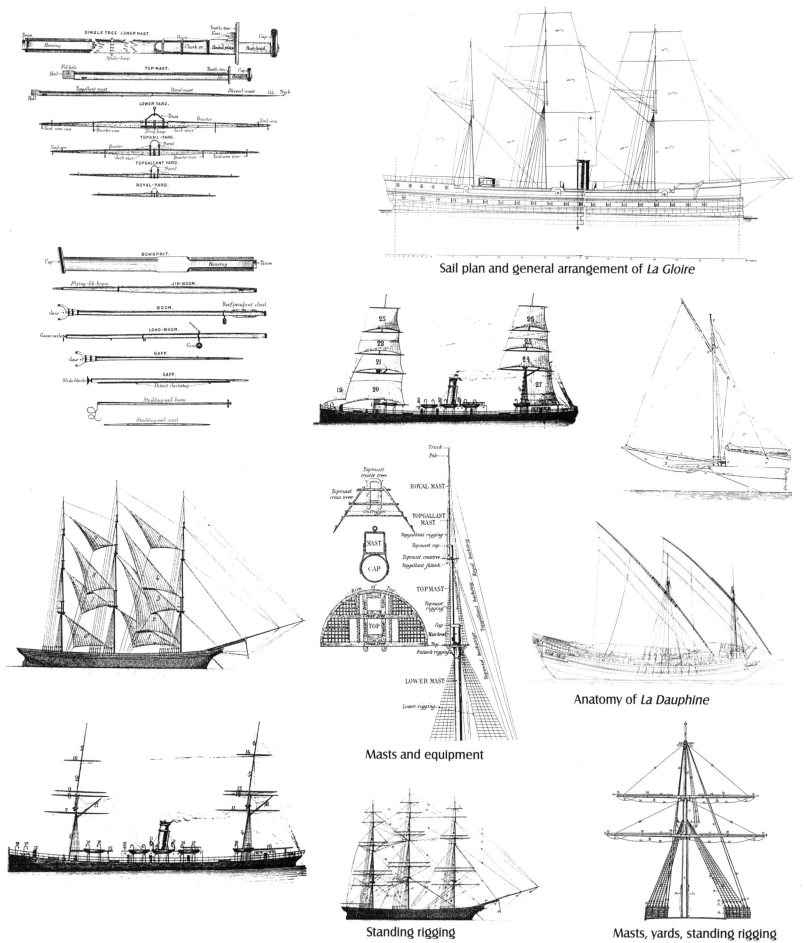

Sail plan and general arrangement of *La Gloire*

Anatomy of *La Dauphine*

Masts and equipment

Standing rigging

Masts, yards, standing rigging

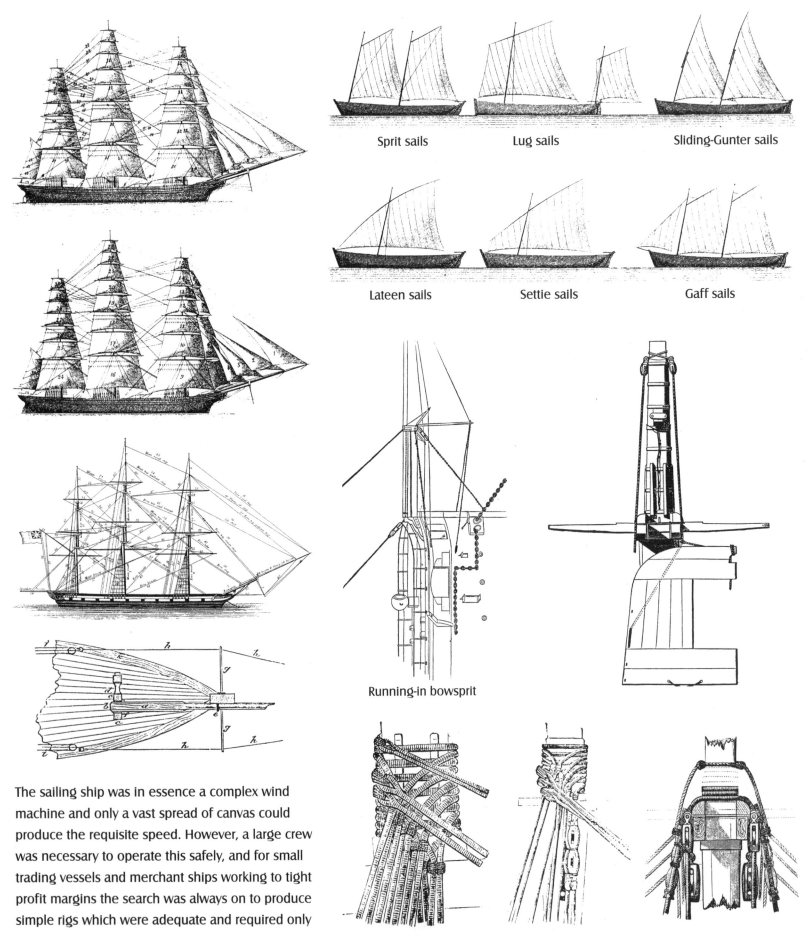

Sprit sails

Lug sails

Sliding-Gunter sails

Lateen sails

Settie sails

Gaff sails

Running-in bowsprit

The sailing ship was in essence a complex wind machine and only a vast spread of canvas could produce the requisite speed. However, a large crew was necessary to operate this safely, and for small trading vessels and merchant ships working to tight profit margins the search was always on to produce simple rigs which were adequate and required only a small number of sailors.

Rigging of masts

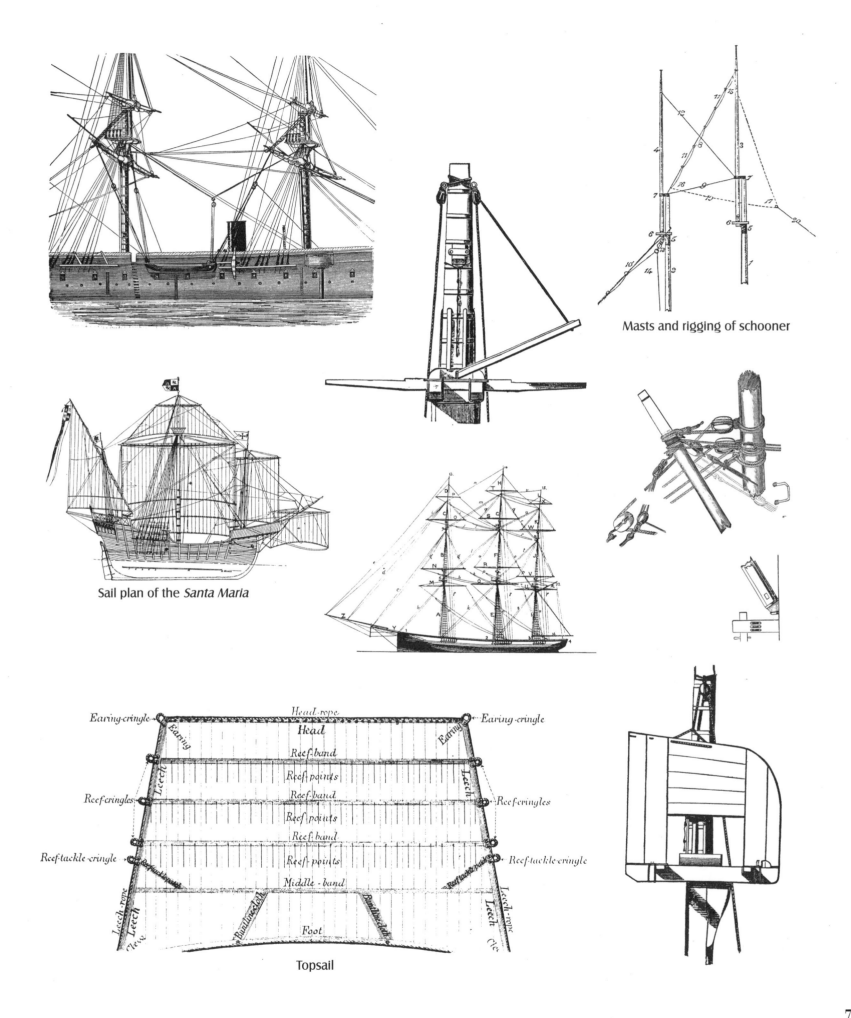

Masts and rigging of schooner

Sail plan of the *Santa Maria*

Topsail

Earing-cringle *Head-rope* *Earing-cringle*

Earing Head *Earing*

Reef-band

Leech *Reef-points* *Leech*

Reef-cringles *Reef-band* *Reef-cringles*

Reef-points

Reef-band

Reef-tackle-cringle *Reef-points* *Reef-tackle-cringle*

Middle-band

Leech-rope *Leech* *Foot* *Leech-rope* *Leech*

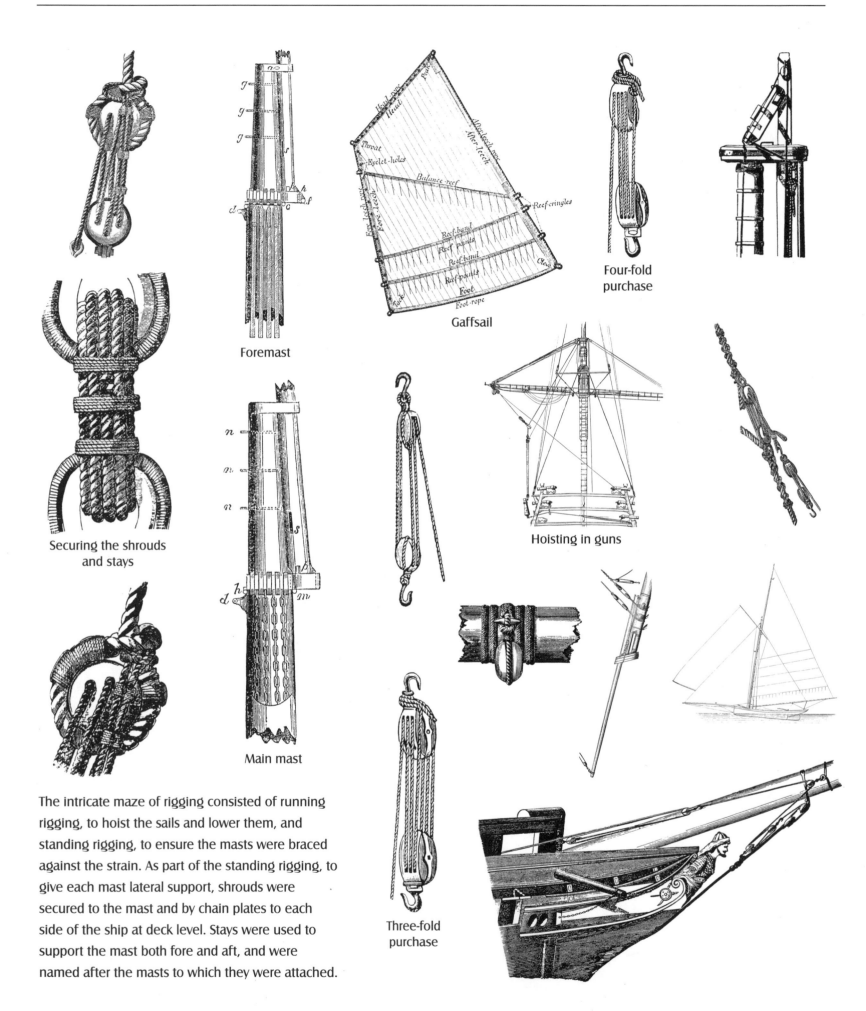

Foremast

Gaffsail

Four-fold purchase

Securing the shrouds and stays

Hoisting in guns

Main mast

Three-fold purchase

The intricate maze of rigging consisted of running rigging, to hoist the sails and lower them, and standing rigging, to ensure the masts were braced against the strain. As part of the standing rigging, to give each mast lateral support, shrouds were secured to the mast and by chain plates to each side of the ship at deck level. Stays were used to support the mast both fore and aft, and were named after the masts to which they were attached.

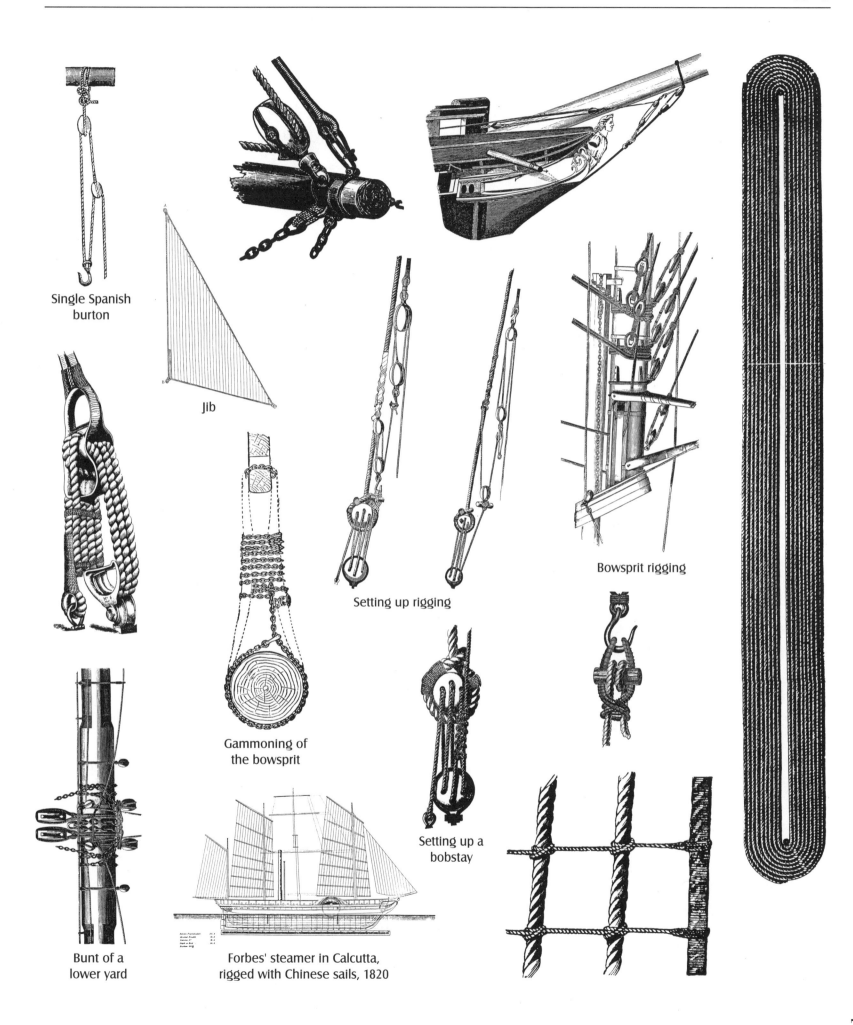

Single Spanish
burton

Jib

Setting up rigging

Bowsprit rigging

Gammoning of
the bowsprit

Setting up a
bobstay

Bunt of a
lower yard

Forbes' steamer in Calcutta,
rigged with Chinese sails, 1820

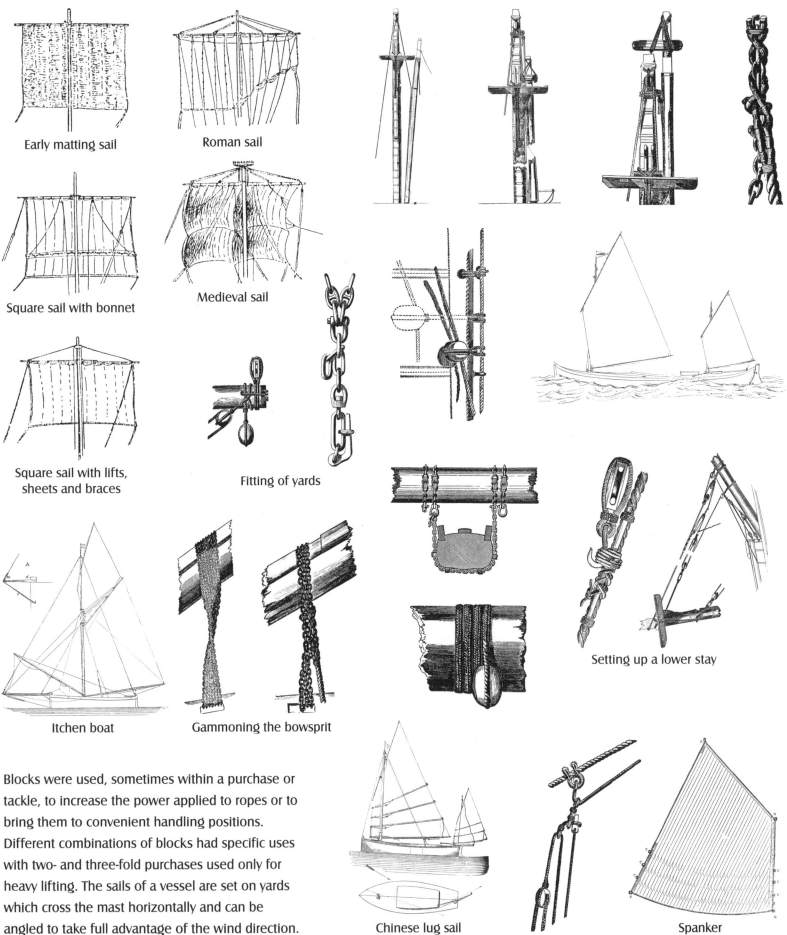

Early matting sail

Roman sail

Square sail with bonnet

Medieval sail

Square sail with lifts, sheets and braces

Fitting of yards

Setting up a lower stay

Itchen boat

Gammoning the bowsprit

Blocks were used, sometimes within a purchase or tackle, to increase the power applied to ropes or to bring them to convenient handling positions. Different combinations of blocks had specific uses with two- and three-fold purchases used only for heavy lifting. The sails of a vessel are set on yards which cross the mast horizontally and can be angled to take full advantage of the wind direction.

Chinese lug sail

Spanker

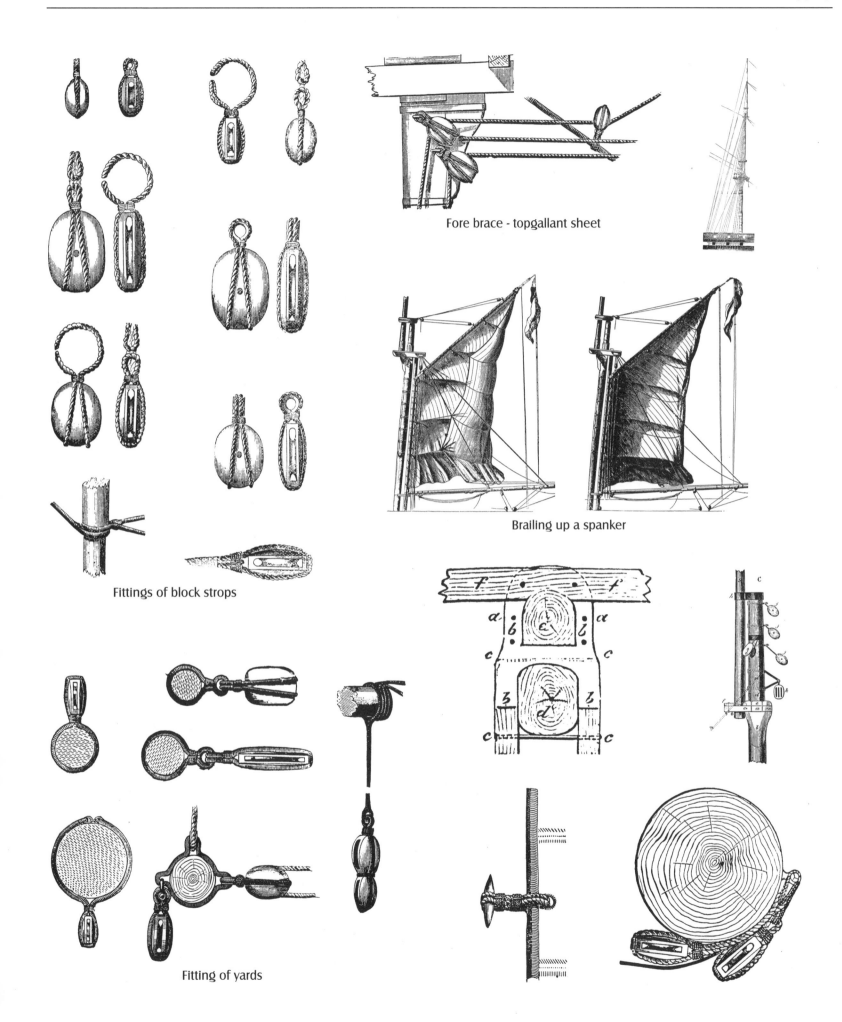

Fore brace - topgallant sheet

Brailing up a spanker

Fittings of block strops

Fitting of yards

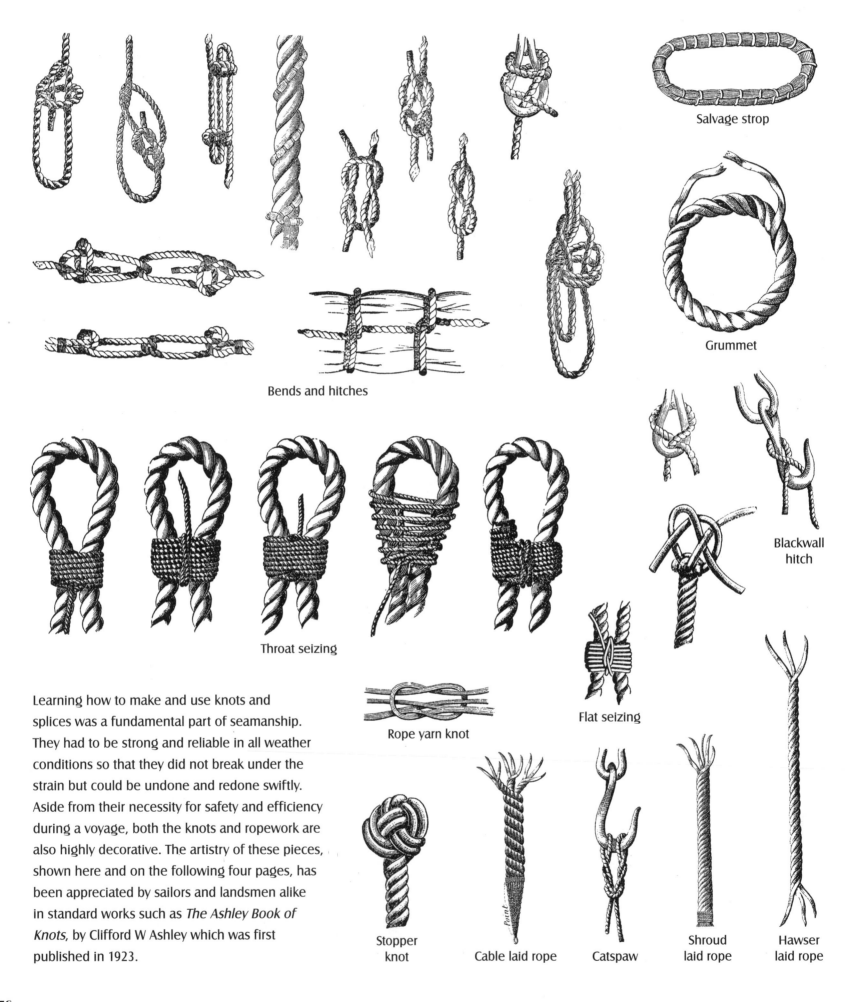

Salvage strop

Grummet

Bends and hitches

Blackwall hitch

Throat seizing

Rope yarn knot

Flat seizing

Learning how to make and use knots and splices was a fundamental part of seamanship. They had to be strong and reliable in all weather conditions so that they did not break under the strain but could be undone and redone swiftly. Aside from their necessity for safety and efficiency during a voyage, both the knots and ropework are also highly decorative. The artistry of these pieces, shown here and on the following four pages, has been appreciated by sailors and landsmen alike in standard works such as *The Ashley Book of Knots*, by Clifford W Ashley which was first published in 1923.

Stopper knot

Cable laid rope

Catspaw

Shroud laid rope

Hawser laid rope

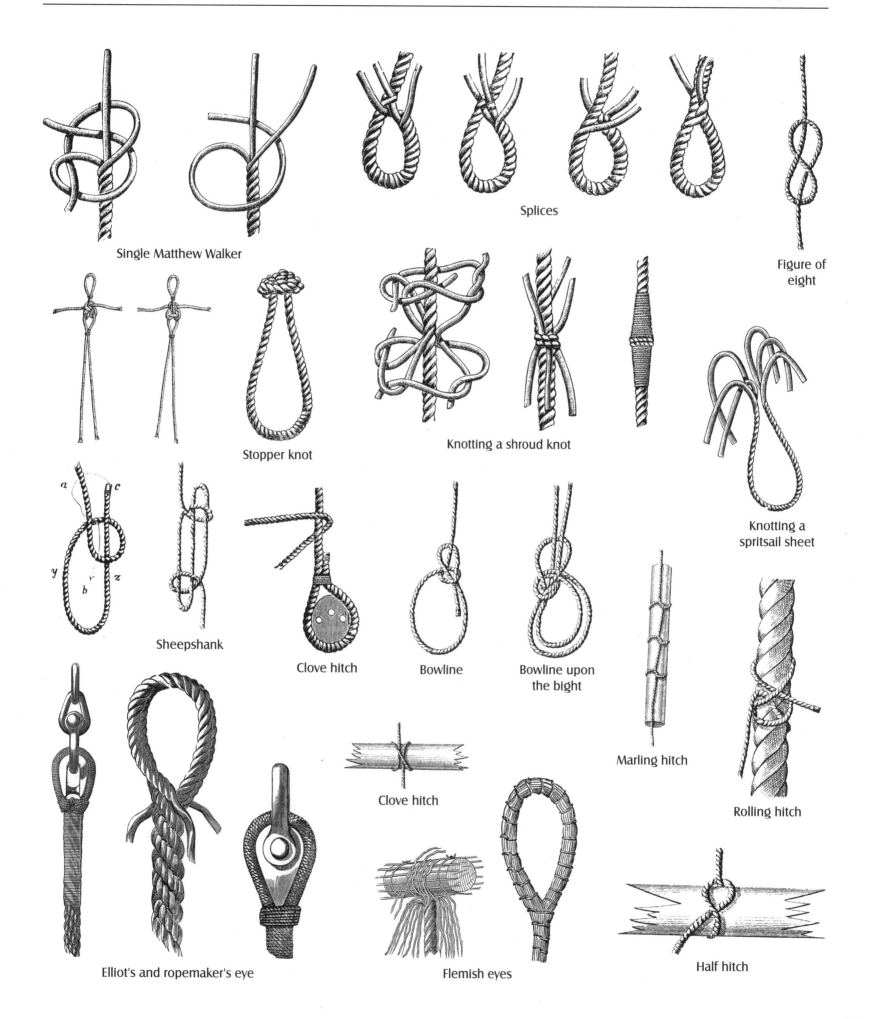

Single Matthew Walker

Splices

Figure of eight

Stopper knot

Knotting a shroud knot

Knotting a spritsail sheet

Sheepshank

Clove hitch

Bowline

Bowline upon the bight

Marling hitch

Rolling hitch

Clove hitch

Elliot's and ropemaker's eye

Flemish eyes

Half hitch

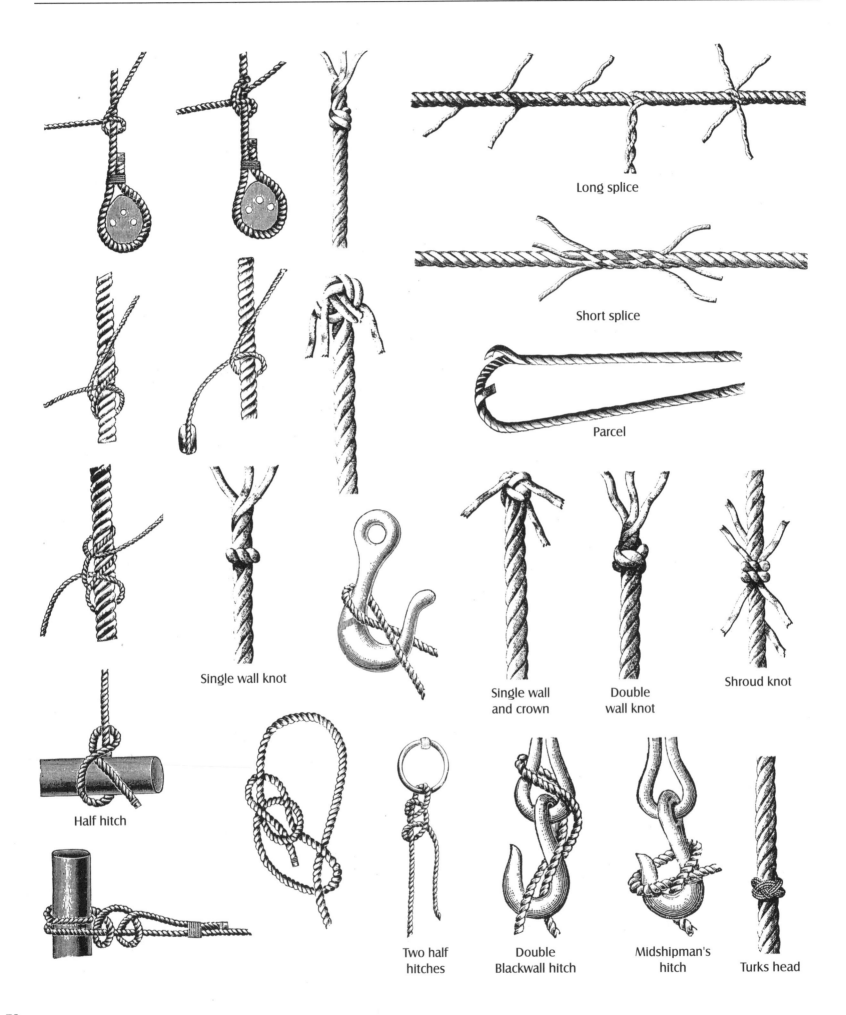

Long splice

Short splice

Parcel

Single wall knot

Single wall and crown

Double wall knot

Shroud knot

Half hitch

Two half hitches

Double Blackwall hitch

Midshipman's hitch

Turks head

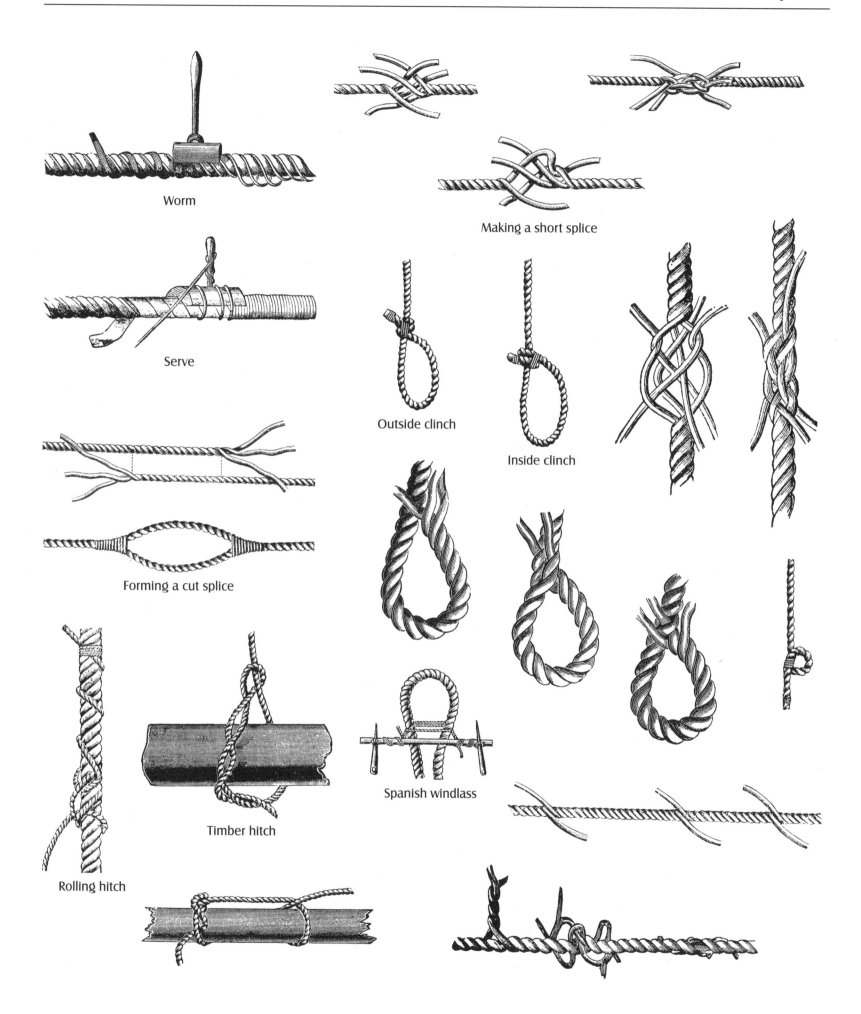

Worm

Making a short splice

Serve

Outside clinch

Inside clinch

Forming a cut splice

Rolling hitch

Timber hitch

Spanish windlass

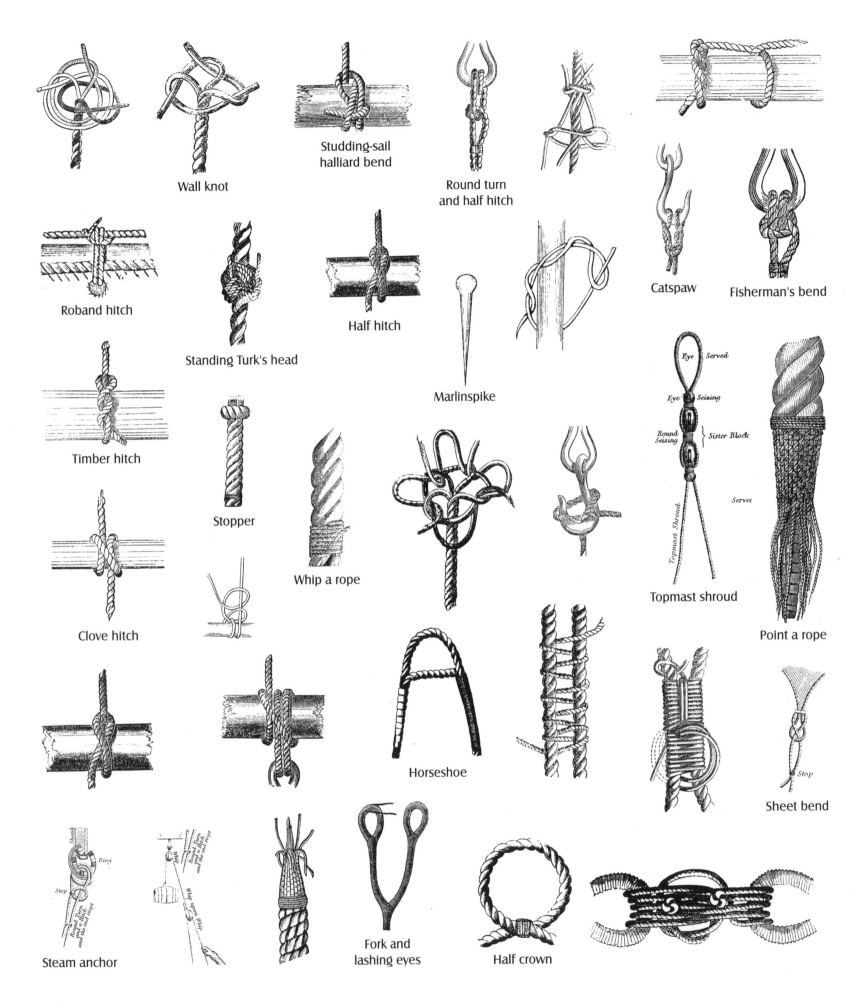

Wall knot

Studding-sail
halliard bend

Round turn
and half hitch

Catspaw

Fisherman's bend

Roband hitch

Standing Turk's head

Half hitch

Marlinspike

Timber hitch

Stopper

Whip a rope

Topmast shroud

Point a rope

Clove hitch

Horseshoe

Sheet bend

Steam anchor

Fork and
lashing eyes

Half crown

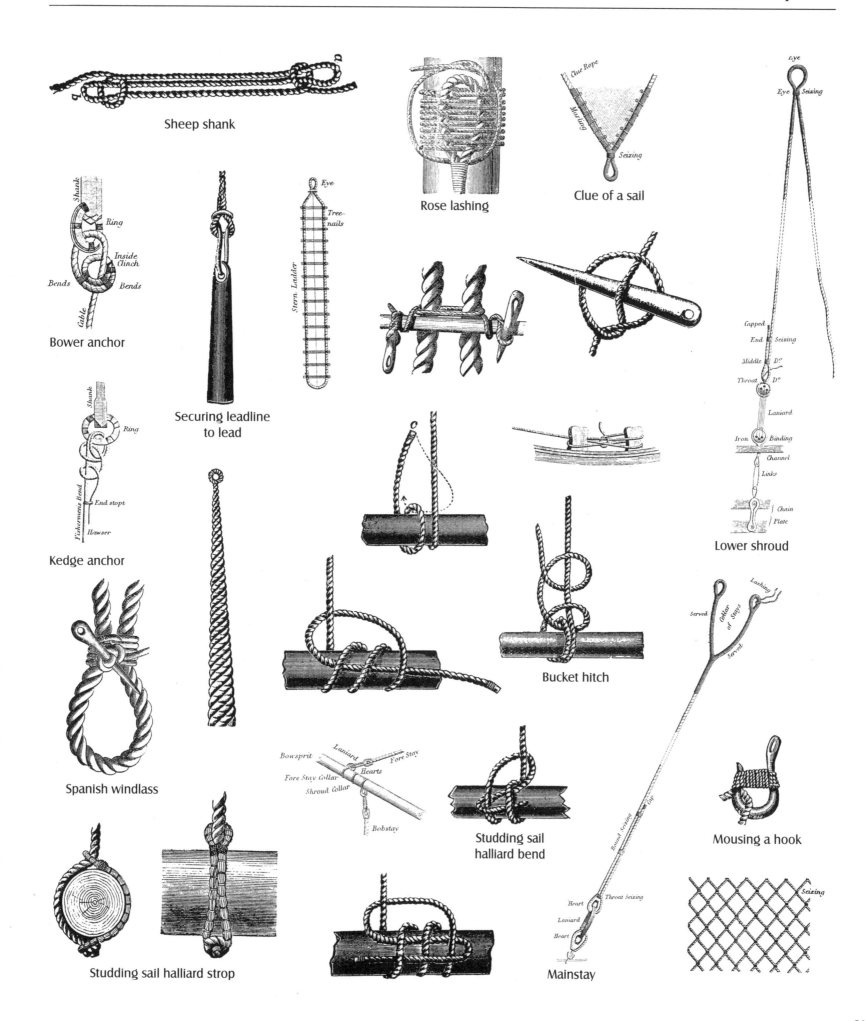

Sheep shank

Rose lashing

Clue of a sail

Bower anchor

Securing leadline to lead

Lower shroud

Kedge anchor

Bucket hitch

Spanish windlass

Studding sail halliard bend

Mousing a hook

Studding sail halliard strop

Mainstay

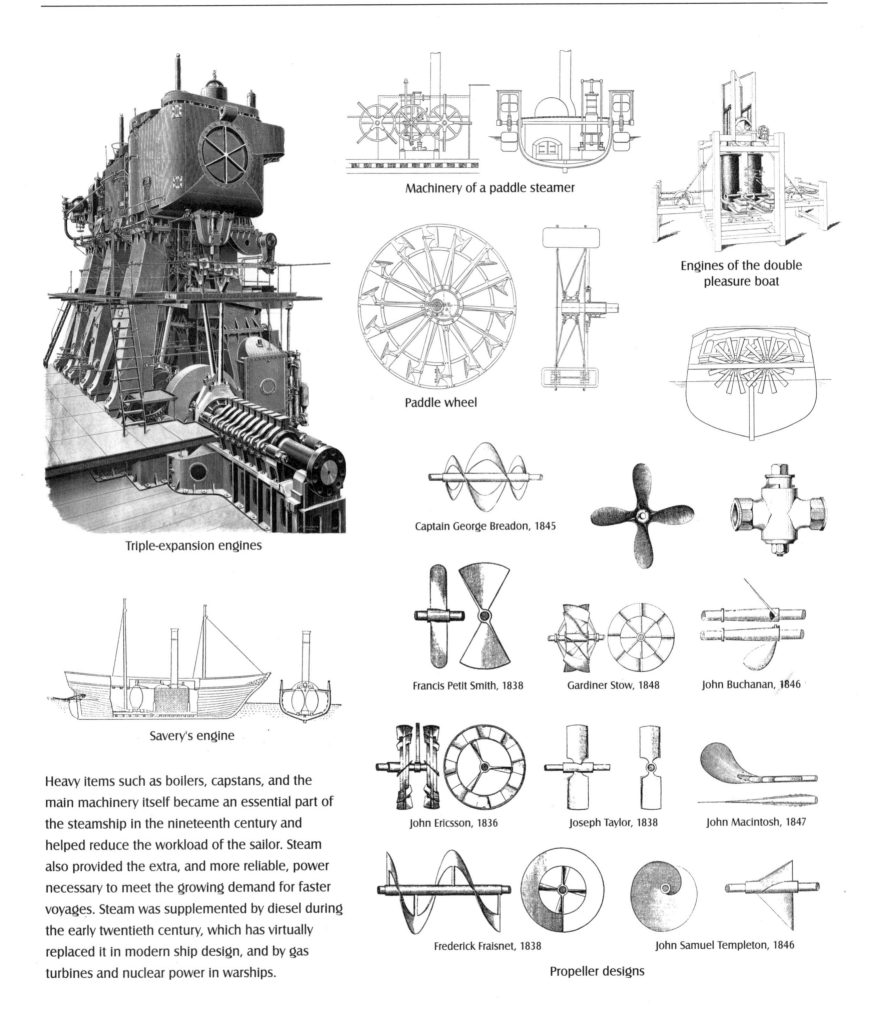

Triple-expansion engines

Machinery of a paddle steamer

Engines of the double
pleasure boat

Paddle wheel

Captain George Breadon, 1845

Francis Petit Smith, 1838

Gardiner Stow, 1848

John Buchanan, 1846

John Ericsson, 1836

Joseph Taylor, 1838

John Macintosh, 1847

Frederick Fraisnet, 1838

John Samuel Templeton, 1846

Propeller designs

Savery's engine

Heavy items such as boilers, capstans, and the main machinery itself became an essential part of the steamship in the nineteenth century and helped reduce the workload of the sailor. Steam also provided the extra, and more reliable, power necessary to meet the growing demand for faster voyages. Steam was supplemented by diesel during the early twentieth century, which has virtually replaced it in modern ship design, and by gas turbines and nuclear power in warships.

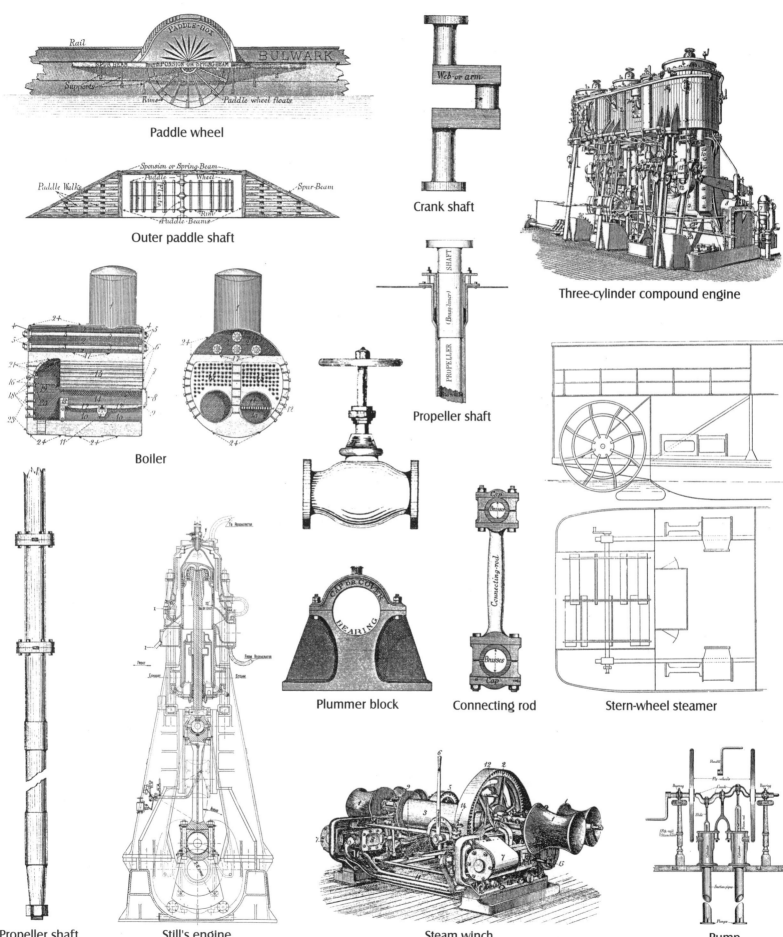

Paddle wheel

Outer paddle shaft

Crank shaft

Three-cylinder compound engine

Boiler

Propeller shaft

Propeller shaft

Plummer block

Connecting rod

Stern-wheel steamer

Still's engine

Steam winch

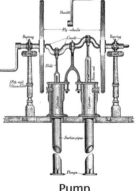

Pump

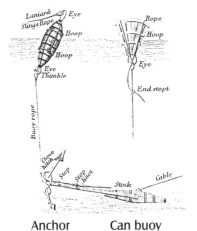

Anchor
buoy

Can buoy

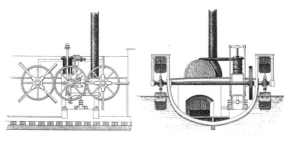

Engine and paddle wheel of Bell's Comet, 1812

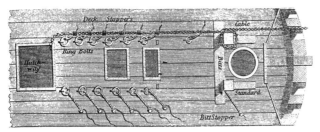

Cable bitted and stoppered

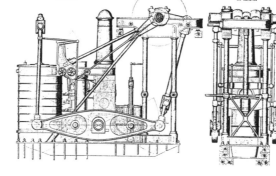

Gatting and fishing
the anchor

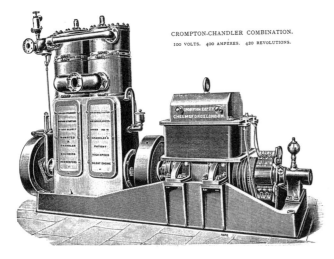

CROMPTON-CHANDLER COMBINATION.
100 VOLTS. 400 AMPÈRES. 420 REVOLUTIONS.

Anchor shackle

Richards' indicator

In the early days of steam, paddle wheels were used in a great variety of vessels, although they brought with them their own problems; it was still necessary for a ship to carry sails in case of breakdowns, which did occasionally occur. Although the paddle wheel had many practical advantages for mercantile vessels, for warships it was quickly superseded by the screw propeller after an initial period of experimentation.

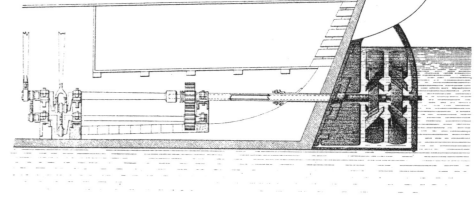

Ericsson's screw propeller, 1839

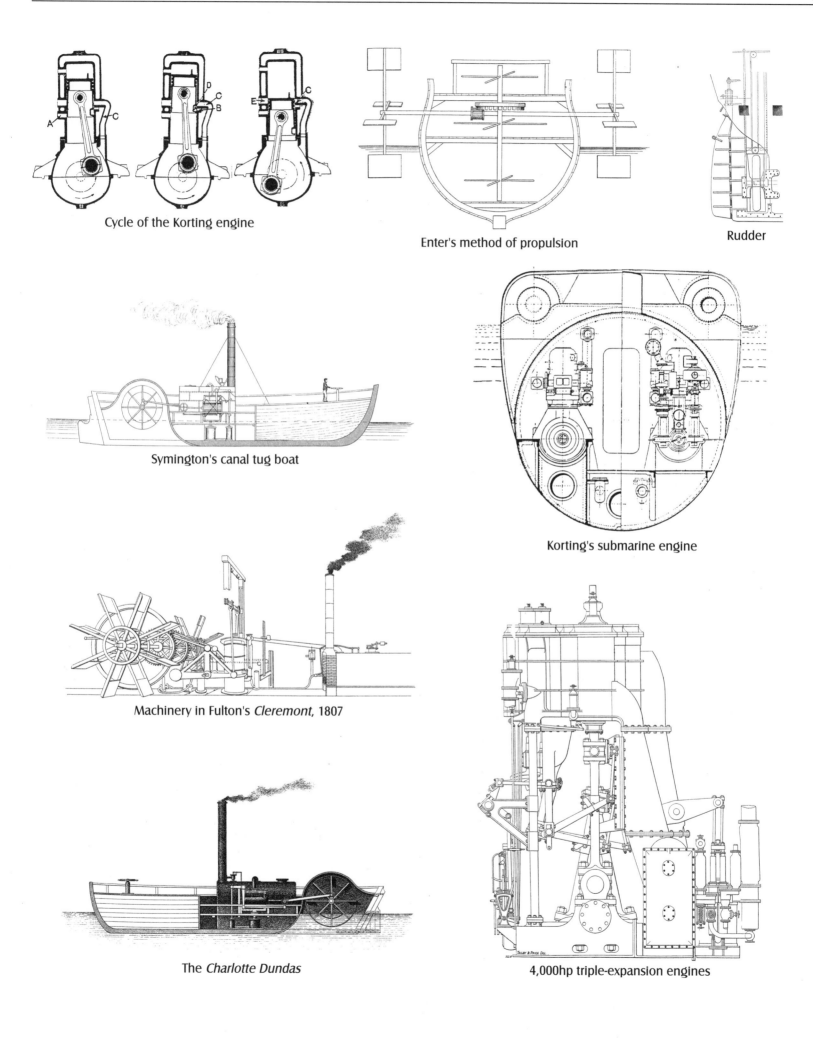

Cycle of the Korting engine

Enter's method of propulsion

Rudder

Symington's canal tug boat

Korting's submarine engine

Machinery in Fulton's *Cleremont*, 1807

The *Charlotte Dundas*

4,000hp triple-expansion engines

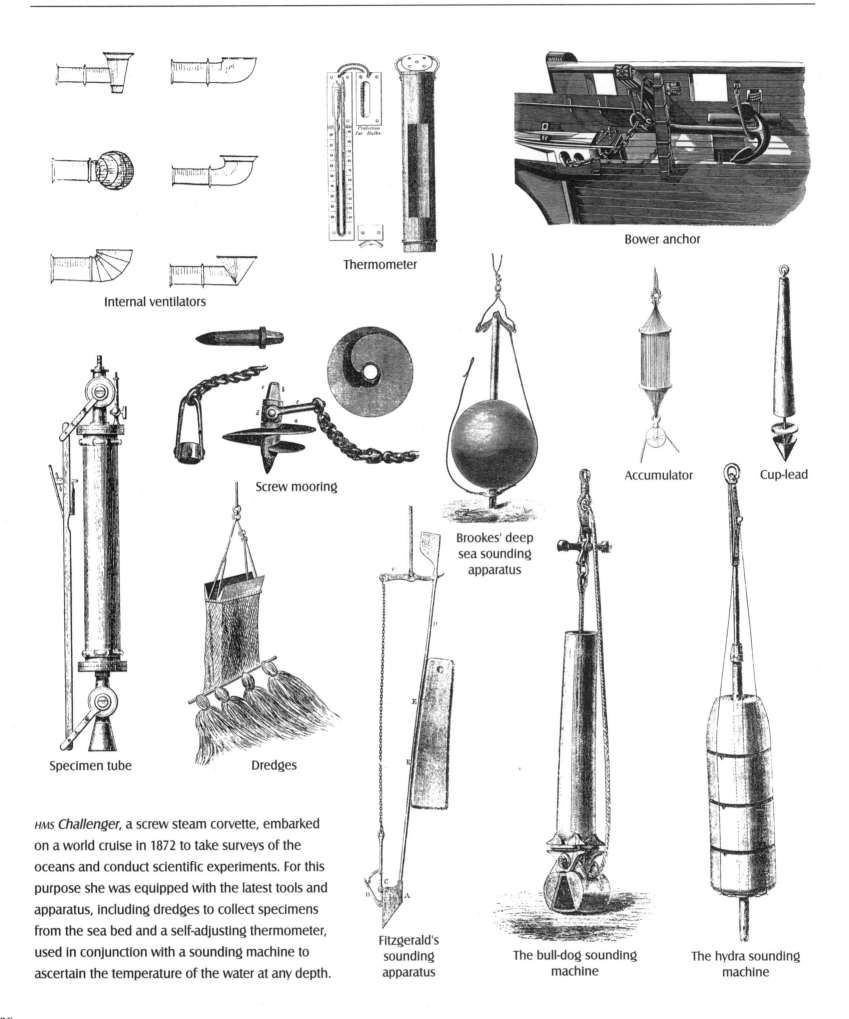

Internal ventilators

Thermometer

Bower anchor

Specimen tube

Screw mooring

Dredges

Brookes' deep
sea sounding
apparatus

Accumulator

Cup-lead

Fitzgerald's
sounding
apparatus

The bull-dog sounding
machine

The hydra sounding
machine

HMS *Challenger*, a screw steam corvette, embarked on a world cruise in 1872 to take surveys of the oceans and conduct scientific experiments. For this purpose she was equipped with the latest tools and apparatus, including dredges to collect specimens from the sea bed and a self-adjusting thermometer, used in conjunction with a sounding machine to ascertain the temperature of the water at any depth.

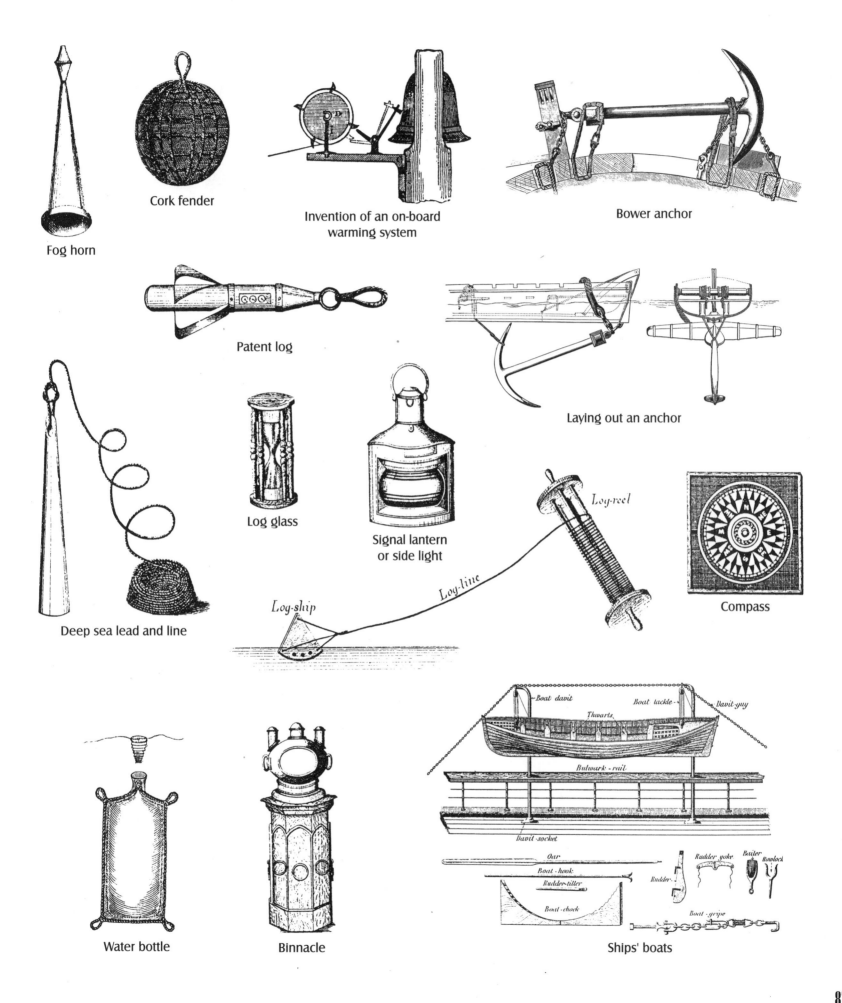

Fog horn

Cork fender

Invention of an on-board
warming system

Bower anchor

Patent log

Laying out an anchor

Deep sea lead and line

Log glass

Signal lantern
or side light

Log-reel

Log-line

Log-ship

Compass

Water bottle

Binnacle

Boat davit *Boat tackle* *Davit-guy*

Thwarts

Bulwark-rail

Davit-socket

Oar

Boat-hook

Rudder-tiller

Boat-chock

Rudder yoke *Bailer* *Rowlock*

Rudder

Boat-gripe

Ships' boats

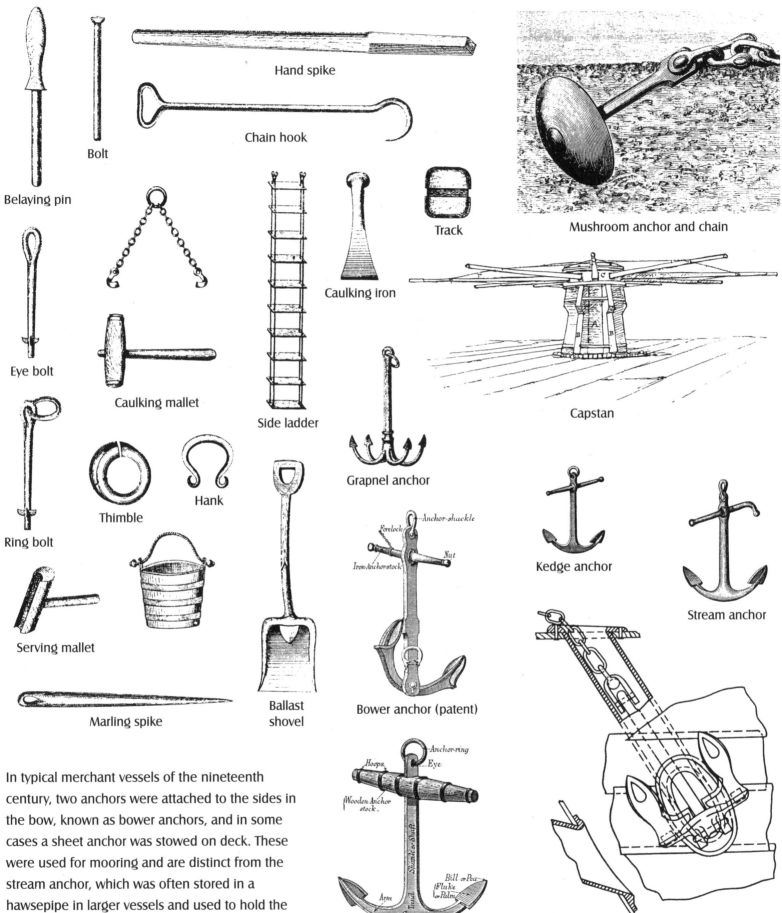

Hand spike

Bolt

Chain hook

Belaying pin

Track

Mushroom anchor and chain

Eye bolt

Caulking iron

Caulking mallet

Capstan

Side ladder

Ring bolt

Thimble

Hank

Grapnel anchor

Kedge anchor

Serving mallet

Stream anchor

Marling spike

Ballast shovel

Anchor-shackle
Forelock
Iron-Anchorstock
Nut

Bower anchor (patent)

In typical merchant vessels of the nineteenth century, two anchors were attached to the sides in the bow, known as bower anchors, and in some cases a sheet anchor was stowed on deck. These were used for mooring and are distinct from the stream anchor, which was often stored in a hawsepipe in larger vessels and used to hold the stern in swiftly running streams.

Anchor-ring
Hoops
Eye
Wooden Anchor stock.
Shank or Shaft
Bill or Pea
Fluke or Palm
Arm
Crown

Bower anchor

Anchor stowed in the hawsepipe

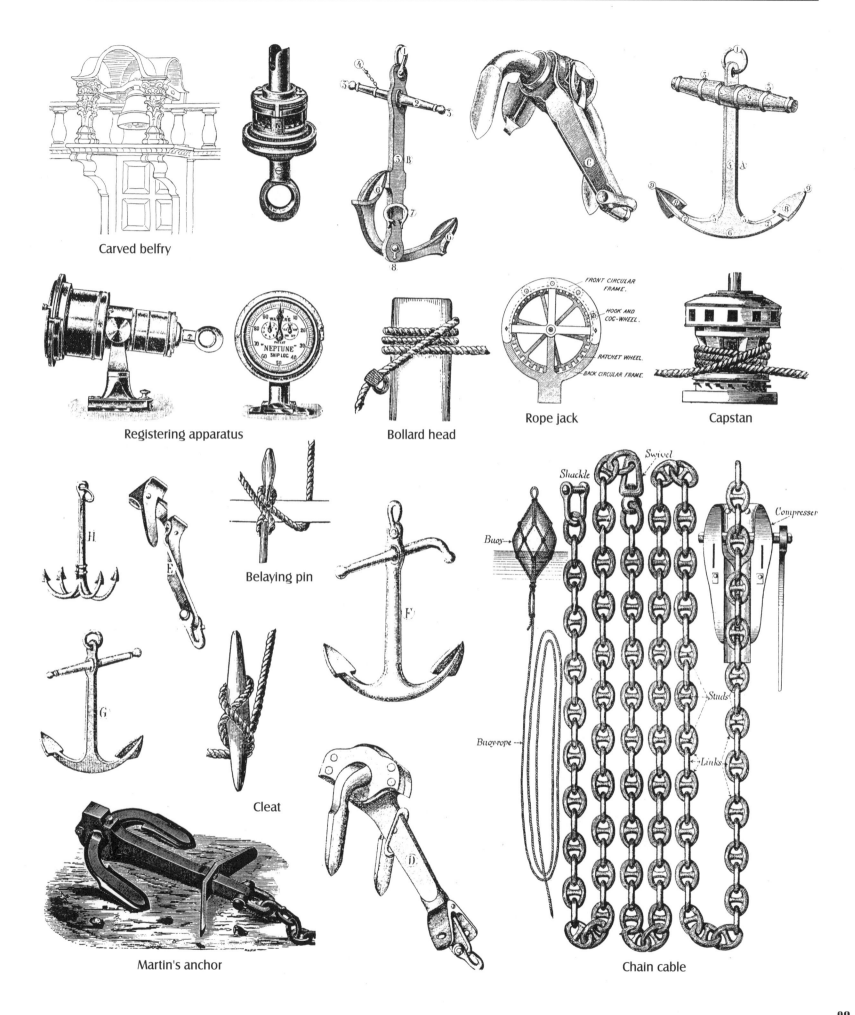

Carved belfry

Registering apparatus

Bollard head

Rope jack

FRONT CIRCULAR FRAME.

HOOK AND COG-WHEEL.

RATCHET WHEEL.

BACK CIRCULAR FRAME.

Capstan

Belaying pin

Cleat

Martin's anchor

Buoy

Shackle

Swivel

Compresser

Buoy-rope

Studs

Links

Chain cable

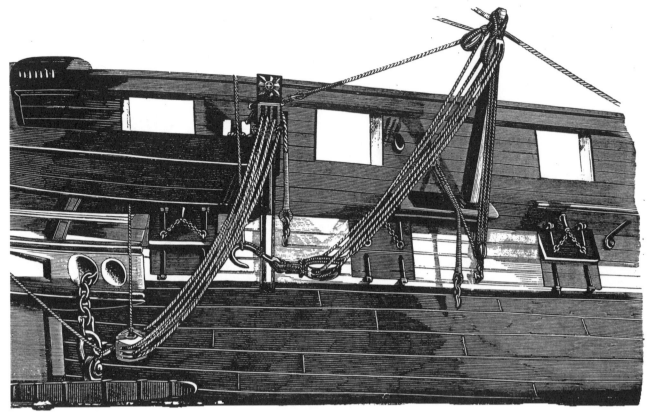

Cat and fish falls

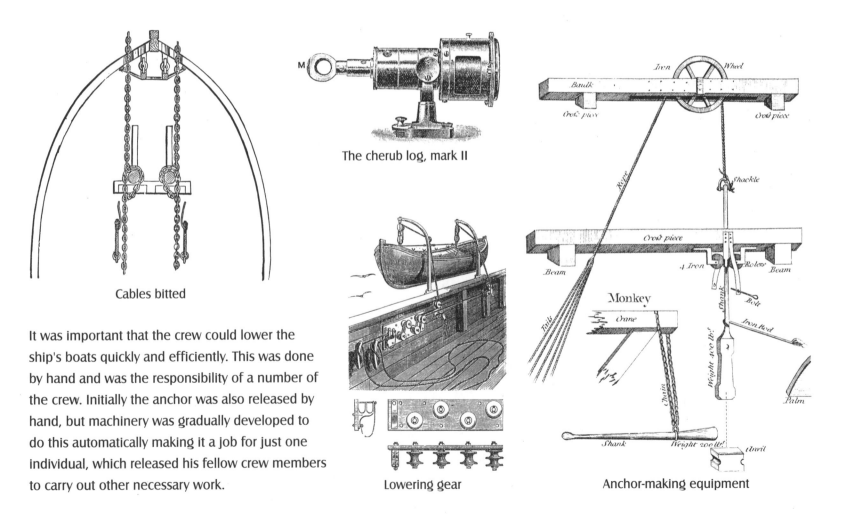

Cables bitted

The cherub log, mark II

It was important that the crew could lower the ship's boats quickly and efficiently. This was done by hand and was the responsibility of a number of the crew. Initially the anchor was also released by hand, but machinery was gradually developed to do this automatically making it a job for just one individual, which released his fellow crew members to carry out other necessary work.

Lowering gear

Anchor-making equipment

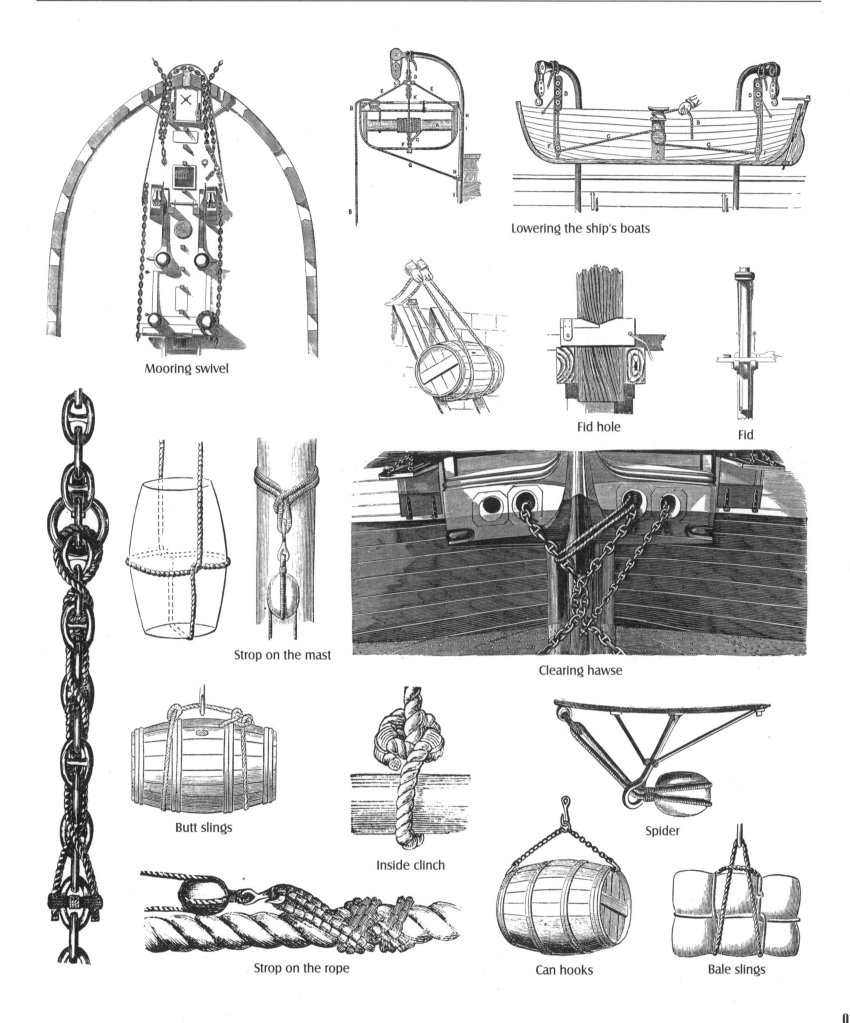

Mooring swivel

Lowering the ship's boats

Fid hole

Fid

Strop on the mast

Clearing hawse

Butt slings

Inside clinch

Spider

Strop on the rope

Can hooks

Bale slings

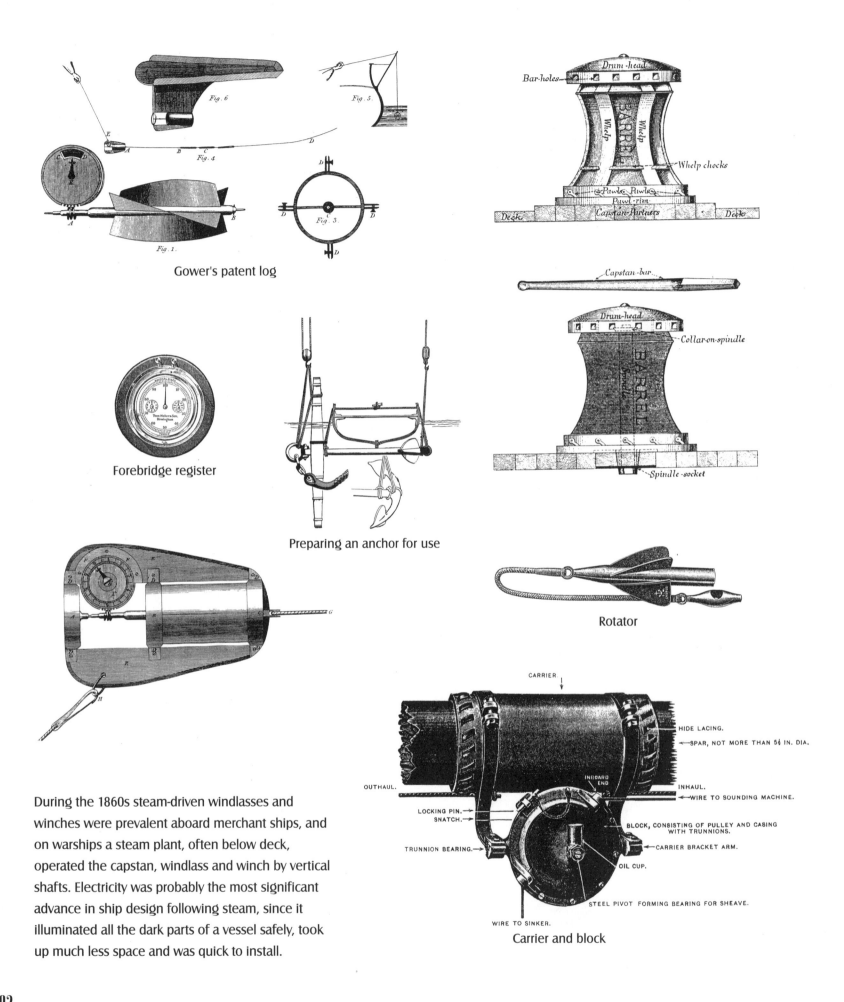

Gower's patent log

Forebridge register

Preparing an anchor for use

Rotator

Carrier and block

During the 1860s steam-driven windlasses and winches were prevalent aboard merchant ships, and on warships a steam plant, often below deck, operated the capstan, windlass and winch by vertical shafts. Electricity was probably the most significant advance in ship design following steam, since it illuminated all the dark parts of a vessel safely, took up much less space and was quick to install.

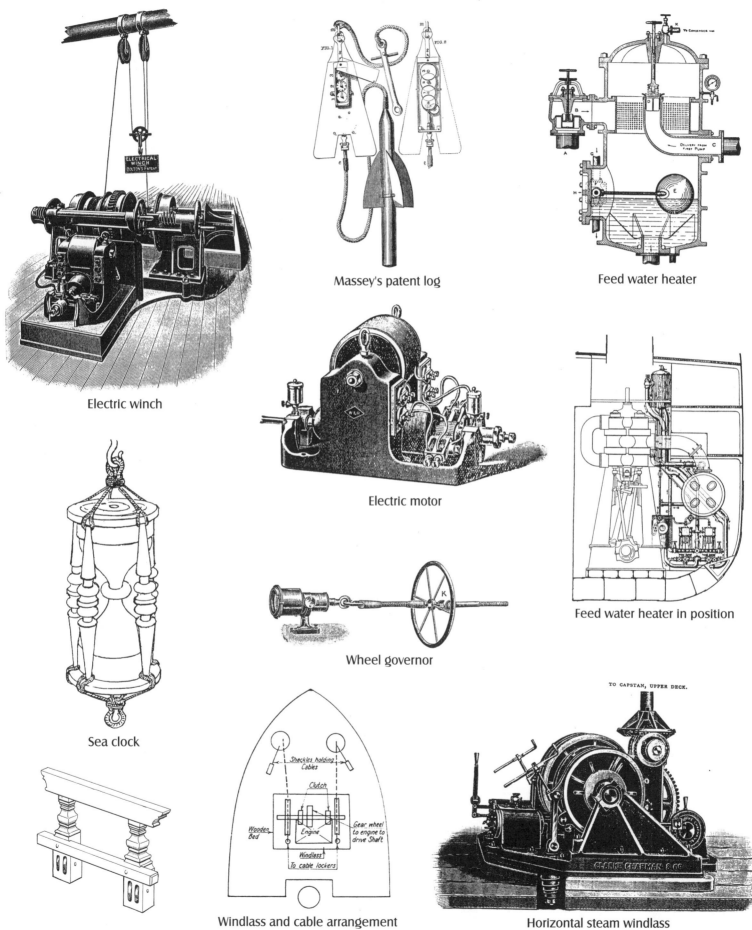

Electric winch

Massey's patent log

Feed water heater

Electric motor

Sea clock

Wheel governor

Feed water heater in position

Windlass and cable arrangement

Horizontal steam windlass

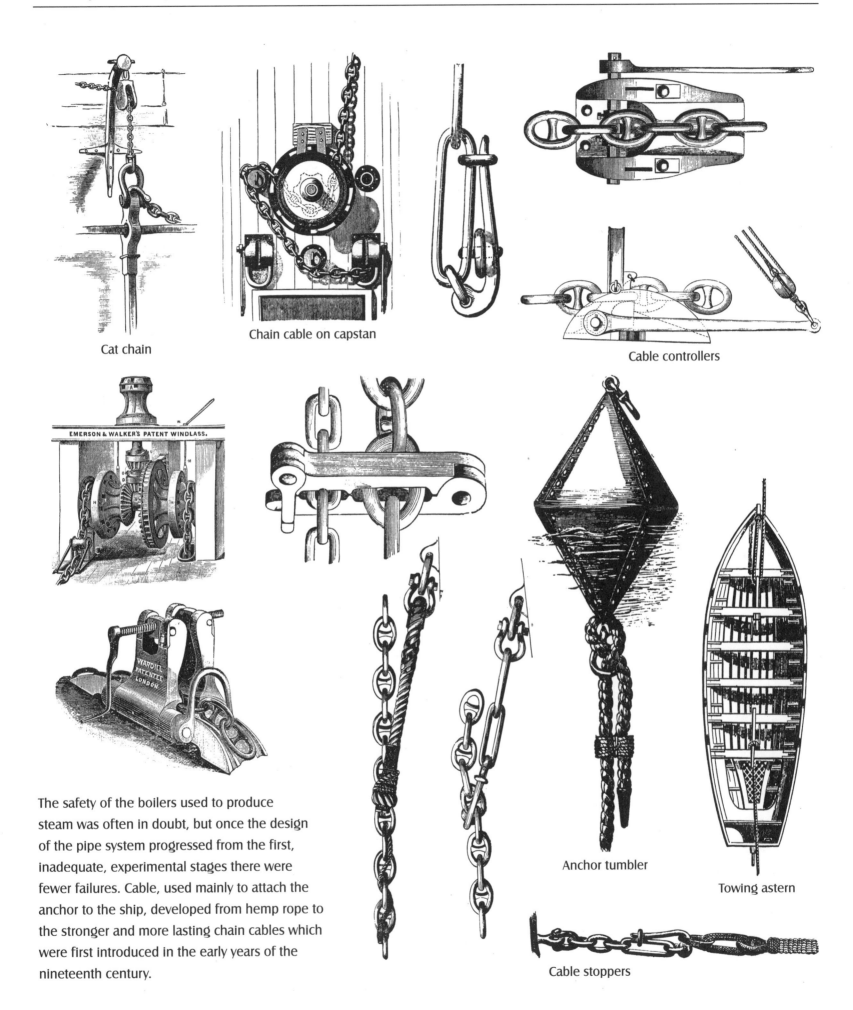

Cat chain

Chain cable on capstan

Cable controllers

EMERSON & WALKER'S PATENT WINDLASS.

WARDILL PATENTEE LONDON

Anchor tumbler

Towing astern

The safety of the boilers used to produce steam was often in doubt, but once the design of the pipe system progressed from the first, inadequate, experimental stages there were fewer failures. Cable, used mainly to attach the anchor to the ship, developed from hemp rope to the stronger and more lasting chain cables which were first introduced in the early years of the nineteenth century.

Cable stoppers

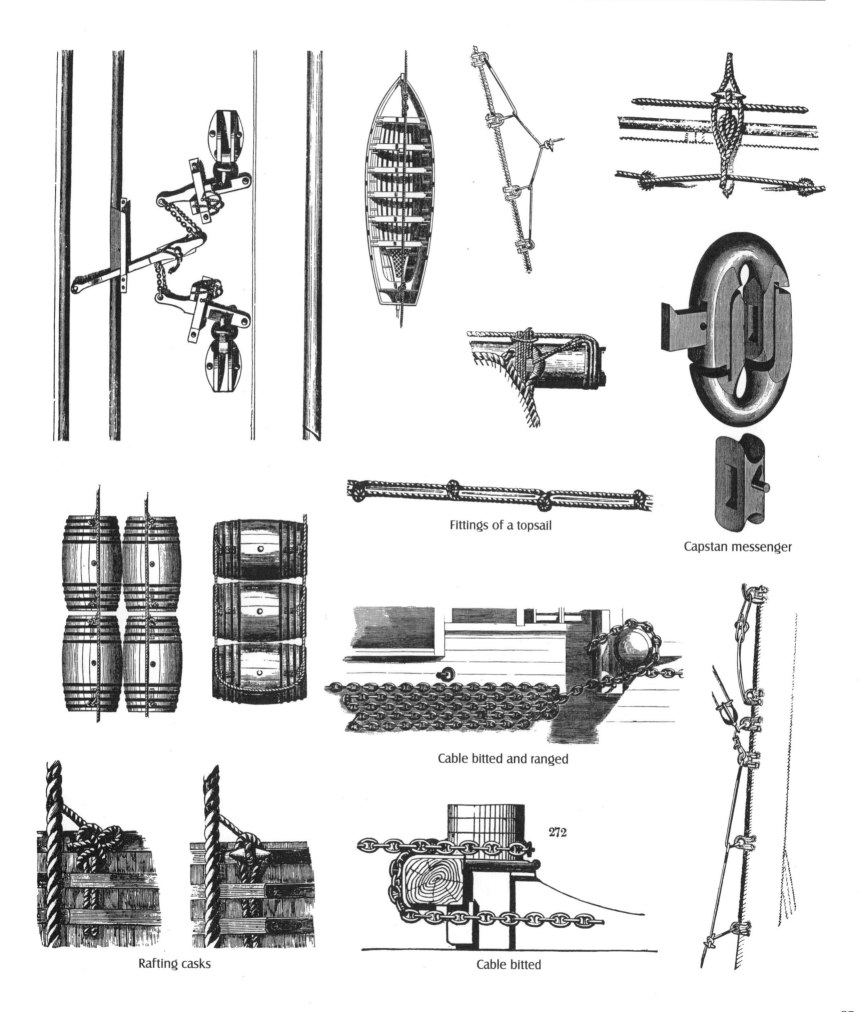

Fittings of a topsail

Capstan messenger

Cable bitted and ranged

272

Rafting casks

Cable bitted

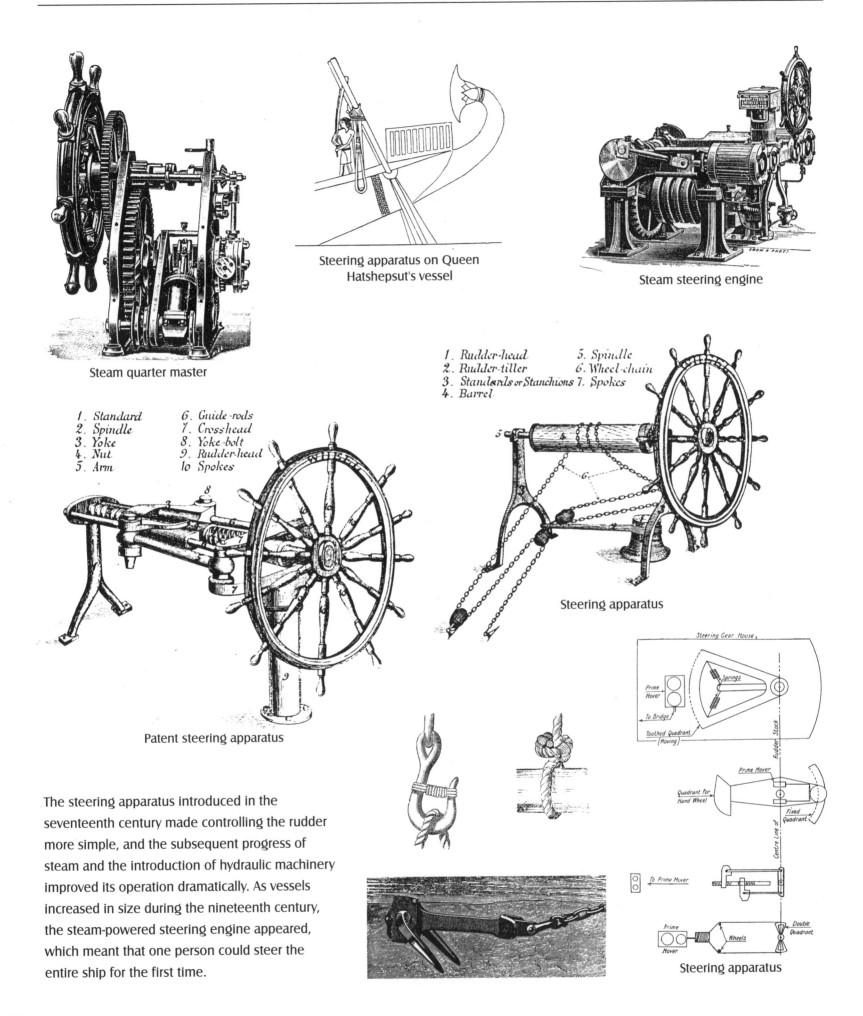

Steering apparatus on Queen
Hatshepsut's vessel

Steam steering engine

Steam quarter master

1. Standard 6. Guide-rods
2. Spindle 7. Crosshead
3. Yoke 8. Yoke-bolt
4. Nut 9. Rudder-head
5. Arm 10. Spokes

1. Rudder-head 5. Spindle
2. Rudder-tiller 6. Wheel-chain
3. Standards or Stanchions 7. Spokes
4. Barrel

Steering apparatus

Patent steering apparatus

The steering apparatus introduced in the
seventeenth century made controlling the rudder
more simple, and the subsequent progress of
steam and the introduction of hydraulic machinery
improved its operation dramatically. As vessels
increased in size during the nineteenth century,
the steam-powered steering engine appeared,
which meant that one person could steer the
entire ship for the first time.

Steering apparatus

Color Plate Section

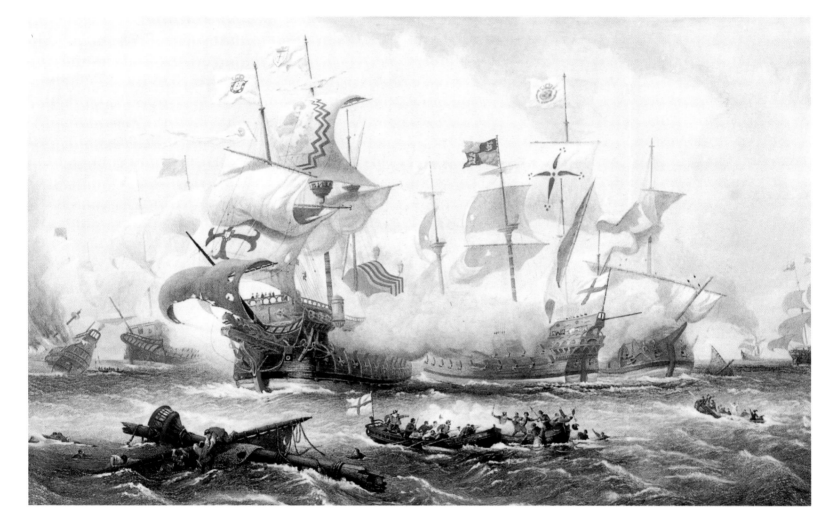

'The Attack of the *Vanguard*, August 8 1588', by
Oswald W Brierly RWS.

Private Collection; courtesy of the Warwick Leadlay Gallery, London

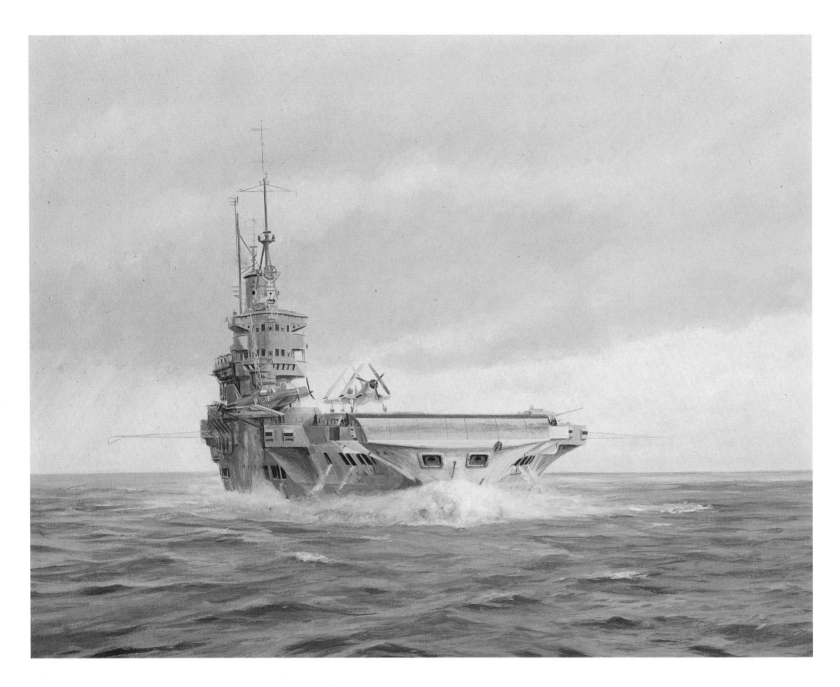

'The Aircraft Carrier *Victorious* in 1944 with MK2
Corsairs on deck', by Ross Watton.

From *Anatomy of the Ship: Victorious* by Ross Watton

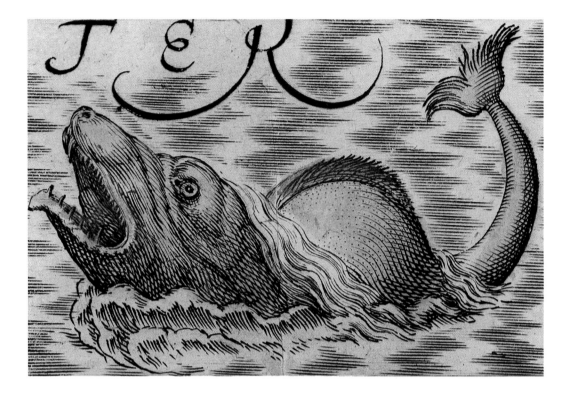

Detail of a sea monster from a sixteenth-century map.

Private Collection; courtesy of the Warwick Leadlay Gallery, London

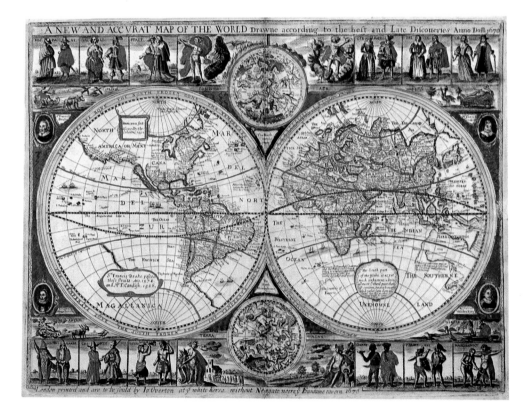

'A New and Accurate Map of the World: Drawn
according to the best and late discoveries,
Anno Domini 1670', by John Speed.

Private Collection; courtesy of the Warwick Leadlay Gallery, London

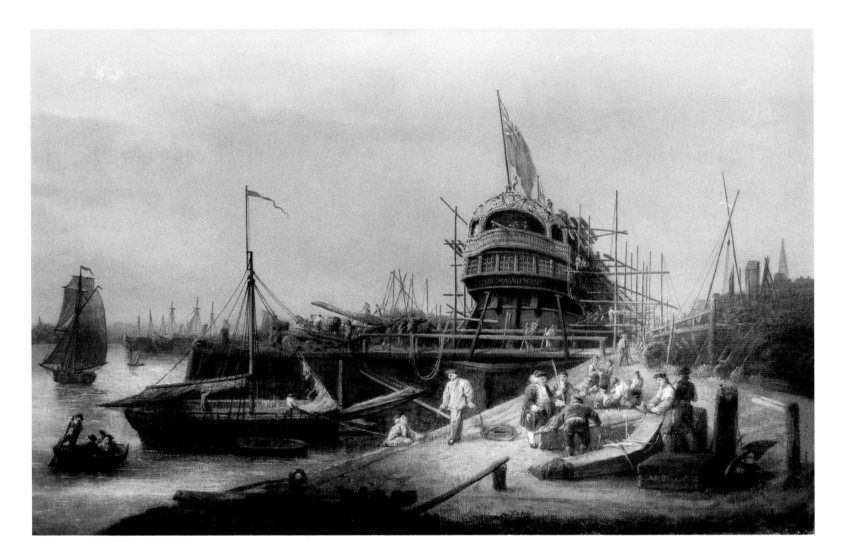

'Launching of the 74-gun HMS *Magnificent* at
Deptford, 1766', by John Clevely the Elder (c.1712–77).

Private Collection; courtesy of The Parker Gallery, London

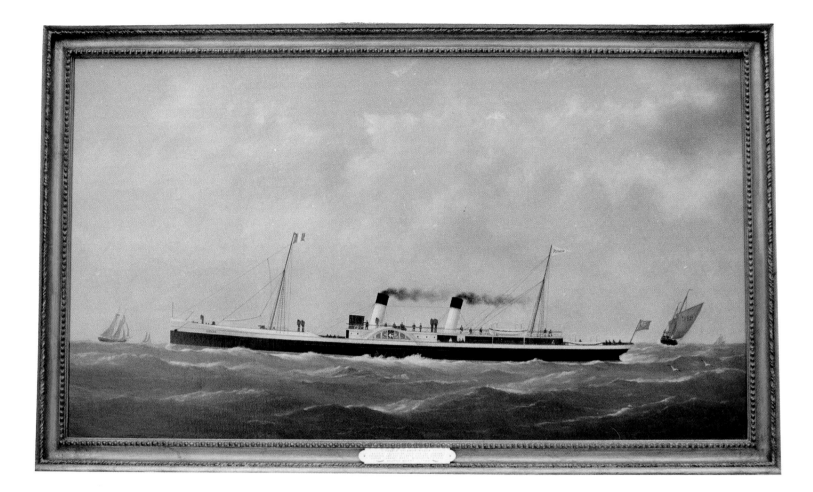

A nineteenth-century portrait of the Steamship *Raven*
on the Newhaven–Dieppe run, by George Mears.

Private Collection; courtesy of The Parker Gallery, London

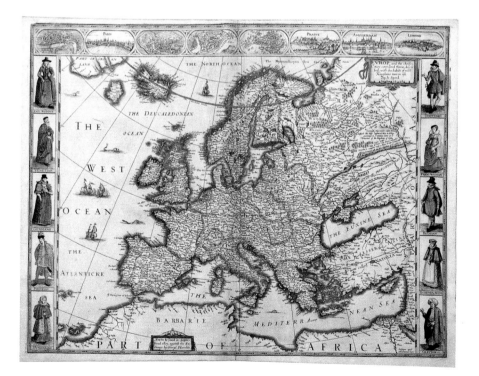

A seventeenth-century map of Europe and its
inhabitants, by John Speed.

Private Collection; courtesy of the Warwick Leadlay Gallery, London

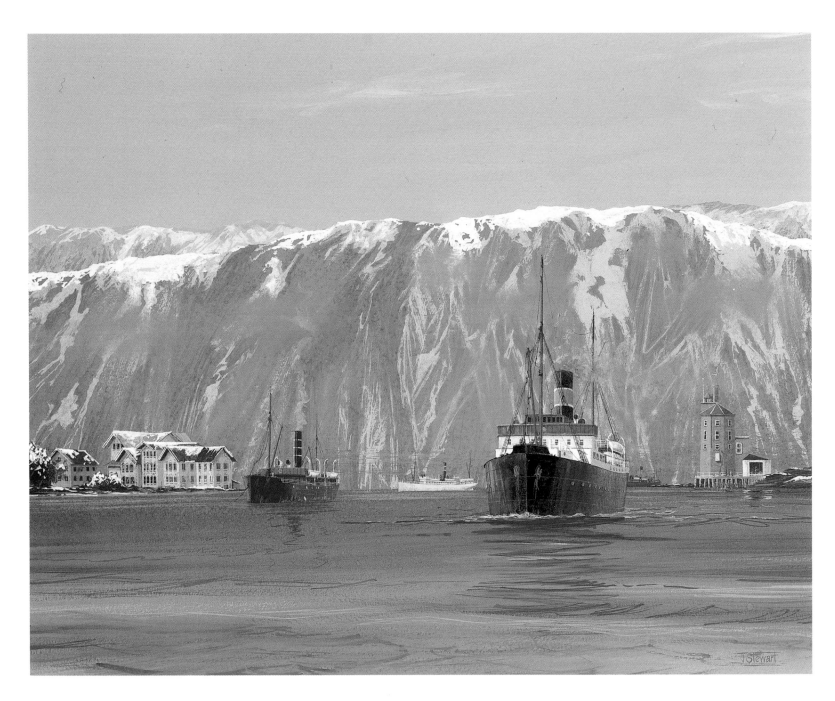

'Steamers of the Fjords', by John Stewart.
From *Steamers of the Fjords* by Mike Bent

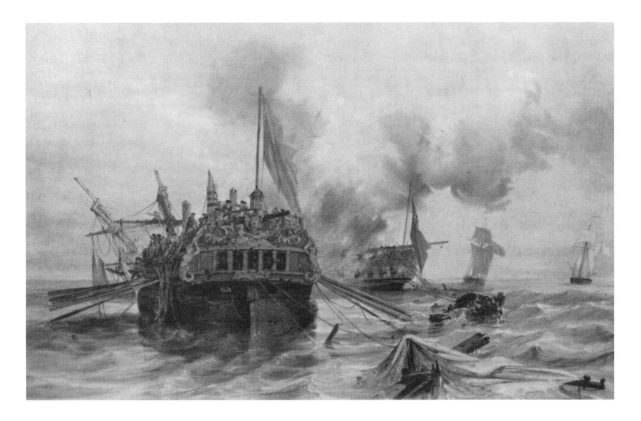

The *Quebec* on fire after fighting the *Surveillante*.

Artist unknown

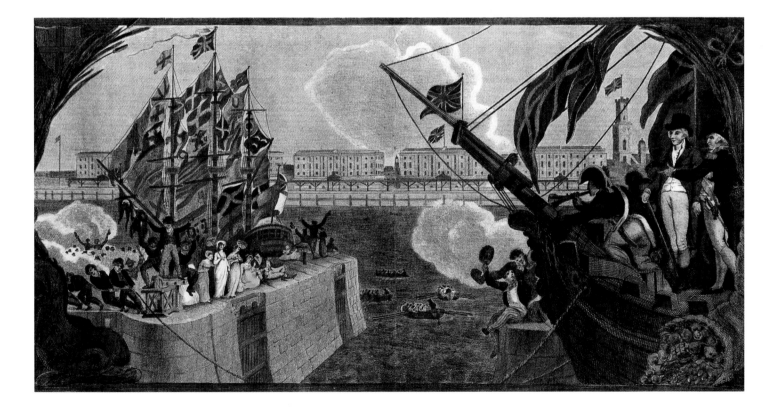

Burney's 'A view of the opening of the London Docks,
Wapping on the 31st of January, 1805', published in
the Stationers Almanack, 1806.

Private Collection; courtesy of the Warwick Leadlay Gallery, London

Borate

Chinarum gens admodum ingeni-
ofa eße pehibetur, adeo ut currus
excogitarint fabricaverintque,
quos velis ventisque per campos
et loca plana, uti navigia per
mare derigere optime norint.

Detail of a land boat from a sixteenth-century map.
Private Collection; courtesy of the Warwick Leadlay Gallery, London

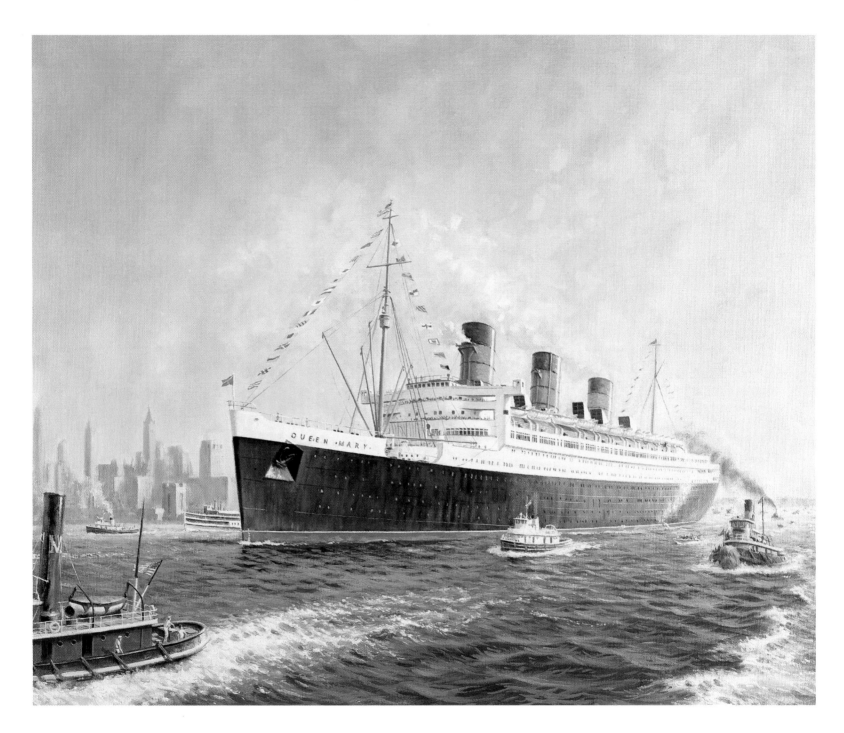

A painting by Ross Watton depicting the Cunard liner
Queen Mary arriving in New York harbour on 1 June
1936 after her maiden voyage.

From *Anatomy of the Ship: Queen Mary* by Ross Watton

An anonymous coloured lithograph of 'Her Majesty's steam-frigate *Avenger*, lost upon the Sorelli Rocks'.

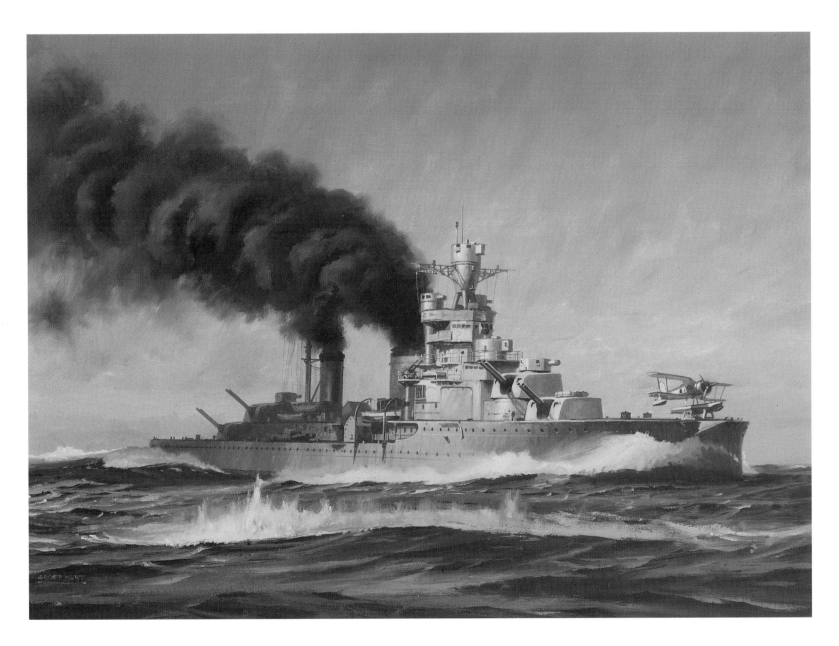

The Cruiser *Bartolomeo Colleoni*, by Geoff Hunt.

From *Anatomy of the Ship: Bartolomeo Colleoni* by Franco Gay and Valerio Gay

'Tilbury Fort – Wind Against Tide', by C Stanfield, RA.

Private Collection; courtesy of the Warwick Leadlay Gallery, London

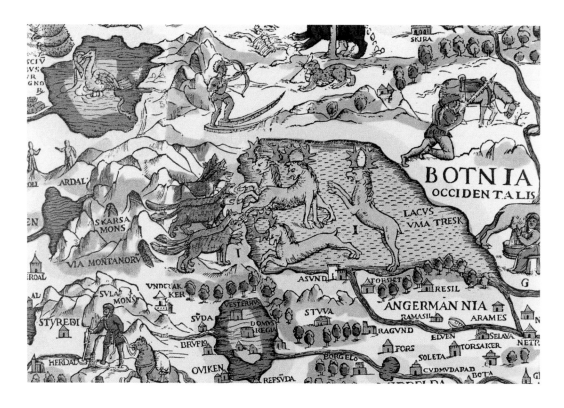

Details of an ancient map showing the land
of Botnia Occidentalis (above) and a variety of
fantastical sea-monsters (below).

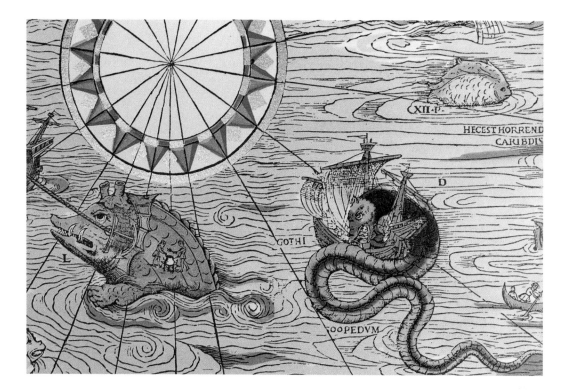

'Lord Hotham's Action, March 14th 1795', painted
by T Whitcombe and engraved by T Sutherland.

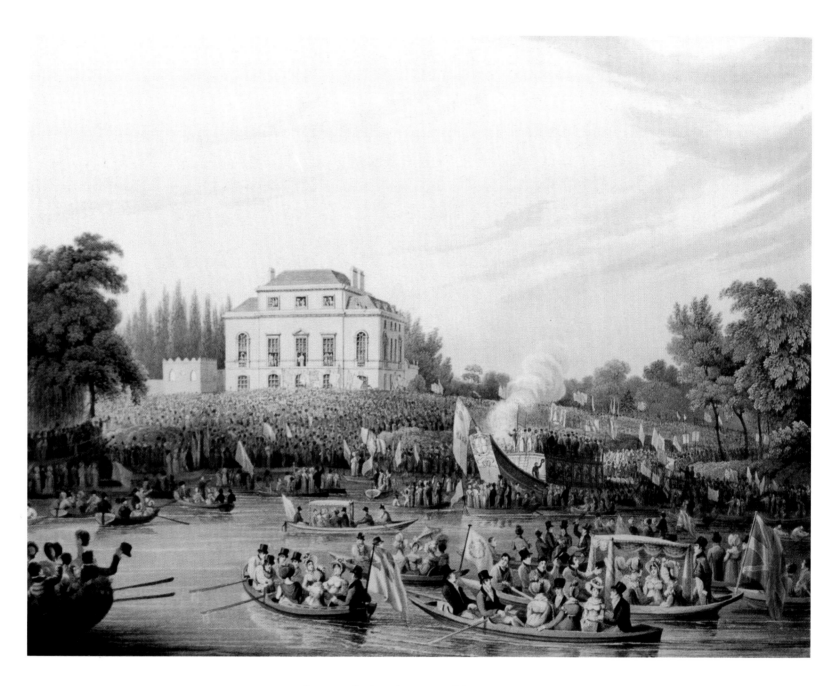

'Arrival at Brandenburgh House of the Watermen with
an address to the Queen on the 3rd October, 1820.'

Private Collection; courtesy of the Warwick Leadlay Gallery, London

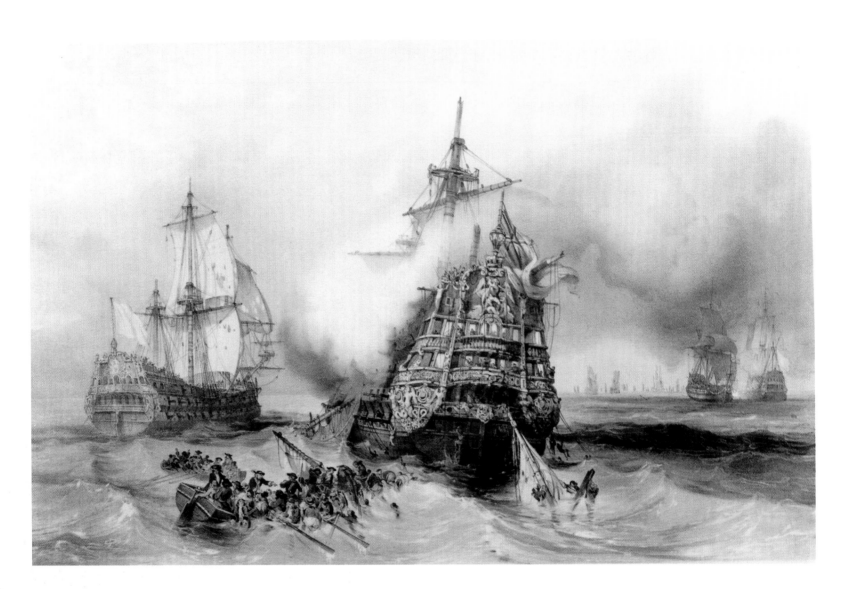

'Incendie du Vaisseau *Le Devonshire*, 21 September 1707', by Mayer & Sabatien.

Chapter 4

Warfare at Sea

Warfare at sea in its original form was nothing more than a continuation of land warfare. Seamen were required to fight in hand-to-hand combat on board their own and enemies' ships once boarding had been achieved. Although primitive weapons, such as the longbow and crossbow, were initially adopted for use at sea, the essence of battle changed entirely with the introduction of gunpowder, as guns could target ships rather than just individual crew members. By the early seventeenth century, the sailing warship carried a vast array of armament, and success in battle depended upon the calibre and efficiency of its numerous guns. The armament was placed ·throughout the ship with guns of the same calibre sharing a deck, the heaviest being on the lower deck. Firepower was still, however, not enough to destroy a ship or win a battle on its own, although the anti-personnel weapons developed during the early part of the century proved a more efficient, and much more deadly, way of successfully boarding the enemy ship.

The Anglo-Dutch War of the 1650s was a significant turning point in the development of armament and battle tactics, with the appearance of line-of-battle vessels. The growth of trade during this period, and the threat that war was placing it under, indicated to the major maritime nations that they could not underestimate the necessity for sea domination. The battle for supremacy on the oceans of Europe, from approximately 1650 to 1840, resulted in navies of immense power and shrewd tactics. The Industrial Revolution profoundly affected the manufacture of weapons, and continuing developments in science and technology created mines, torpedoes and guns of deadly efficiency. During the twentieth century, there have been rapid developments in warfare technology, including aircraft, submarines, radars and electronic weaponry, all of which have revolutionised naval combat.

Gun recovered from the *Mary Rose*

Chain shot

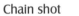

Bar shot

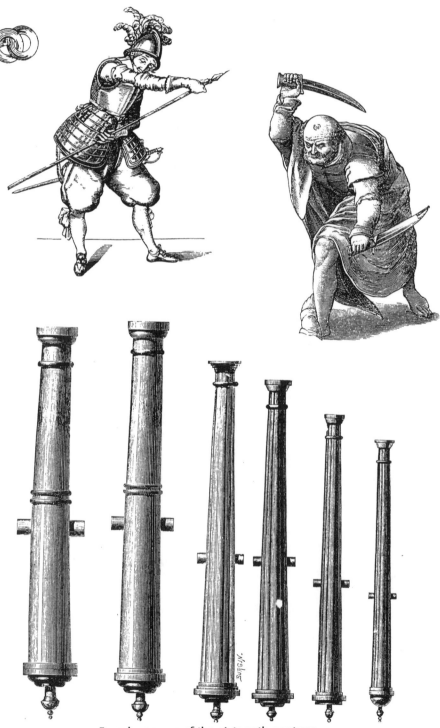

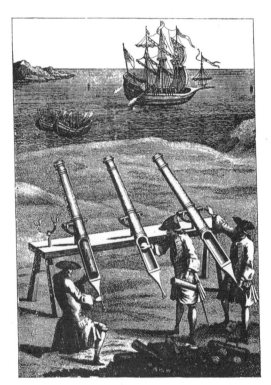

Early cannon

Primitive weapons such as the longbow and the crossbow, developed in the early Middle Ages, began to be used as an alternative to hand-to-hand combat. On the invention of gunpowder, guns quickly became essential as hand-held weapons to sweep the enemies decks before boarding. To sink the ships seamen still relied on ancient weapons such as Greek fire and catapults.

French cannon of the sixteenth century

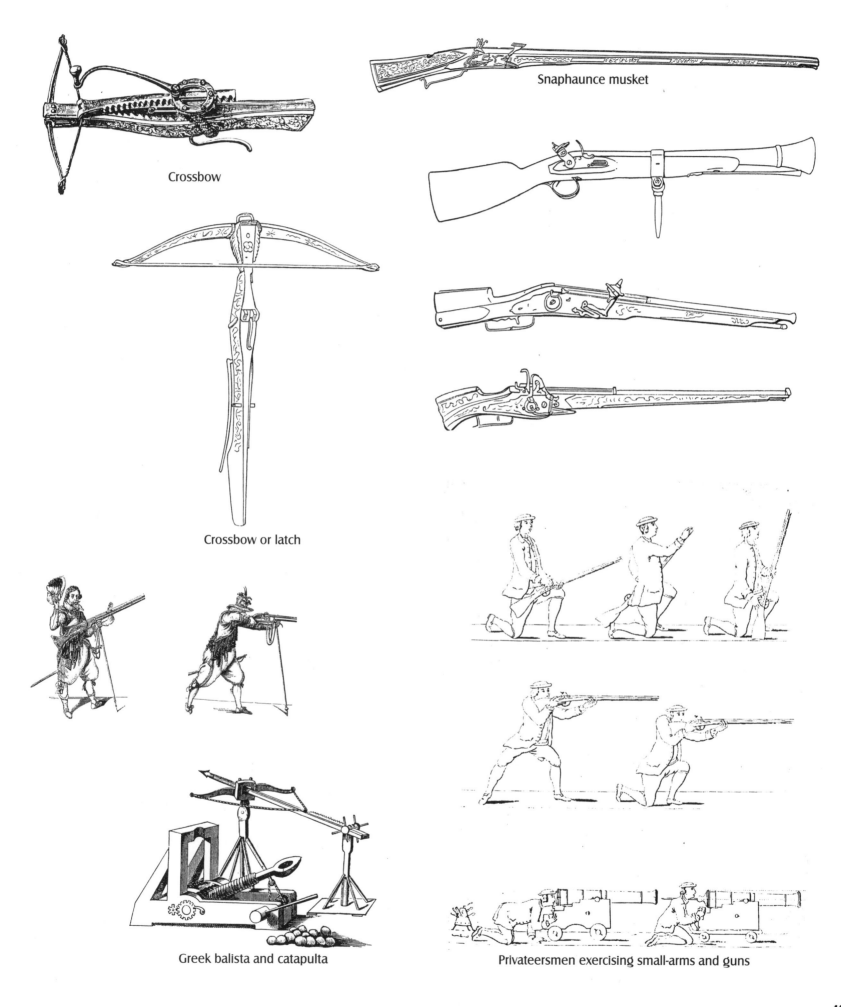

Crossbow

Snaphaunce musket

Crossbow or latch

Greek balista and catapulta

Privateersmen exercising small-arms and guns

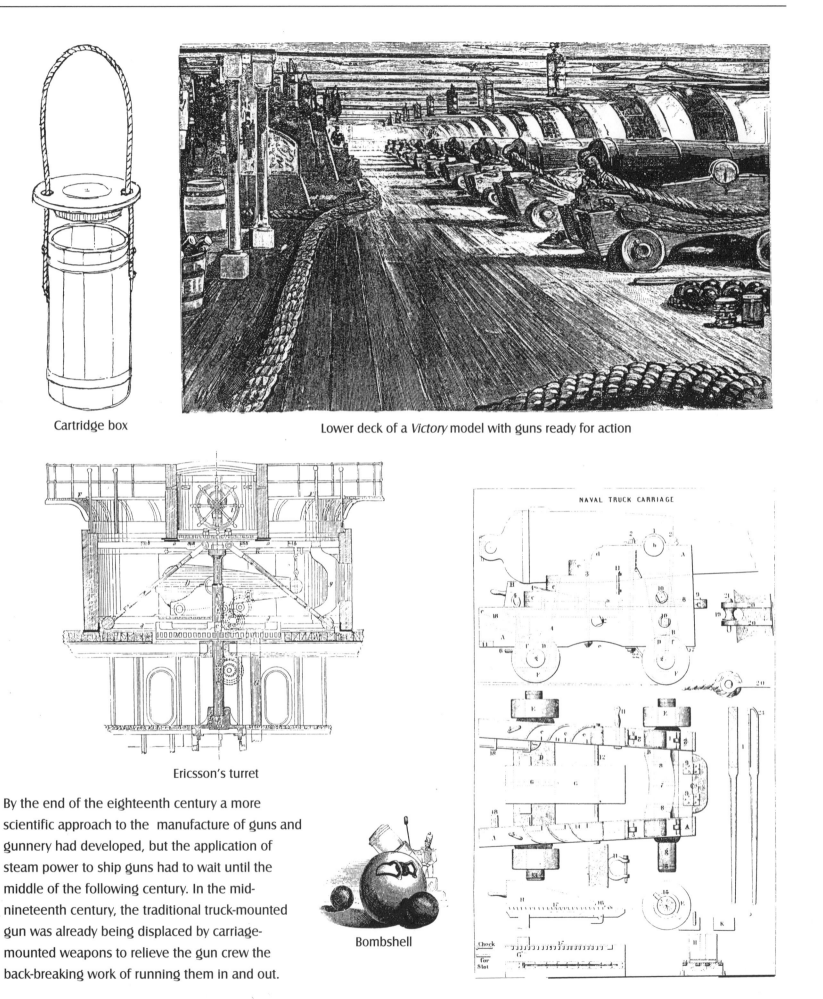

Cartridge box

Lower deck of a *Victory* model with guns ready for action

Ericsson's turret

NAVAL TRUCK CARRIAGE

Bombshell

By the end of the eighteenth century a more scientific approach to the manufacture of guns and gunnery had developed, but the application of steam power to ship guns had to wait until the middle of the following century. In the mid-nineteenth century, the traditional truck-mounted gun was already being displaced by carriage-mounted weapons to relieve the gun crew the back-breaking work of running them in and out.

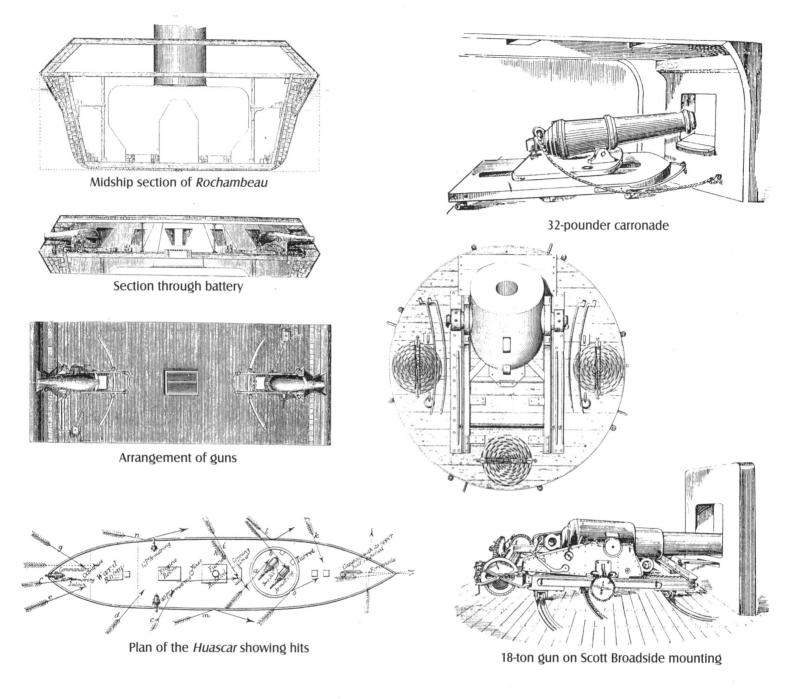

Midship section of *Rochambeau*

Section through battery

Arrangement of guns

Plan of the *Huascar* showing hits

32-pounder carronade

18-ton gun on Scott Broadside mounting

The bow compressor

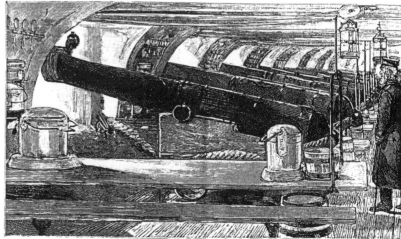

The *Victory* model with mess-tables and guns triced up

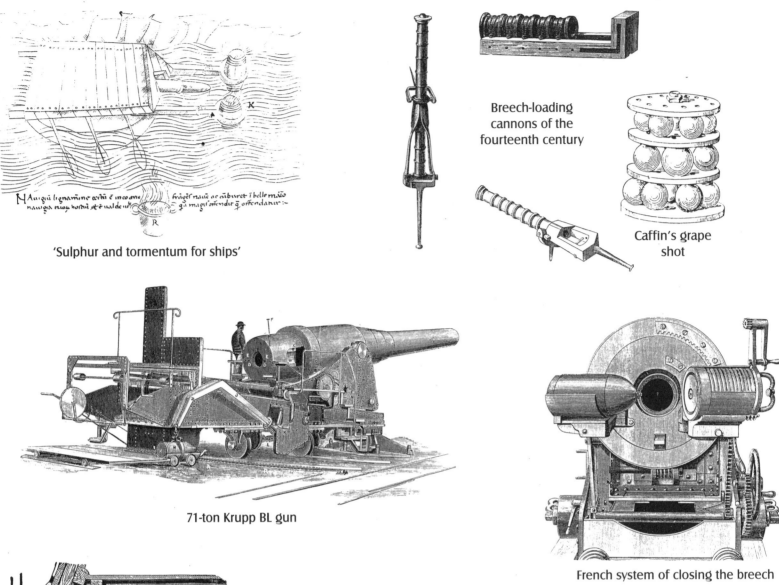

'Sulphur and tormentum for ships'

Breech-loading cannons of the fourteenth century

Caffin's grape shot

71-ton Krupp BL gun

French system of closing the breech

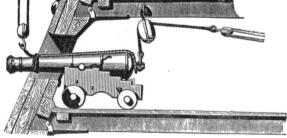

Getting the guns in or out through the port

With advances in iron and steel came even more improved means of manufacturing guns, which finally allowed the bridge loading principle to re-emerge after four centuries. The rapid advance in gun manufacture produced weapons which were much more destructive and so huge that they could no longer be handled by muscle power alone.

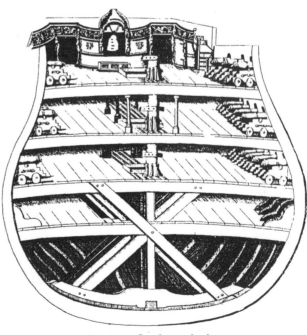

Section of a three-decker

Original armament of ironclads

Bellerophon's armament

Hercules' armament

Monarch's armament

Thunderer's armament

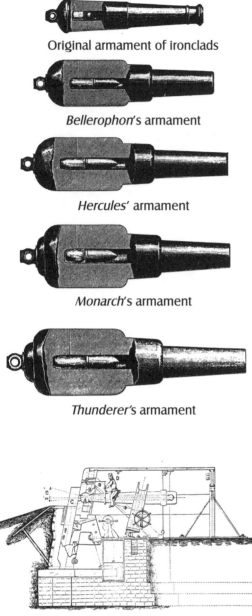

Krupp's Muzzle-pivoted gun

French 72-ton gun

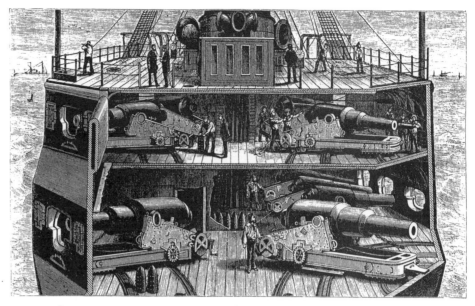

Batteries of *Alexandria*

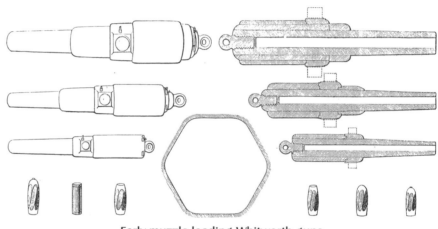

Early muzzle-loading Whitworth guns

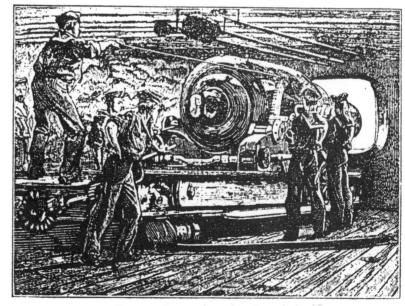

Gun practice on board an ironclad

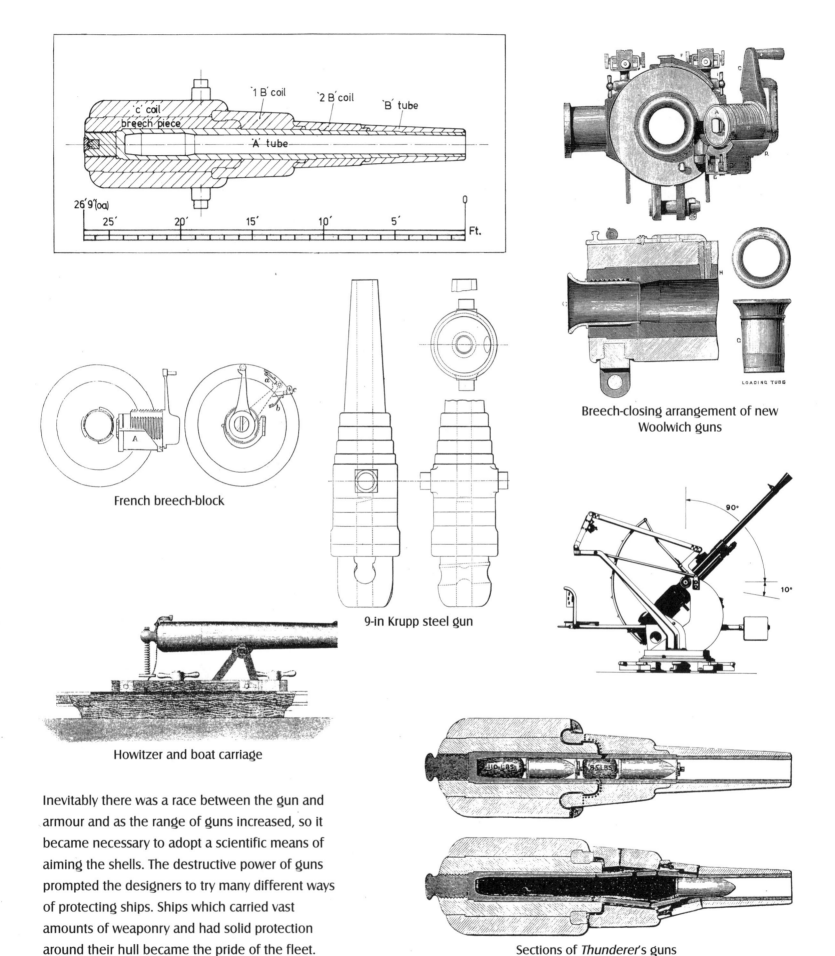

'c' coil
breech piece
'1 B' coil
'2 B' coil
'B' tube
'A' tube

26'9"(oa)

25' 20' 15' 10' 5' Ft.

French breech-block

9-in Krupp steel gun

Howitzer and boat carriage

Breech-closing arrangement of new
Woolwich guns

LOADING TUBE

90°

10°

Sections of *Thunderer*'s guns

Inevitably there was a race between the gun and armour and as the range of guns increased, so it became necessary to adopt a scientific means of aiming the shells. The destructive power of guns prompted the designers to try many different ways of protecting ships. Ships which carried vast amounts of weaponry and had solid protection around their hull became the pride of the fleet.

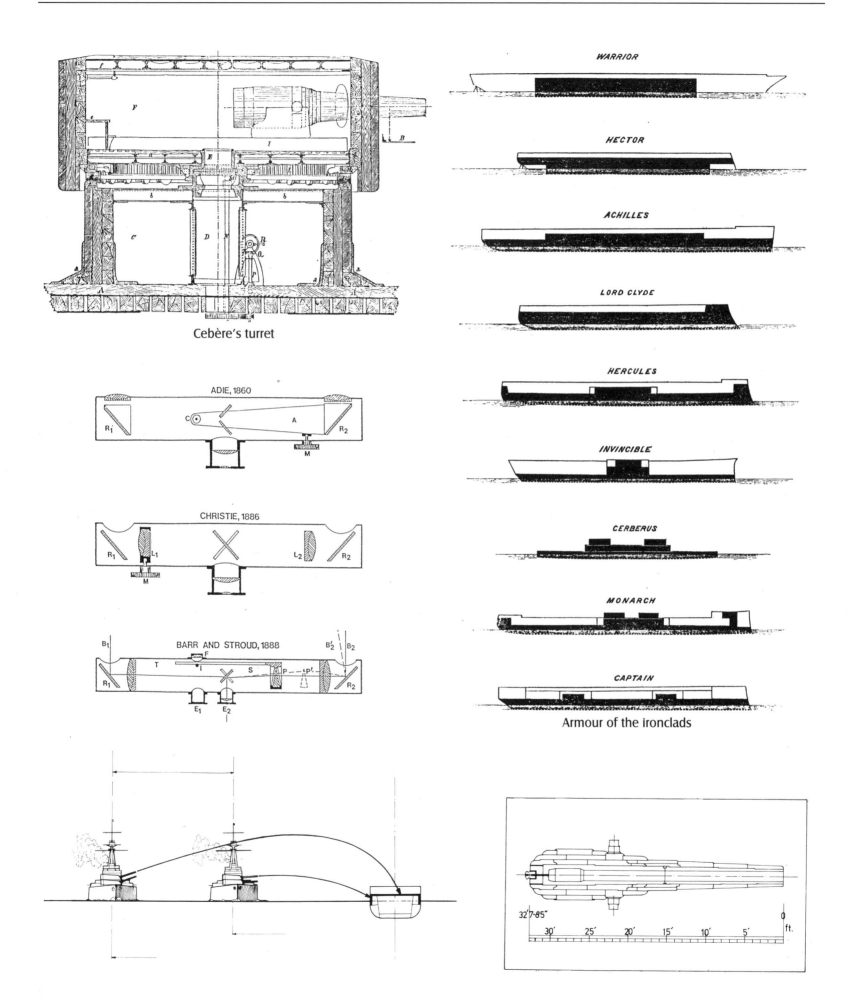

Cebère's turret

ADIE, 1860

CHRISTIE, 1886

BARR AND STROUD, 1888

WARRIOR

HECTOR

ACHILLES

LORD CLYDE

HERCULES

INVINCIBLE

CERBERUS

MONARCH

CAPTAIN

Armour of the ironclads

32'7·85"

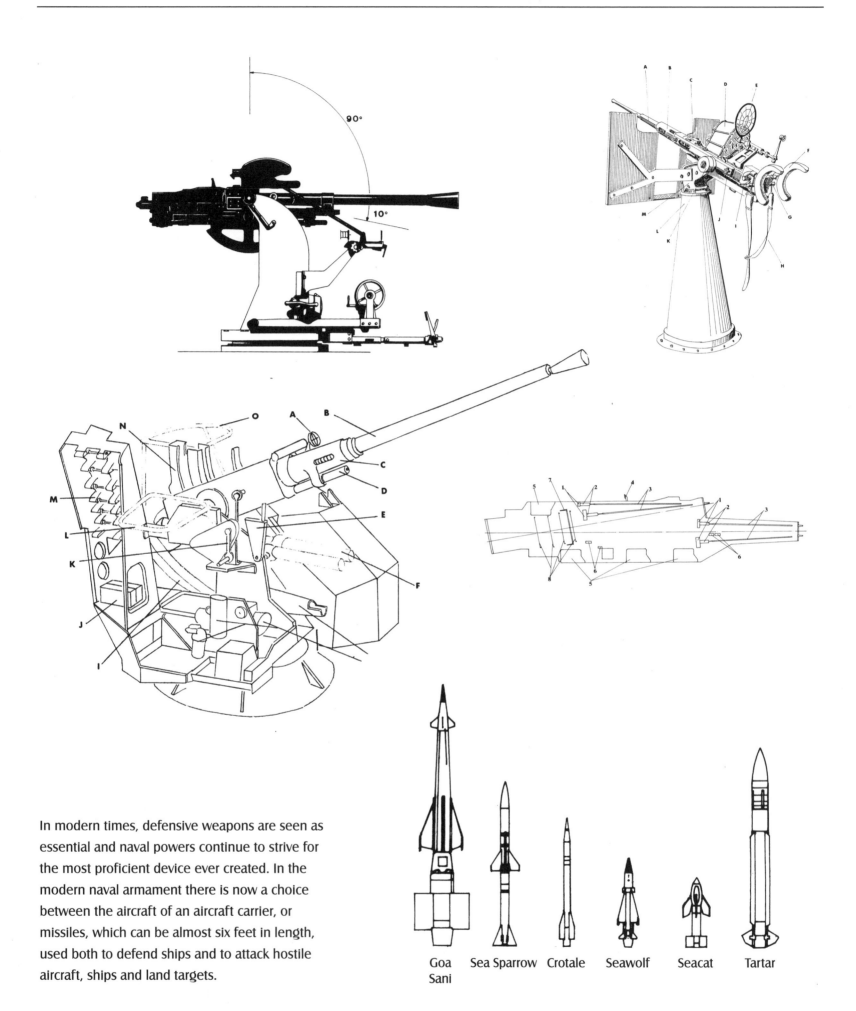

90°

10°

O A B

N

C

M D

L E

K F

J

I

In modern times, defensive weapons are seen as essential and naval powers continue to strive for the most proficient device ever created. In the modern naval armament there is now a choice between the aircraft of an aircraft carrier, or missiles, which can be almost six feet in length, used both to defend ships and to attack hostile aircraft, ships and land targets.

Goa
Sani

Sea Sparrow

Crotale

Seawolf

Seacat

Tartar

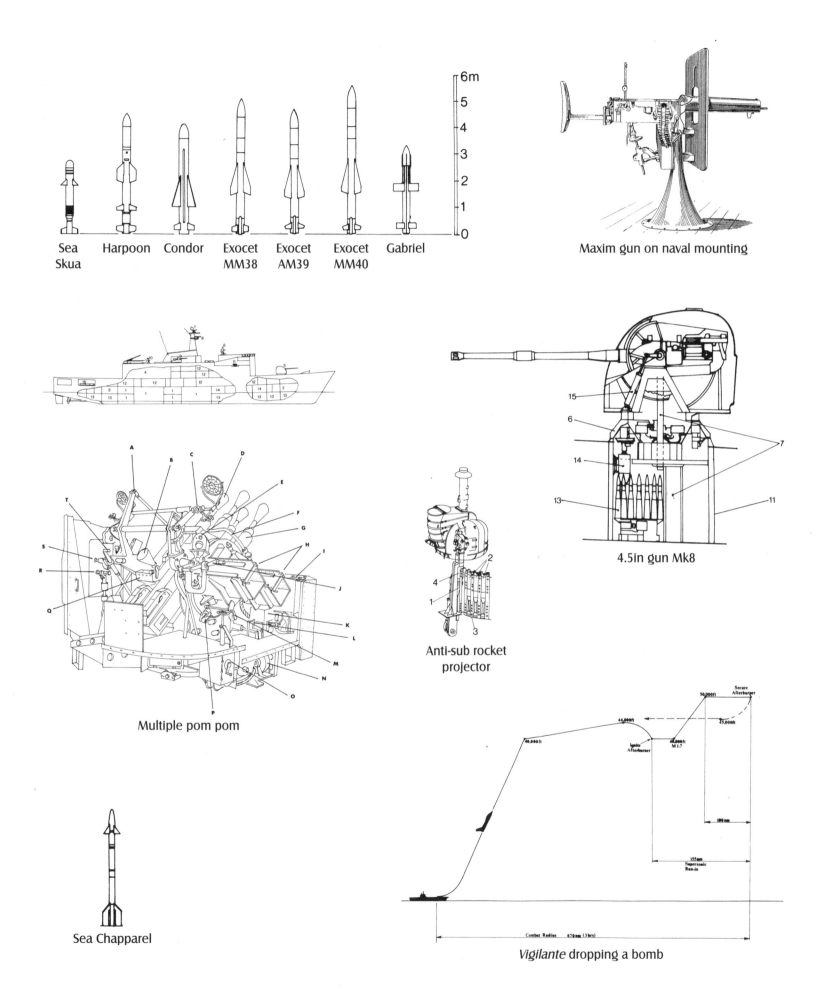

Sea Skua

Harpoon

Condor

Exocet MM38

Exocet AM39

Exocet MM40

Gabriel

Maxim gun on naval mounting

Multiple pom pom

Anti-sub rocket projector

4.5in gun Mk8

Sea Chapparel

Vigilante dropping a bomb

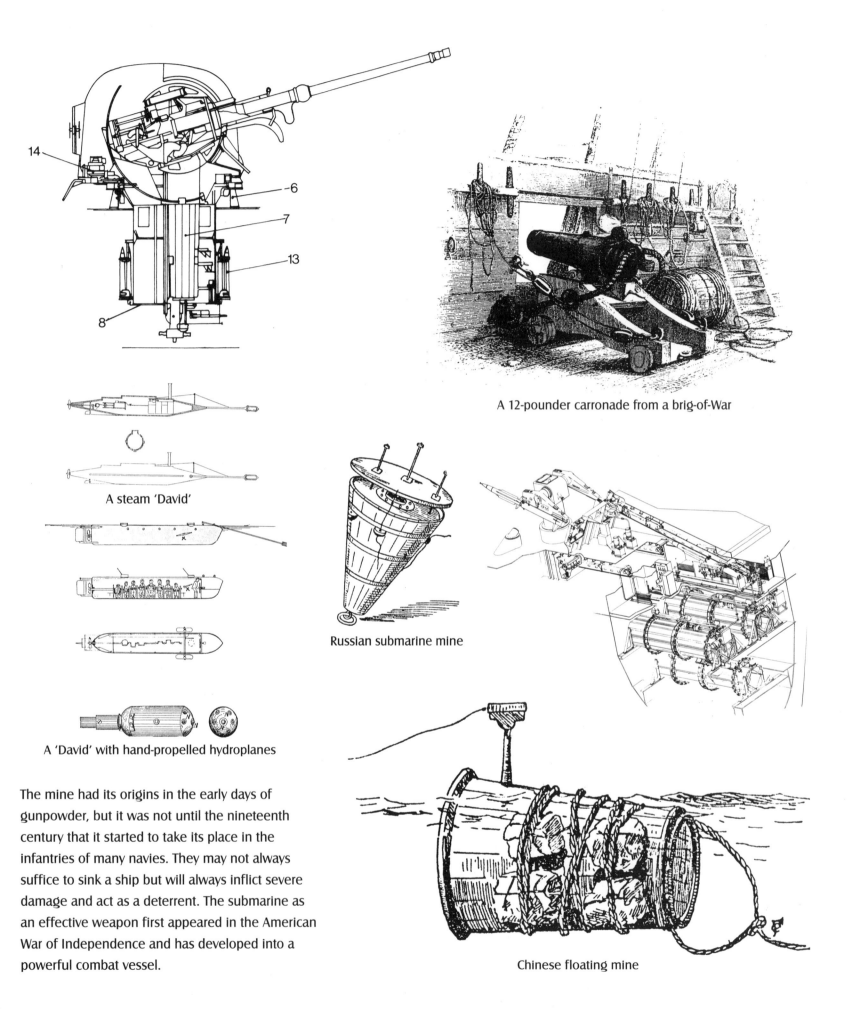

14

6

7

13

8

A 12-pounder carronade from a brig-of-War

A steam 'David'

A 'David' with hand-propelled hydroplanes

Russian submarine mine

Chinese floating mine

The mine had its origins in the early days of gunpowder, but it was not until the nineteenth century that it started to take its place in the infantries of many navies. They may not always suffice to sink a ship but will always inflict severe damage and act as a deterrent. The submarine as an effective weapon first appeared in the American War of Independence and has developed into a powerful combat vessel.

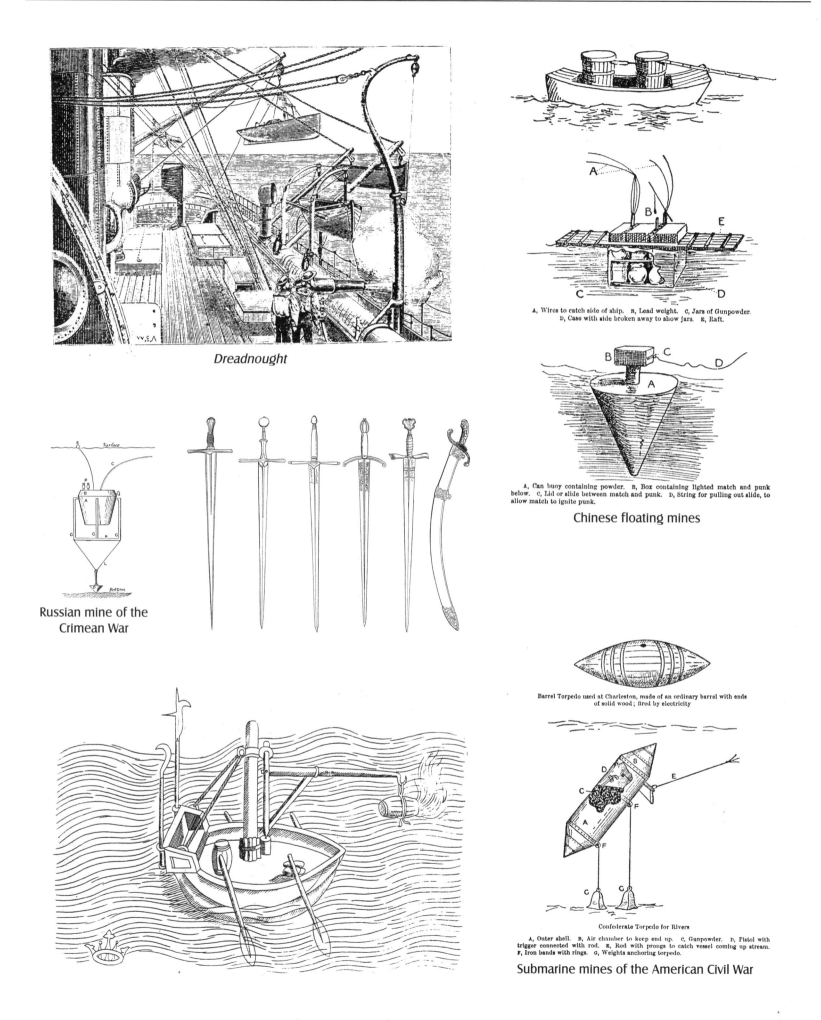

Dreadnought

A, Wires to catch side of ship. B, Lead weight. C, Jars of Gunpowder.
D, Case with side broken away to show jars. E, Raft.

A, Can buoy containing powder. B, Box containing lighted match and punk
below. C, Lid or slide between match and punk. D, String for pulling out slide, to
allow match to ignite punk.

Chinese floating mines

Russian mine of the Crimean War

Barrel Torpedo used at Charleston, made of an ordinary barrel with ends
of solid wood; fired by electricity

A, Outer shell. B, Air chamber to keep end up. C, Gunpowder. D, Pistol with
trigger connected with rod. E, Rod with prongs to catch vessel coming up stream.
F, Iron bands with rings. G, Weights anchoring torpedo.

Confederate Torpedo for Rivers

Submarine mines of the American Civil War

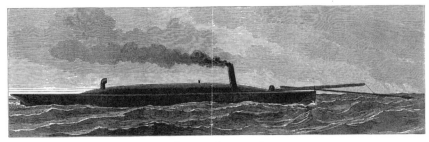

Steel torpedo vessel

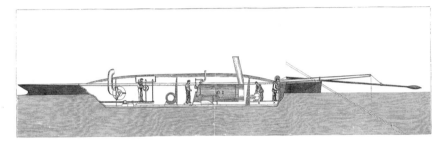

Section of steel torpedo vessel

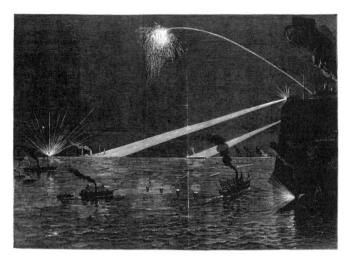

Torpedo warfare at Portsmouth

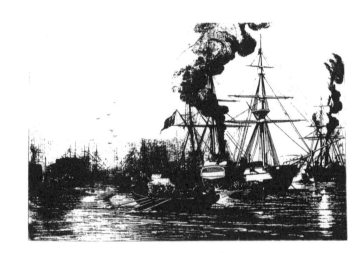

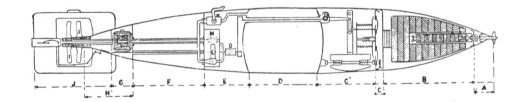

The torpedo has been probably the biggest single advance in anti-ship warfare in the last one hundred years. The Whitehead torpedo, the origins of which first appeared in 1867, was a great progression over the spar torpedo and other primitive weapons; from a relatively unsophisticated mobile underwater vehicle it developed into an accurate and deadly weapon by the end of the nineteenth century.

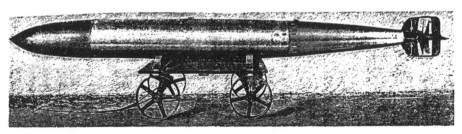

Whitehead torpedo

Torpedo warfare at sea

OCT. 2, 1885.] [SUPPLEMENT] ENGINEERING. XXXVII

F. SCHICHAU, Engineer & Shipbuilder, ELBING-PRUSSIA.

6
Boats Built to this, 1884;
39
BOATS TO THIS NOW BUILDING.
DISPLACEMENT 85 TONS.

ECONOMICAL TRIPLE EXPANSION ENGINES.

BUNKER CAPACITY
for a DISTANCE of
3,500 KNOTS
on a Speed of 10 Knots per hour.

ZIESE'S PATENT VENTILATION AND FIRING APPARATUS.

SEA-GOING TORPEDO BOATS FOR THE IMPERIAL GERMAN GOVERNMENT,
Mean Speed on the Measured Mile 21.7 knots, and on a run of 5h. 26m. covering a distance of 115 knots, carrying a load of 12.5 tons.

Argentinean torpedo steam launch

127

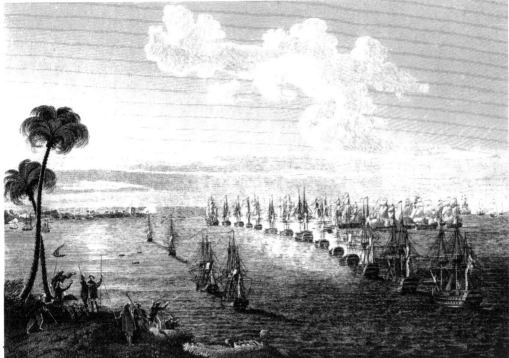

The Battle of the Nile, 1798

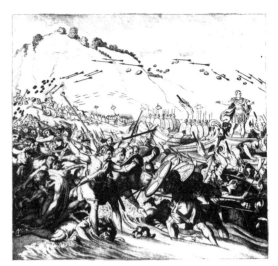

The landing of Caesar in England

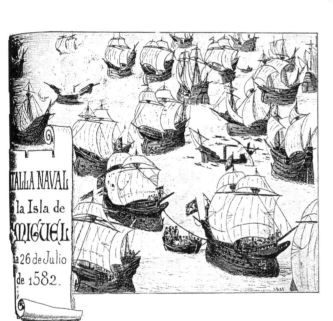

Medieval war vessel

As naval warfare progressed from the mêlées of ancient times we became more disciplined but infinitely more destructive. The Battle of the Nile became the first major victory in the career of Horatio Nelson, then a junior rear admiral. His commendable leadership of the British forces against Napoleon's French fleet, who were aiming to further their Eastern conquests by attacking Egypt, resulted in immediate promotion.

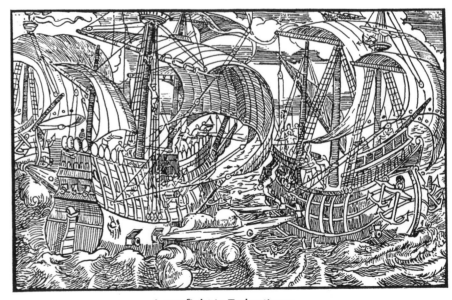

A sea fight in Tudor times

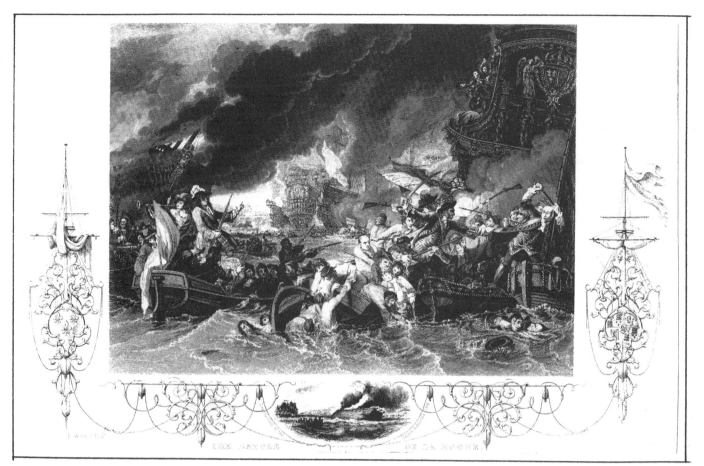

The Battle of La Hogue, 1692

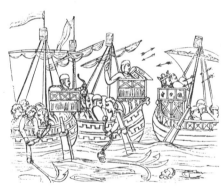

Combat in the Middle Ages

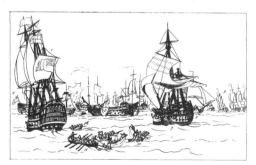

Sea battle of the 1790s

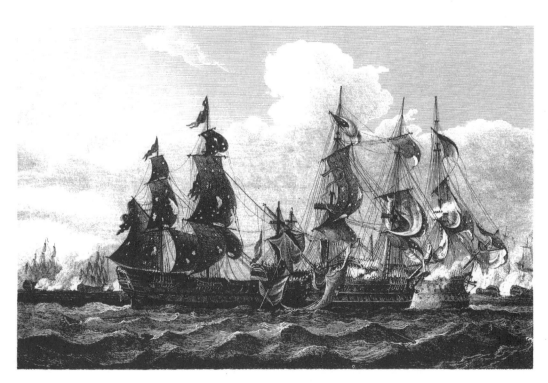

Warfare in the Nelsonic period

Sixteenth-century ship chasing a galley

Boarding the enemy vessel

Although sails were necessary to harness wind power on large ships until the eighteenth century, the oared galley proved superior in areas such as the coastal waters of the Mediterranean and Caribbean, where sailing ships were frequently becalmed and therefore unable to stay underway. The galley offered supreme manoeuvrability in battle, and by the sixteenth century the weaponry had increased, with the ram supplemented by guns mounted on platforms in the bow of the ship. The Battle of Lepanto was the last naval action in which galleys played a prominent role.

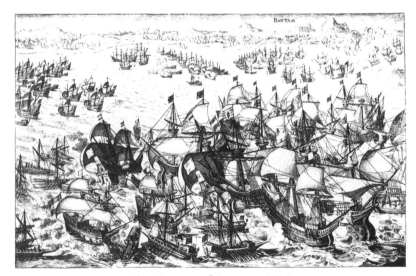

The Capture of Bantam, 1684

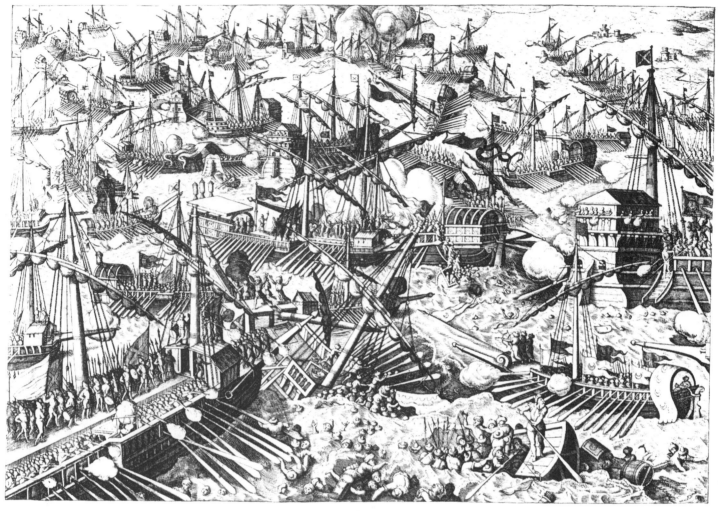

The Battle of Lepanto, 1571

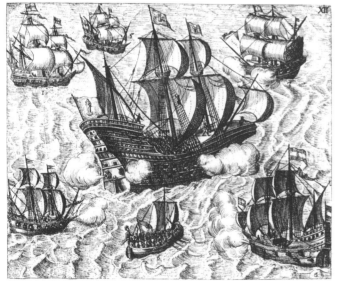

Portuguese ship captured in the Straits of Magellan, 1602

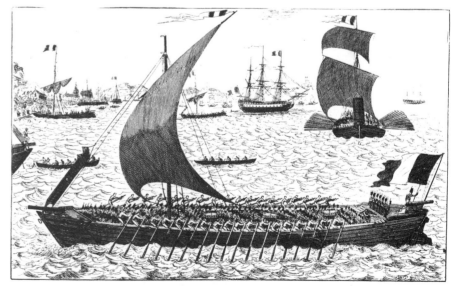

Boulogne flotilla preparing to invade England

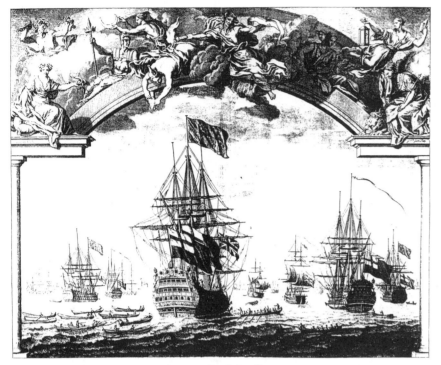

The revolt of the fleet

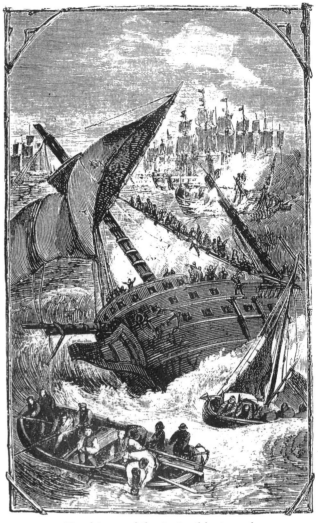

Fireships and the invincible Armada

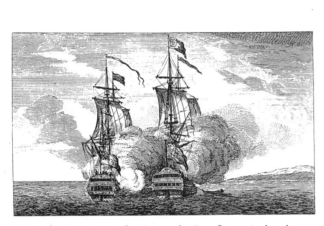

Drake engaging the Spanish *Cacafuego* in battle

The infamous Spanish Armada, assembled by Philip II, sailed alongside the army of the Prince of Palma to invade England in 1588. Sighted off the Lizard on 19 July, the Armada was met by an expectant English force and the battle commenced almost immediately. After six days of intermittent fighting, the English fleet gained the upper hand with the use of fireships, resulting in a final battle off Gravelines and a Spanish retreat.

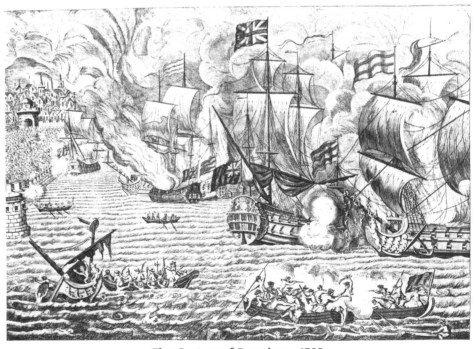

The Capture of Barcelona, 1705

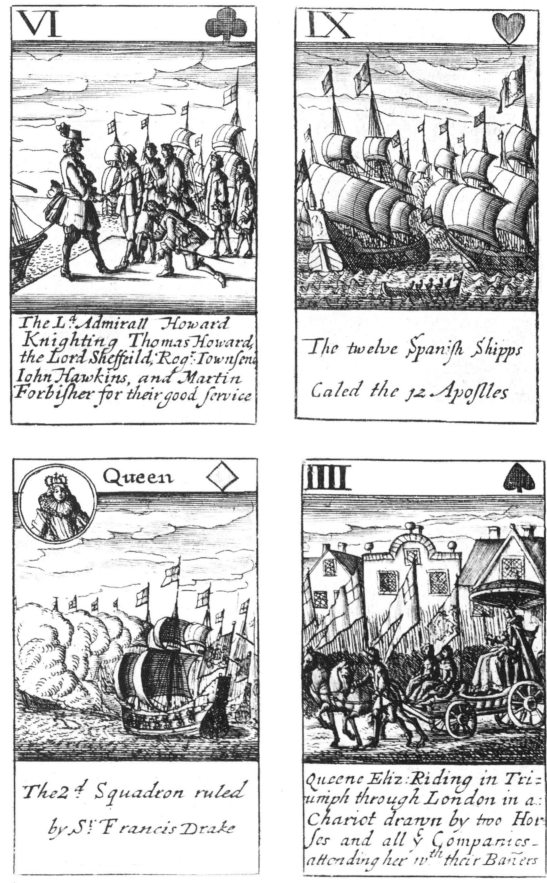

Armada playing cards, dated 1680

Action between *Centurion* and a Spanish galleon

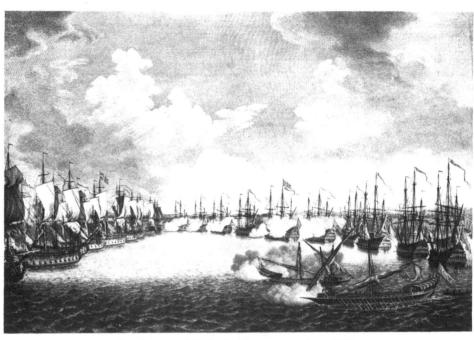

Russians and Turks in Chesmeme Bay, 1770

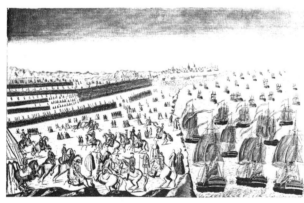

Lord Cornwallis surrenders at Yorktown, 1781

During the eighteenth century sea power rose to new heights, becoming an instrument of national policy. Maritime nations attacked territories for commercial gain, to assume control of essential sea passages, and to deprive enemies of similar economic advantage. The Battle of Lissa in the following century, between the Italians and Austrians, was unusual as it was the first encounter between armoured ships and the first employment of ramming techniques.

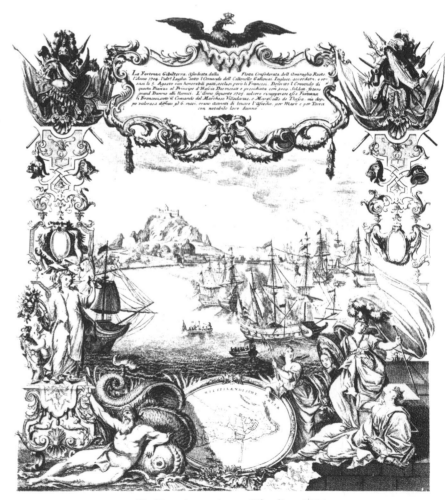

Sir George captures Gibraltar, 1704

Battle between the maritime
powers Britain and France

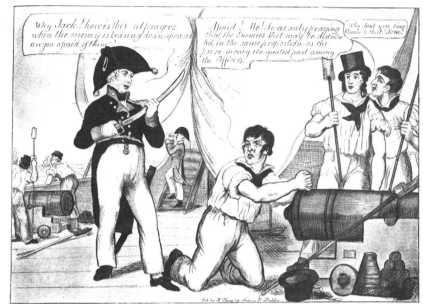

Contemporary caricature of the Battle of Trafalgar

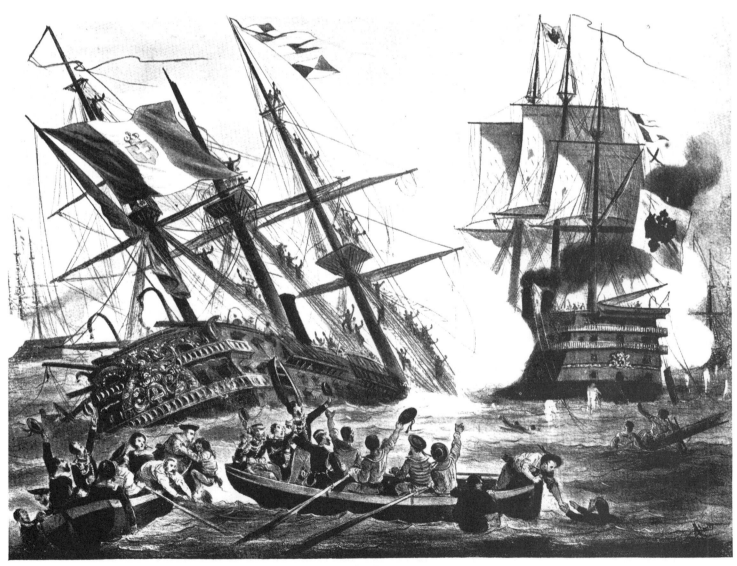

The Battle of Lissa, 1866

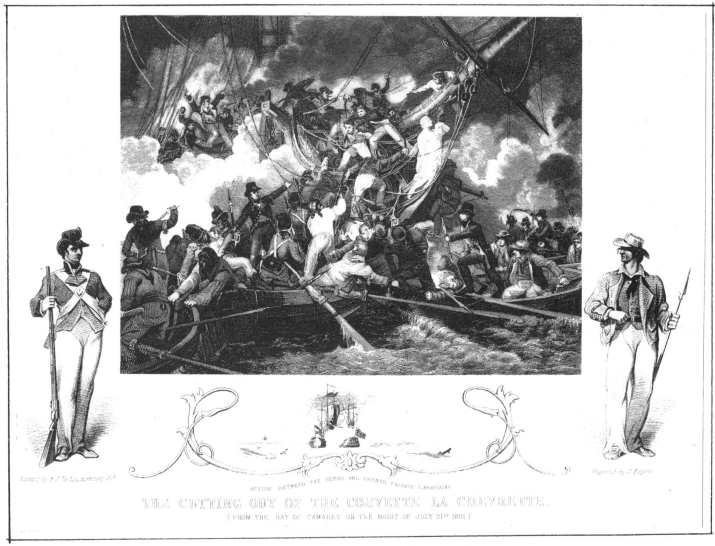

ACTION BETWEEN THE PHŒBE AND FRENCH FRIGATE L'AFRICAINE

THE CUTTING OUT OF THE CORVETTE LA CHEVRETTE

(FROM THE BAY OF CAMARET ON THE NIGHT OF JULY 21ST 1801)

Action between *Phoebe* and the French frigate *L'Africaine*, 1801

During the time of sustained fighting in Europe, from the seventeenth to the nineteenth centuries, fierce battles raged between the major maritime powers. Much of the most severe action took place between the mightiest nations, Britain and France. France, under the 'Sun King' Louis XIV, was initially the stronger but Britain eventually became an invincible force. Brest became a major French seaport and naval base, after being recognised as a suitable site by Richlieu in the early seventeenth century, and battles were fought in the harbour for centuries in an attempt to diminish French naval power. In World War II, Brest was occupied by the German navy and suffered heavy damage from British bombers.

Action in Brest Harbour

Chapter 5

Sea-farers

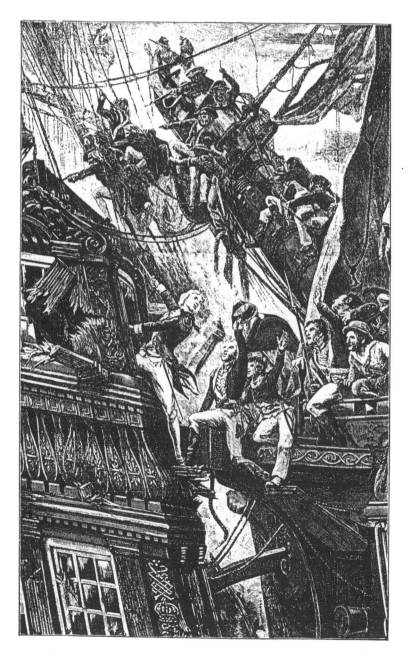

Stories of desperate dangers and incredible exploits on the high seas by the commanders of the day, led to the creation of larger-than-life heroes and villains: great captains who shaped the destiny of nations; explorers who opened up vast tracts of the world to new influences; and pirates who with cunning or violence seized vast treasures from merchant vessels. To maritime nations, their naval heroes were often treasured icons to be richly rewarded. But the distinction between villain and hero was often a matter of national perspective. Privateers, who were commissioned by letters of marque to seize vessels and properties of a hostile nation, were often seen as licensed pirates or buccaneers who took advantage of their commission to gain personal riches. To the Spanish, Drake was a ruthless pirate, but to his home country he was a legend to be revered. Sir Henry Morgan, although holding a commission, was also seen as a vengeful corsair through his exploits on the Spanish Main.

Some of the most celebrated figures in maritime history are the royal and political leaders who built and patronised great fleets: Peter the Great founded the Russian Navy, one of the greatest the world has known; and Prince Henry of Portugal, known as the Navigator, inspired the discovery and opening of new trade routes to Africa and India.

But the real story of the sea belongs to the ordinary seamen who travelled with the great heroes on perilous journeys in indescribable conditions. Lured by adventure, or to escape dire poverty, most were rewarded by death from drowning or disease, or by destitution in old age. Not until the eighteenth century did these unknown sailors begin to appear in popular art, acknowledged for their role in naval and mercantile development. The crews, the 'hearts of oak' who fought in the battles, explored the new lands, and worked the trade routes, became recognised as playing their part, alongside the great commanders, in shaping the modern world.

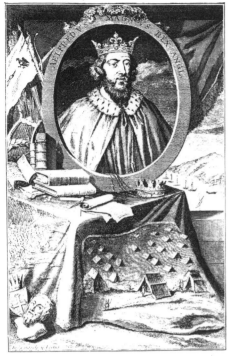

King Alfred the Great

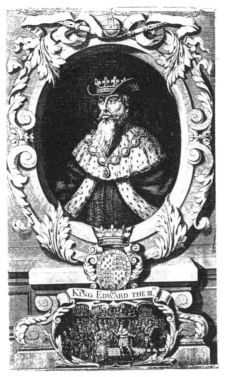

King Edward III

The Cabot Family

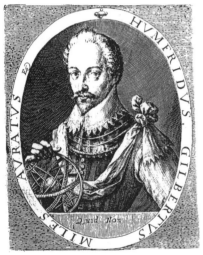

Sir Humphrey Gilbert

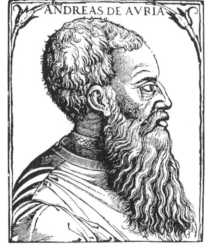

Andrea Doria

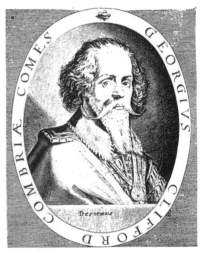

The Earl of Cumberland

Some of the most famous maritime figures were not regular seamen: Alfred the Great is often credited with establishing the English Navy; and the enthusiasm shown by Henry the Navigator for ocean expeditions continued to inspire his countrymen long after his death. There were, of couse, daring explorers, including Drake, Frobisher and the Cabots, and distinguished naval officers, such as Andrea Doria, Michiel de Ruyter and Admiral Blake, who laid the foundations for modern seamanship.

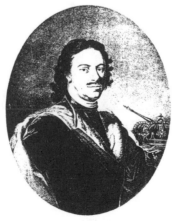

Alexander I of Russia

Admiral Blake

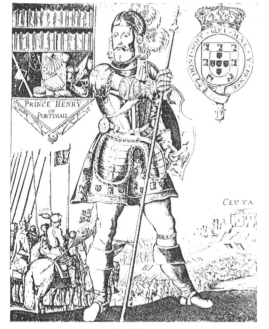

Prince Henry the Navigator

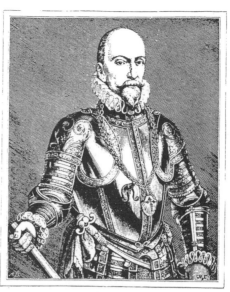

Sir John Hawkins

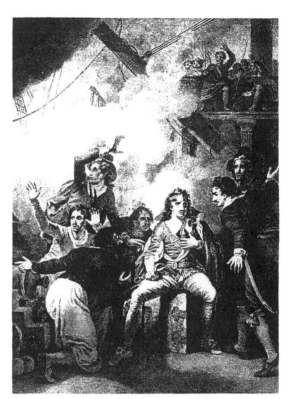

Earl Sandwich at Sole Bay

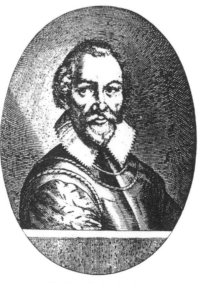

Sir Walter Raleigh

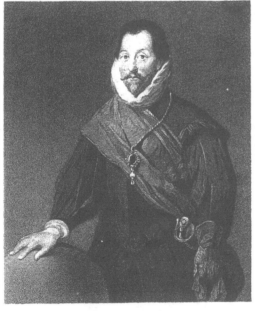

Sir Francis Drake

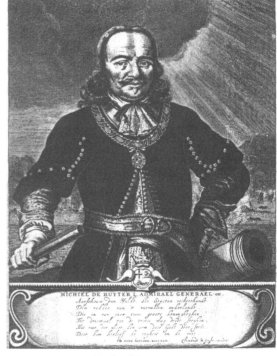

Michiel De Ruyter

Sir Martin Frobisher

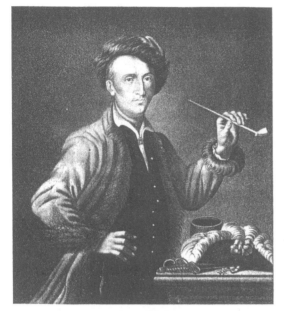

Jean Bart

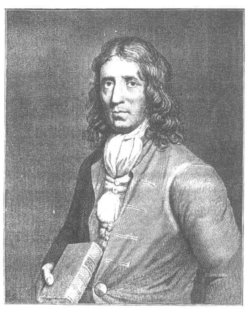

Captain William Dampier

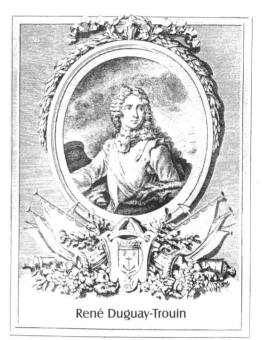

René Duguay-Trouin

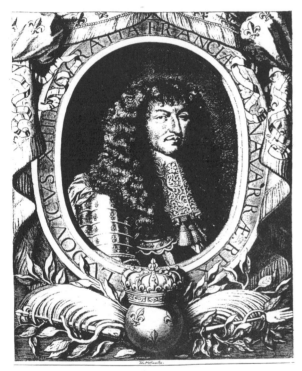

Louis XIV

Captain Anson

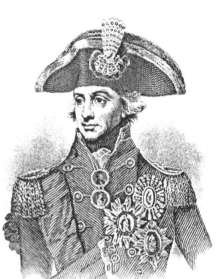

Admiral the Lord Nelson

In the period of sustained warfare in Europe from the seventeenth to the nineteenth centuries, France and Britain both displayed outstanding skill at sea through the activities of their most successful commanders; the French found heroes in Captain Jean Bart and Vice-Admiral Duguay-Trouin, with Captain Anson, Admiral Saunders and, of course, Lord Nelson becoming legends in Britain.

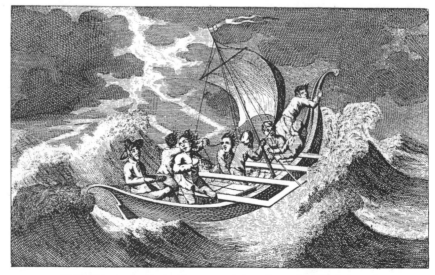

'Dampier and companions overtaken by a dreadful storm'

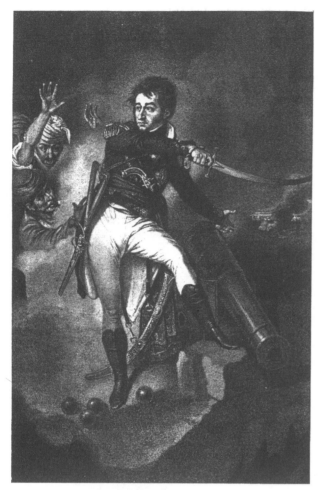

Sir William Sydney Smith

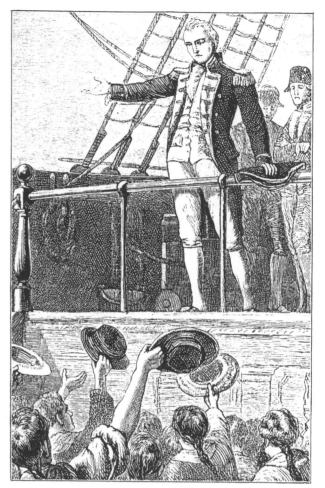

Admiral Duncan addressing his crew

Abraham Duquesne

Pero Menendez de Avillés

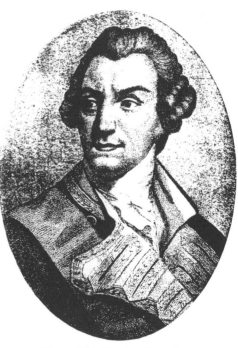

Admiral Sir Charles Saunders

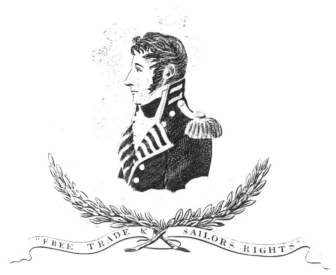

Commander Decatur

Mary Anne Talbot

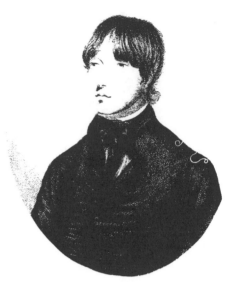

Mary Anne Talbot as a male sailor

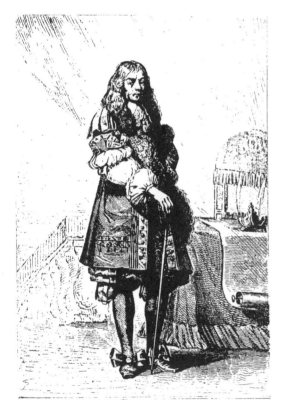

Vice-Admiral Villeneuve

Captain William Bligh

The promise of fame and fortune attracted many ambitious men to a life on the oceans. Women, too, sought commissions at sea by dressing and acting as men, including Mary Ann Talbot, who had a long naval career. Failure at sea, however, could be cruelly punished. In 1757, Admiral Byng was executed for failing in battle, and in 1806 the French Vice-Admiral Villeneuve killed himself rather than face the shame of having been taken prisoner at Trafalgar.

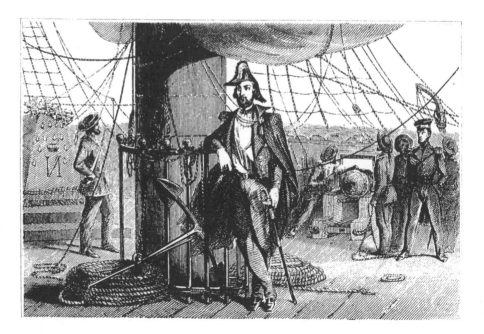

The Count de Grasse

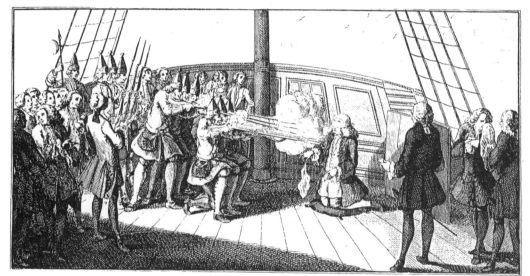

The shooting of Admiral Byng

Admiral Sir William Cornwallis GCB

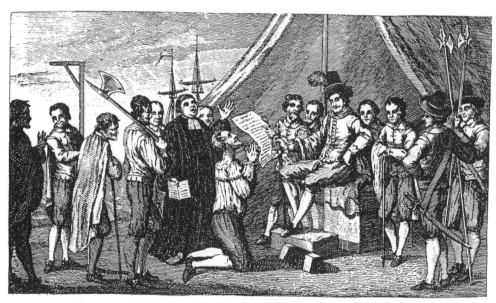

The Beheading of Captain Doughty by Drake

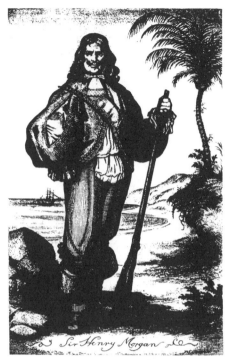
Sir Henry Morgan

Alff and the female pirates Alwilda and Rusila

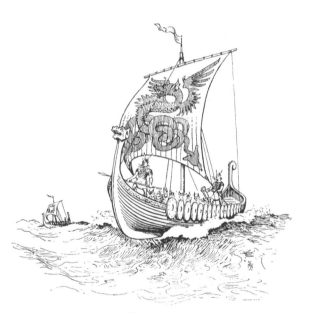
North Sea Pirates

Alwilda

Bartholomeus de Portugees

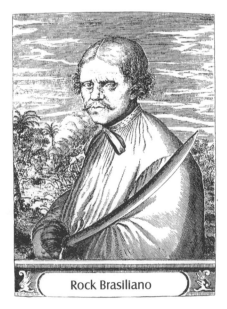
Rock Brasiliano

Captain Edward England

Piracy was at its height in the late seventeeth and early eighteenth centuries with a number of bloodthirsty men and women taking control of the seas, including the dreaded Blackbeard, Mary Read, Anne Bonny, and Lolonois, who was said to have ripped out and eaten his victims' hearts. If caught, pirates were often hanged along the coastline as a warning to others. In England, they were staked to the ground by the Thames in London, and drowned by the rising tide.

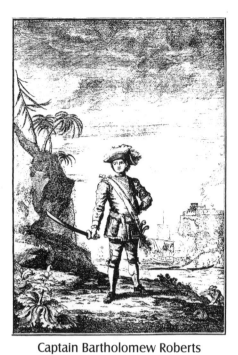

Captain Bartholomew Roberts

Anne Mills

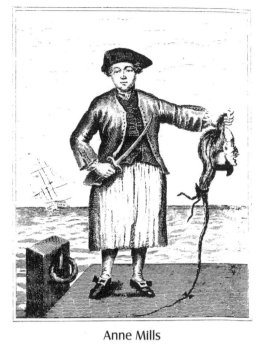

Captain George Lowther

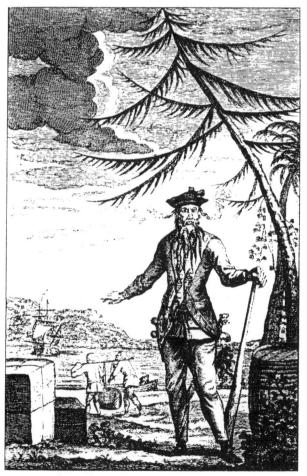

Captain Edward Teach (Blackbeard)

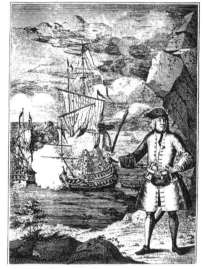

Captain Avery

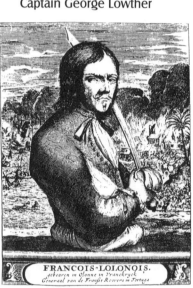

François Lolonois

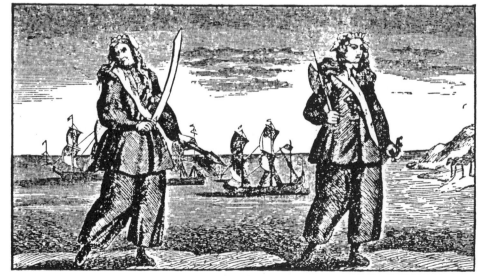

Mary Read and Ann Bonny

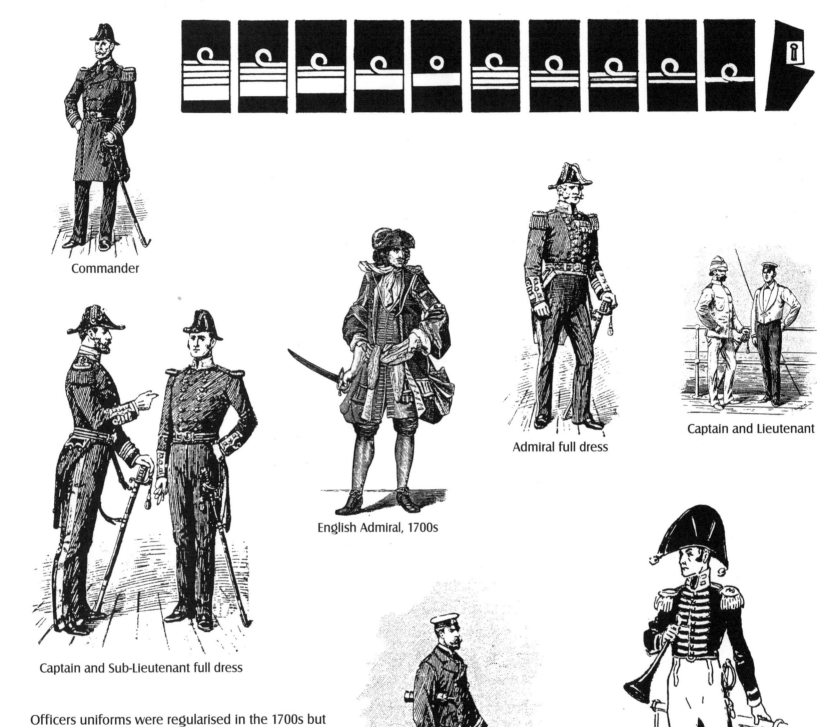

Commander

Captain and Sub-Lieutenant full dress

English Admiral, 1700s

Admiral full dress

Captain and Lieutenant

Lieutenant summer undress

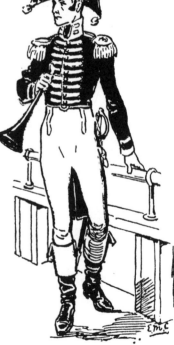

French Naval Captain, 1805

Officers uniforms were regularised in the 1700s but contemporary artworks depict the variety of clothing adopted by both naval and mercantile seamen who did not receive a uniform until the following century. As navies became more organised in the mid-nineteenth century, badges of rank became more widespread, denoting seniority and special skills. With cap badges, insignia and decoration, it is possible for seamen to easily identify each other by ship, post and rank.

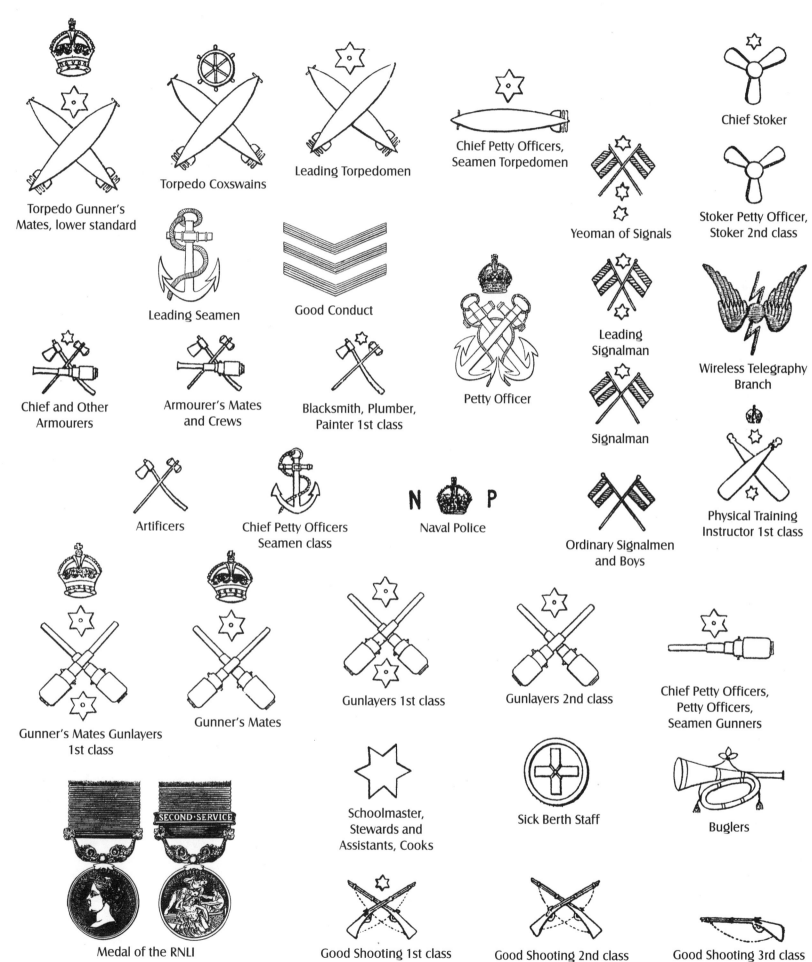

Torpedo Gunner's Mates, lower standard

Torpedo Coxswains

Leading Torpedomen

Chief Petty Officers, Seamen Torpedomen

Chief Stoker

Yeoman of Signals

Stoker Petty Officer, Stoker 2nd class

Leading Seamen

Good Conduct

Leading Signalman

Wireless Telegraphy Branch

Chief and Other Armourers

Armourer's Mates and Crews

Blacksmith, Plumber, Painter 1st class

Petty Officer

Signalman

Artificers

Chief Petty Officers Seamen class

N P Naval Police

Ordinary Signalmen and Boys

Physical Training Instructor 1st class

Gunner's Mates Gunlayers 1st class

Gunner's Mates

Gunlayers 1st class

Gunlayers 2nd class

Chief Petty Officers, Petty Officers, Seamen Gunners

Medal of the RNLI

SECOND·SERVICE

Schoolmaster, Stewards and Assistants, Cooks

Sick Berth Staff

Buglers

Good Shooting 1st class

Good Shooting 2nd class

Good Shooting 3rd class

Lieutenants frockcoats

Spanish Naval
Captain, 1805

Master Mariner, 1740

Officers of the East India Company

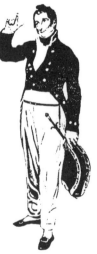

Seafarers have traditionally been a race apart, hardy men enured to a life of hardship and discomfort at sea, and possessing skills totally beyond the ken of landsmen. Before the nineteenth century, however, it was the hard life ashore that attracted mariners to the sea, although there were still times when members of the crew tried to leave a ship when visiting at port. In these cases, the crew 'shanghaid', or kidnapped, the offending sailors or, indeed, any unsuspecting man of the town.

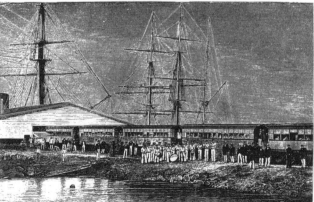

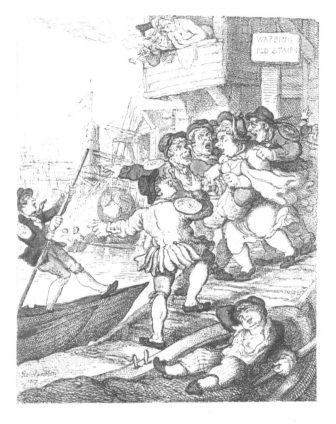

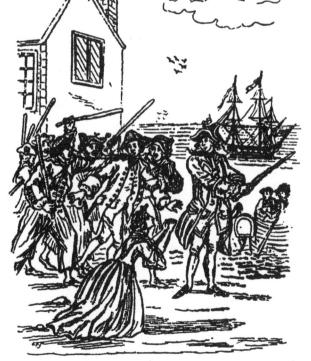

A crew member being shanghaid

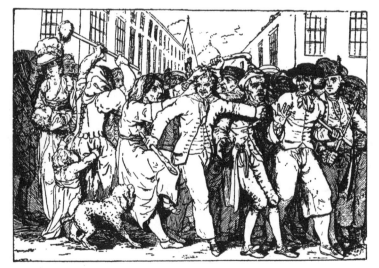

Saved from the press gang

Tall tales on high seas

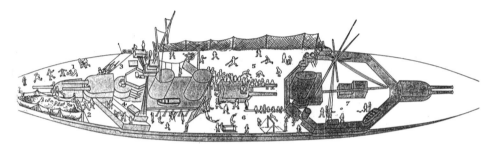

Recreation at sea in the twentieth century

In all nations, the sea-faring community developed its own language and customs, some of which are now internationally used. Crossing the Line, a ceremony thought to have its origins in Pagan rites and which continues to this day, takes place whenever a ship crosses the equator. Members of the crew dress as Neptune, Amphritrite and their attendants, and those on board who have not previously crossed the equator are presented to them for initiation and certification.

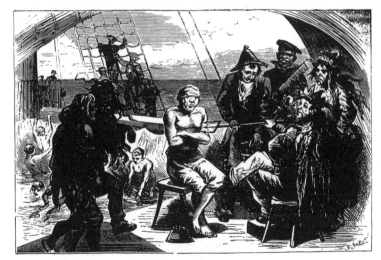

Crossing the Line

Navigation and Seamanship

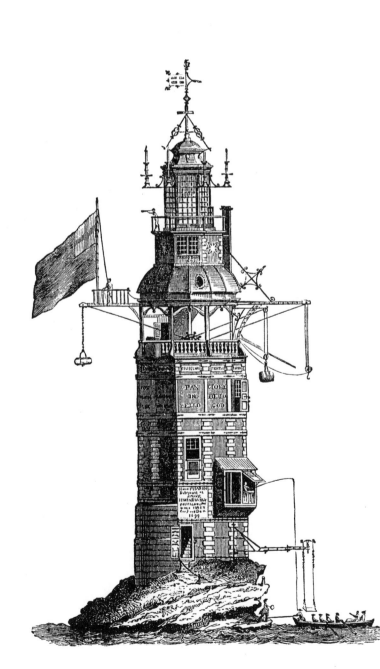

In the era of discovery, accurate navigation was essential for safe passages across the oceans and correctly recording the sites of new lands. Lighthouses and lightships on the more treacherous stretches of coastline and reefs were a crucial step forward in safety at sea. Navigational aids were also constantly being developed to make use of Mercator's projections of latitude and longitude. In the early years of the sixteenth century the cross-staff became adapted for use on ships alongside Davis's quadrant, or backstaff. Despite the arrival of the more accurate Hadley's quadrant, it was still impossible for navigators to calculate longitude, and in 1714 a Board of Longitude was created to support inventions for this purpose. Harrison's chronometers, given trials during 1762 and 1764, were the prize innovation for the Board. Although a simple idea the chronometer is still faithfully serving today alongside the twentieth-century developments of radio time signals and satellite receivers. With the advent of the sextant towards the end of the eighteenth century, and its subsequent evolution, and the development of beacons and buoys, navigation can now be conducted with extreme accuracy.

Efficiency of the crew, and confidence in their own and fellow sailors' competence, was essential when operating the complex ships and continually developing instruments. In war and in trade the sailors' ability to carry out instructions quickly and safely meant the difference between life and death, success and failure. This understood, the practices and skills necessary for success began to be taught by naval and nautical colleges. A complete system embracing the ship at sea and in port, seamanship is essentially a practical subject, taught through demonstrations on models or on board training ships. Students practice every aspect of the subject so that they are able to support one another and work together more efficiently. The study of seamanship is still as essential today for sailors intending to work on merchant vessels or in the Navy.

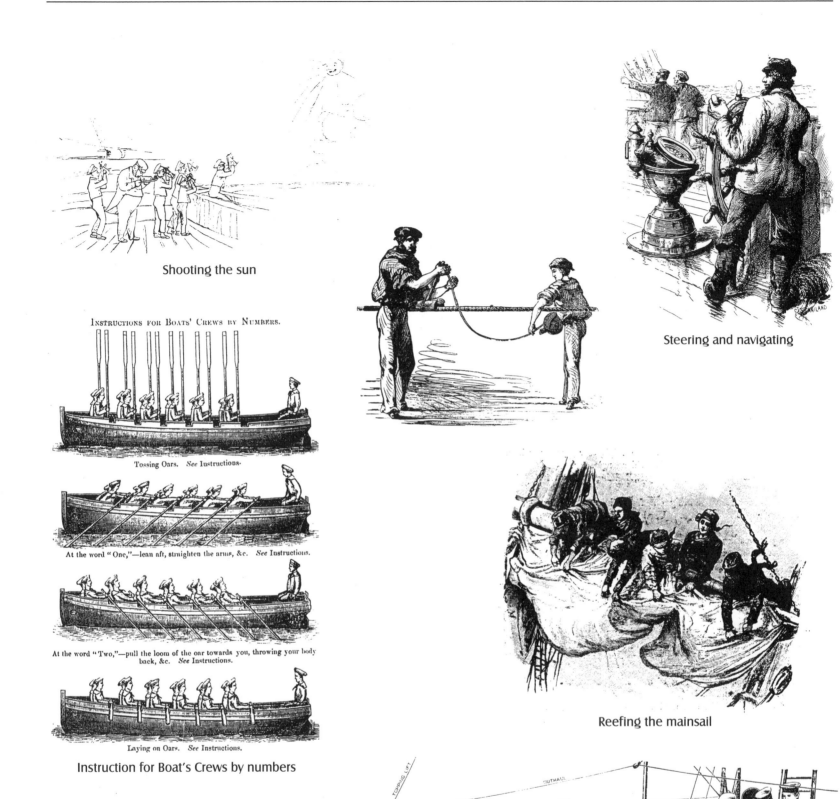

Shooting the sun

INSTRUCTIONS FOR BOATS' CREWS BY NUMBERS.

Tossing Oars. *See Instructions.*

At the word "One,"—lean aft, straighten the arms, &c. *See Instructions.*

At the word "Two,"—pull the loom of the oar towards you, throwing your body back, &c. *See Instructions.*

Laying on Oars. *See Instructions.*

Instruction for Boat's Crews by numbers

Steering and navigating

Reefing the mainsail

Sounding from the Fore Bridge

Seamanship students needed to become proficient in all aspects of the work they would be required to do whilst at sea and in harbour. Jobs such as reefing the mainsail and crossing or shifting the yards needed to be quickly done during a voyage, confidently and in silence. Learning how to take accurate readings with the navigational aids was also essential for a successful passage.

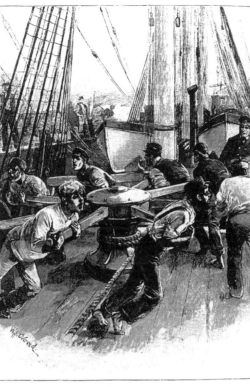

At the capstan

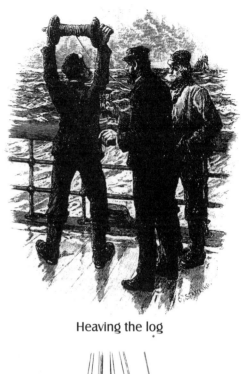

Heaving the log

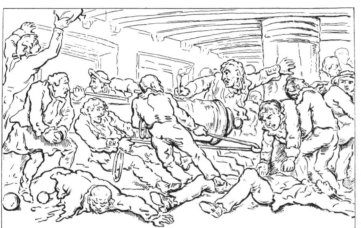

Seamanship in battle

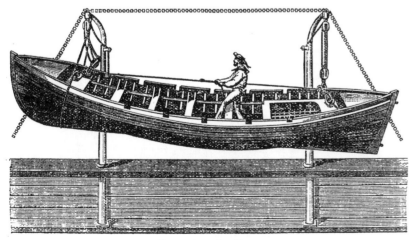

Fastening the lines

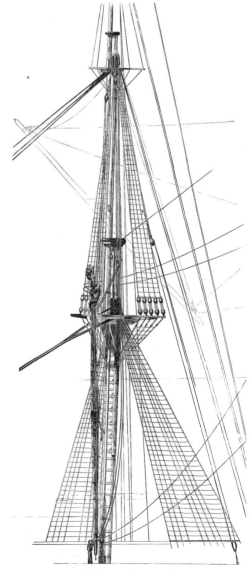

Shifting the yards

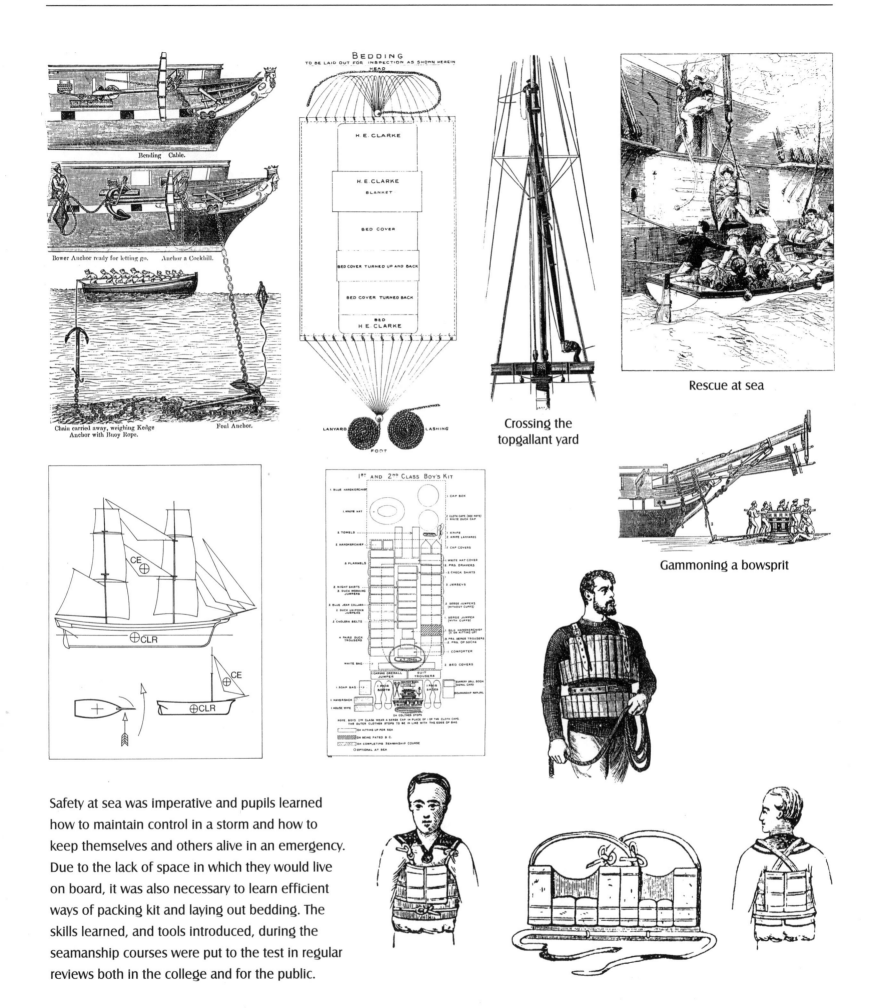

Bending Cable.

Bower Anchor ready for letting go. Anchor a Cockbill.

Chain carried away, weighing Kedge Anchor with Buoy Rope. Foul Anchor.

BEDDING
TO BE LAID OUT FOR INSPECTION AS SHOWN HEREIN

Crossing the topgallant yard

Rescue at sea

Gammoning a bowsprit

1ST AND 2ND CLASS BOY'S KIT

Safety at sea was imperative and pupils learned how to maintain control in a storm and how to keep themselves and others alive in an emergency. Due to the lack of space in which they would live on board, it was also necessary to learn efficient ways of packing kit and laying out bedding. The skills learned, and tools introduced, during the seamanship courses were put to the test in regular reviews both in the college and for the public.

Measuring distance at sea

Brading in a storm

Water on deck

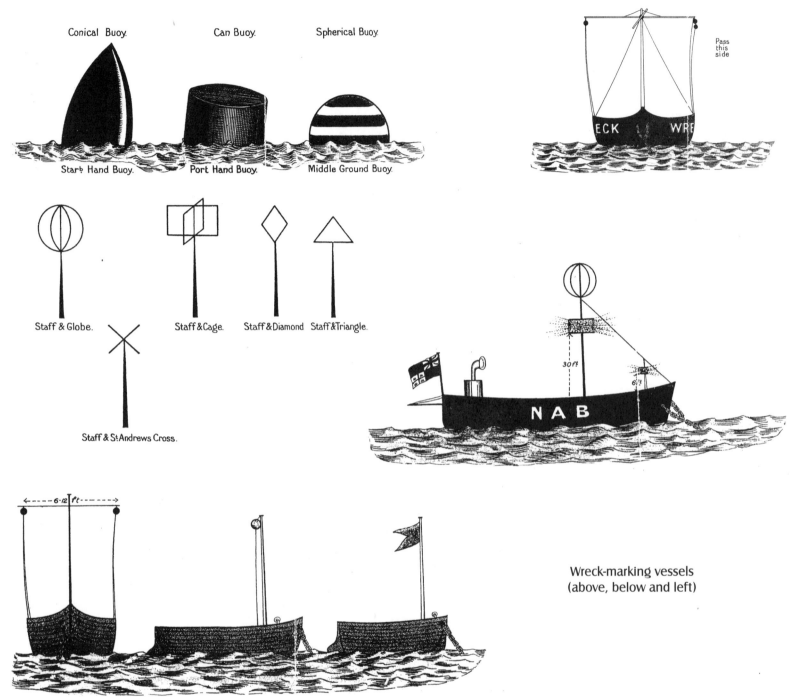

Conical Buoy. Can Buoy. Spherical Buoy.

Starb Hand Buoy. Port Hand Buoy. Middle Ground Buoy.

Pass this side

ECK WRE

Staff & Globe. Staff & Cage. Staff & Diamond Staff & Triangle.

Staff & St Andrews Cross.

NAB

30ft

6ft

Wreck-marking vessels
(above, below and left)

Buoys are used to mark the entrances to channels or ports and follow a distinctive colour system set by the Trinity House; those on the starboard side of an approaching vessel are single colour, and those on the port side are patterned. Beacons, individually designed, can be used to mark entrances but usually identify areas dangerous at low tide or in certain currents. Wreck-marking vessels distinguish hazardous sites.

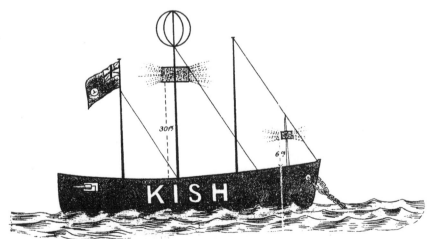

30ft

6ft

KISH

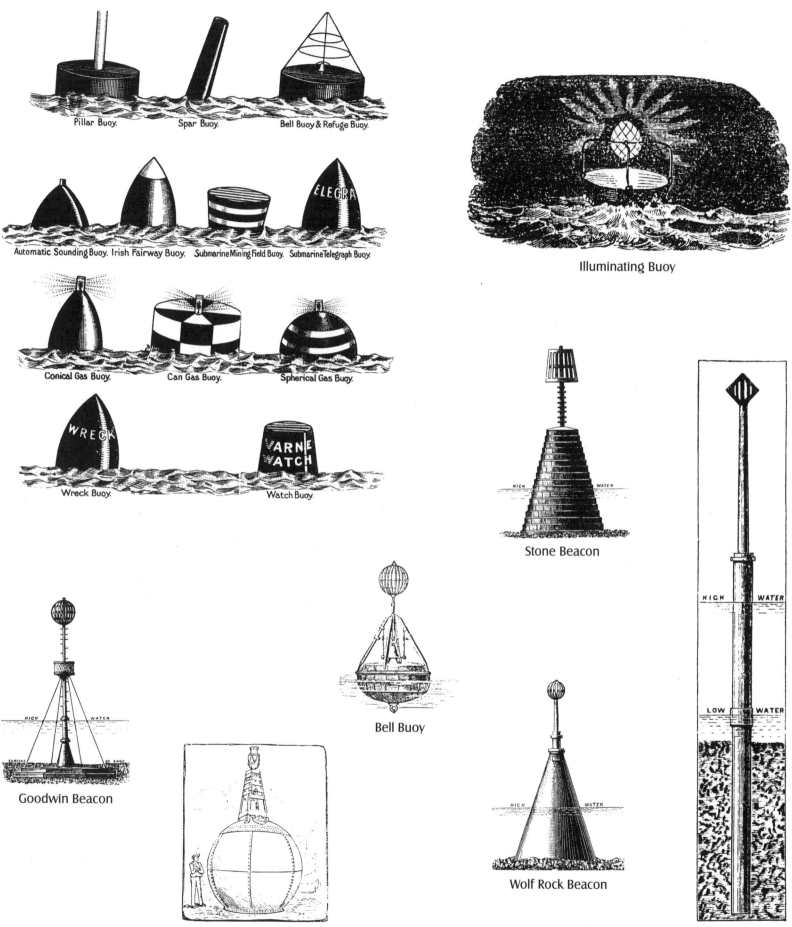

Pillar Buoy.

Spar Buoy.

Bell Buoy & Refuge Buoy.

Automatic Sounding Buoy. Irish Fairway Buoy. Submarine Mining Field Buoy. Submarine Telegraph Buoy.

Conical Gas Buoy.

Can Gas Buoy.

Spherical Gas Buoy.

Wreck Buoy.

Watch Buoy.

Illuminating Buoy

Stone Beacon

Goodwin Beacon

Bell Buoy

Gas Buoy

Wolf Rock Beacon

Shingles Beacon

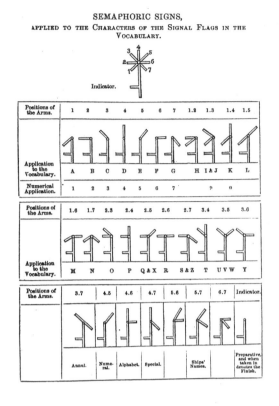

SEMAPHORIC SIGNS,
APPLIED TO THE CHARACTERS OF THE SIGNAL FLAGS IN THE VOCABULARY.

Indicator.

Positions of the Arms.	1	2	3	4	5	6	7	1.2	1.3	1.4	1.5
Application to the Vocabulary.	A	B	C	D	E	F	G	H I & J	K	L	
Numerical Application.	1	2	3	4	5	6	7		9	0	

Positions of the Arms.	1.6	1.7	2.3	2.4	2.5	2.6	2.7	3.4	3.5	3.6
Application to the Vocabulary.	M	N	O	P	Q & X	R	S & Z	T	U V W	Y

Positions of the Arms.	3.7	4.5	4.6	4.7	5.6	5.7	6.7	Indicator.
	Annul.	Numeral.	Alphabet.	Special.		Ships' Names.		Preparative, and when taken in denotes the Finish.

ALPHABET FOR COMPOSING DISTANT SIGNALS USED IN CONNEXION WITH THE COMMERCIAL CODE OF SIGNALS BY MERCHANT SHIPS.

In addition to the examples on previous page, the following Distant Signals composed of two Symbols have the special signification indicated beneath.

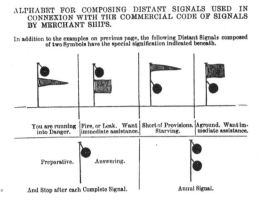

You are running into Danger. | Fire, or Leak. Want immediate assistance. | Short of Provisions. Starving. | Aground. Want immediate assistance.

Preparative. | Answering.

And Stop after each Complete Signal. | Annul Signal.

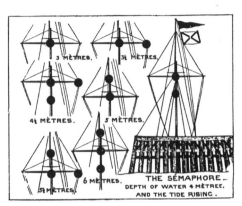

3 MÈTRES. | 3½ MÈTRES.
4½ MÈTRES. | 5 MÈTRES.
6 MÈTRES. | 5½ MÈTRES. | THE SÉMAPHORE. DEPTH OF WATER 4 MÈTRES. AND THE TIDE RISING.

French harbour signals

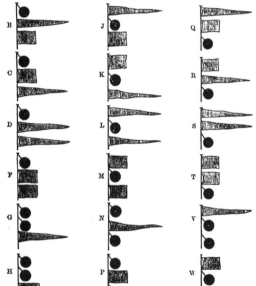

Coastguard signalling

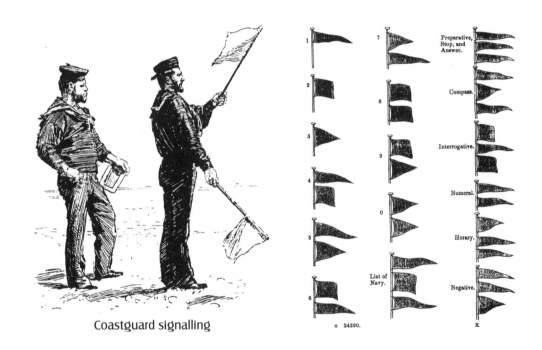

o 24290.

1 | 7 | Preparative, Stop, and Answer.
2 | 8 | Compass.
3 | 9 | Interrogative.
4 | 0 | Numeral.
5 | List of Navy. | Horary.
6 | | Negative.

Colomb's flashing signals

TABLE OF FLASHES FOR ALL SIGNAL BOOKS.		
1	6	
2	7	
3	8	
4	9	
5	0	
Preparative	&c.	
Finish or Stop	&c.	
General Answer	&c.	

NOTE.—Two descriptions of flashes are used, the short and the long, the former being about half a second in duration, and the latter about a second and a half.

NAVAL SIGNAL BOOKS.	FLASHES.	ALPHABET.					
Compass				A 5			
Pendants			B 6	C 7	D 8	E 9	F 10
Numeral							
Geographical			G 11	H 12	I 13	J 14	K 15
Horary							
Interrogative			L 16	M 17	N 18	O 19	P 20
Negative							
List of Navy			Q 21	R 22	S 23	T 24	U 25
Alphabet			V 26	W 27	X 28	Y 29	Z 30

To be answered and repeated the same as Flag Signals by day unless ordered to the contrary.

All Signals made to a single Ship, Division, or Squadron, to commence and *end* with their Pendants.

Care to be taken in trimming the lamps, not to spread the wicks.

The " Distant Signals " of Ships to be used with the " List of the Navy " Pendant.

" Starboard Division " is denoted by " Pendants " 1.

" Port Division " by " Pendants " 2.

Introduced in the mid-seventeenth century, the method of signalling by flags was developed during the following two centuries. Semaphore and Morse Code, taken from successful land use, were important additions to the signalling facility. Sound signals indicate ships movements and are part of the safety regulations for poor visibility.

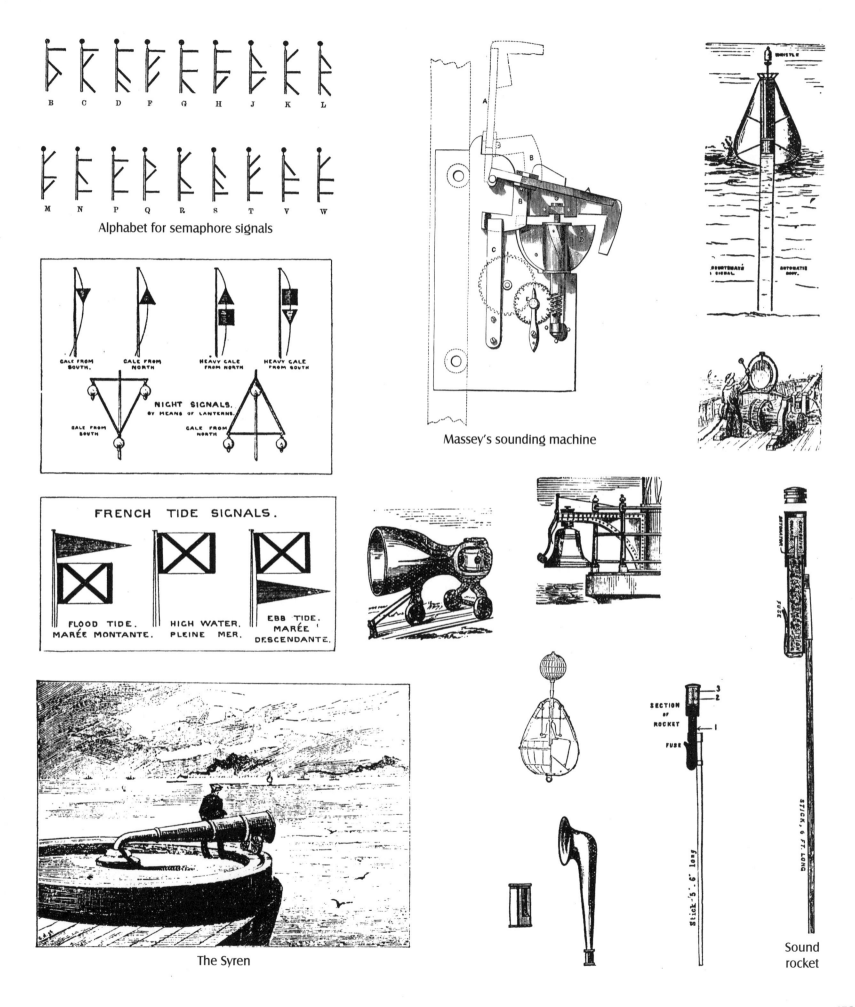

Alphabet for semaphore signals

NIGHT SIGNALS.
BY MEANS OF LANTERNS.

FRENCH TIDE SIGNALS.

FLOOD TIDE.
MARÉE MONTANTE.

HIGH WATER.
PLEINE MER.

EBB TIDE.
MARÉE DESCENDANTE.

Massey's sounding machine

SECTION OF ROCKET

FUSE

Stick 5'. 6" long

Stick, 6 ft. long

The Syren

Sound rocket

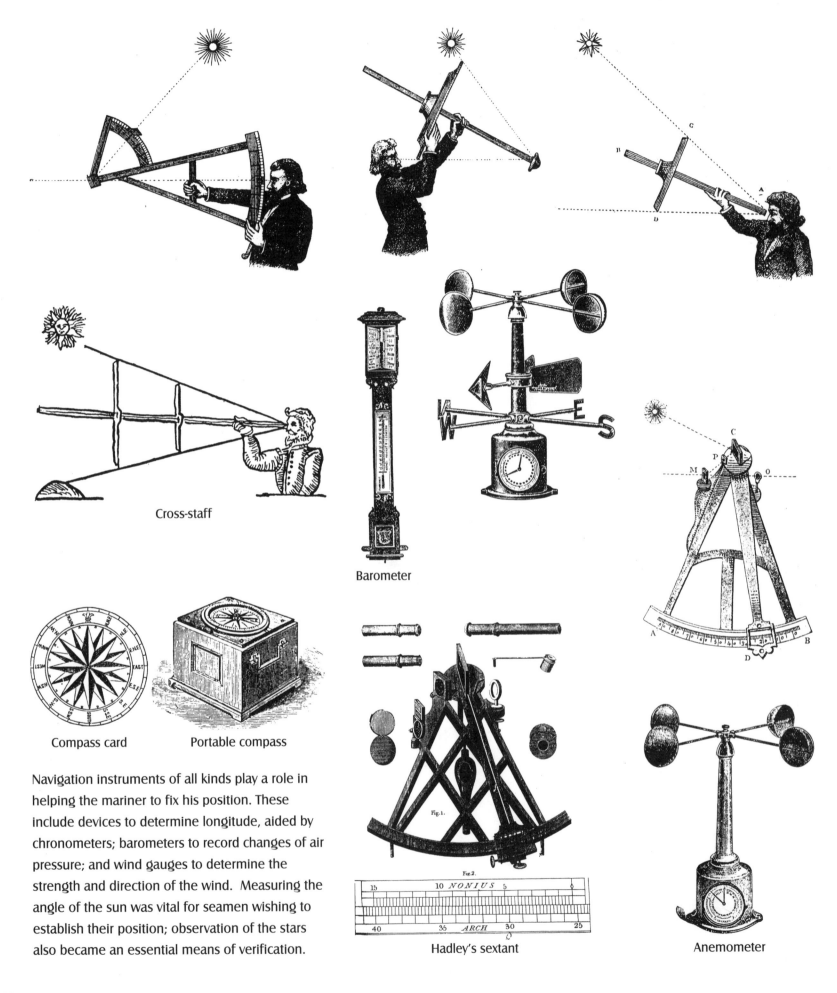

Cross-staff

Barometer

Compass card

Portable compass

Hadley's sextant

Anemometer

Navigation instruments of all kinds play a role in helping the mariner to fix his position. These include devices to determine longitude, aided by chronometers; barometers to record changes of air pressure; and wind gauges to determine the strength and direction of the wind. Measuring the angle of the sun was vital for seamen wishing to establish their position; observation of the stars also became an essential means of verification.

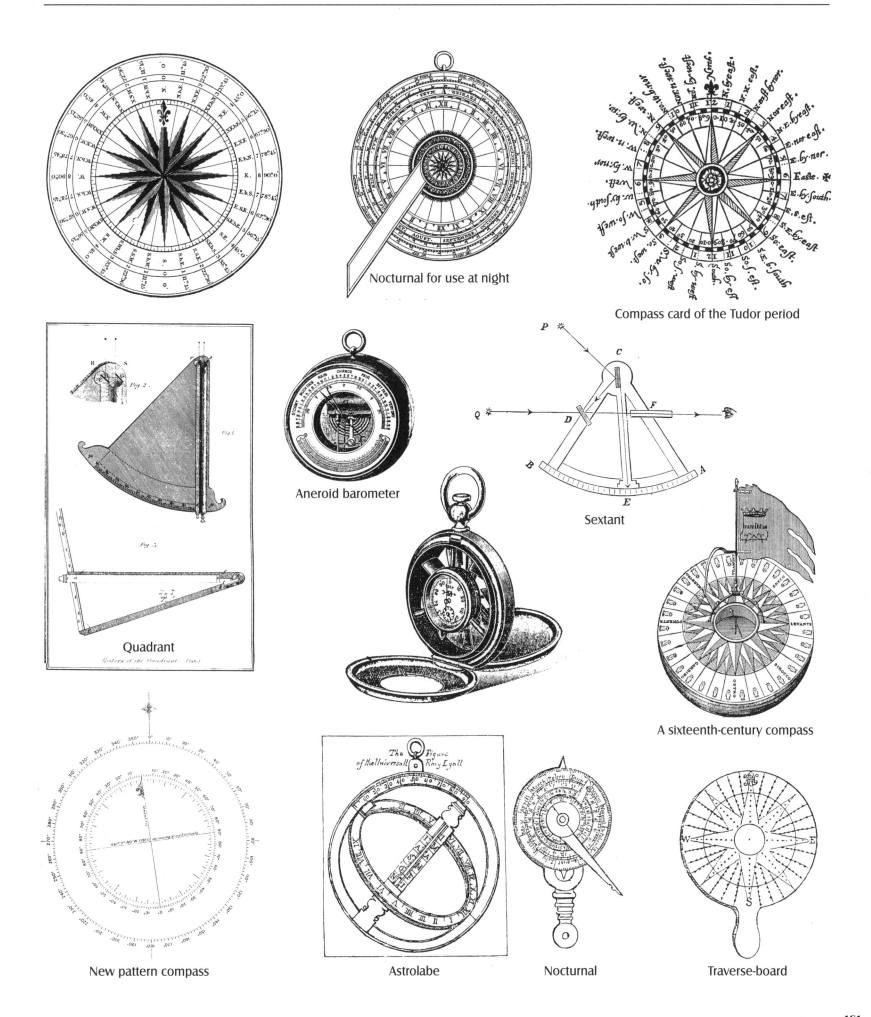

Nocturnal for use at night

Compass card of the Tudor period

Aneroid barometer

Sextant

Quadrant

A sixteenth-century compass

New pattern compass

Astrolabe

Nocturnal

Traverse-board

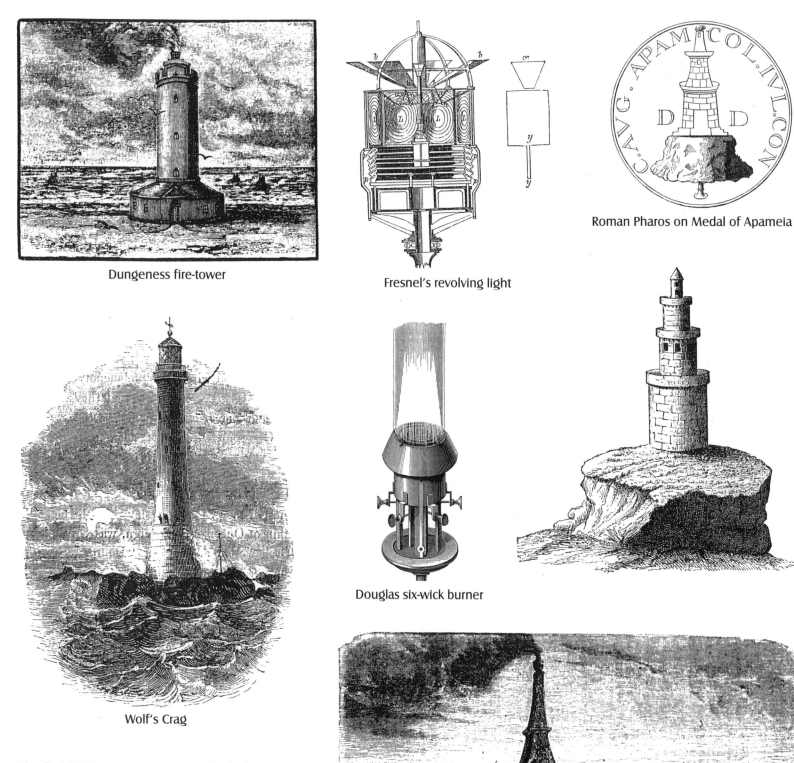

Dungeness fire-tower

Fresnel's revolving light

Roman Pharos on Medal of Apameia

Wolf's Crag

Douglas six-wick burner

Ancient Pharos of Alexandria

The first lighthouses were probably the beacon sites kept alight by priests in ancient Egypt, but the most famous is the Pharos of Alexandria built between 283 and 247 BC. Introduced to Europe by the Romans in the second century AD, the importance of lighthouses developed alongside the growth of sea-borne trade. One of the more famous lighthouses designed in the nineteenth century was Winstanley's on the Eddystone Rock.

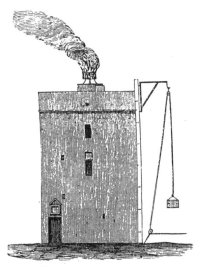

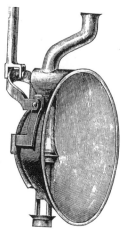

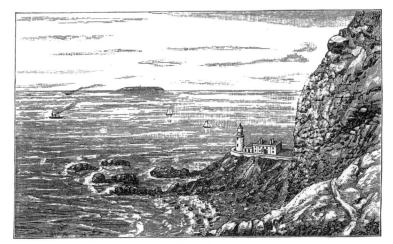

Hartland Point

Chauffer light on the Isle of May

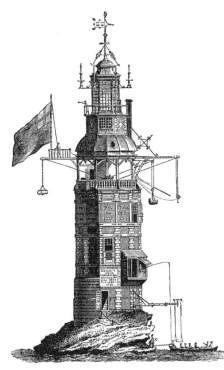

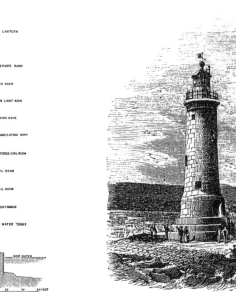

Section of New Eddystone
lighthouse

Plymouth Breakwater

Winstanley's lighthouse at
the Eddystone Rock

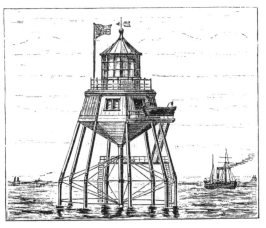

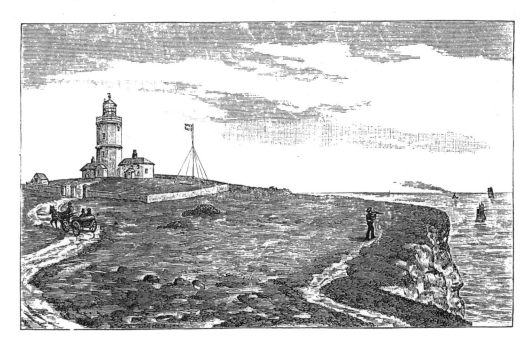

Maplin Screw Pile lighthouse

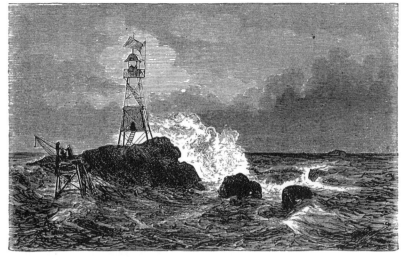

Lighthouse of the Enfant Perdu

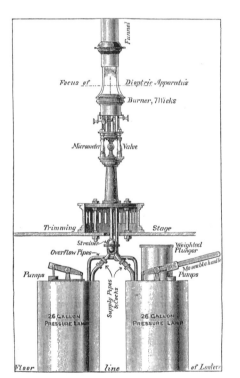

Douglas seven-wick oil burner

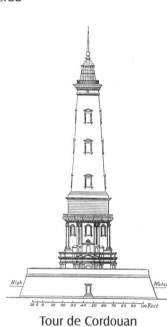

Tour de Cordouan

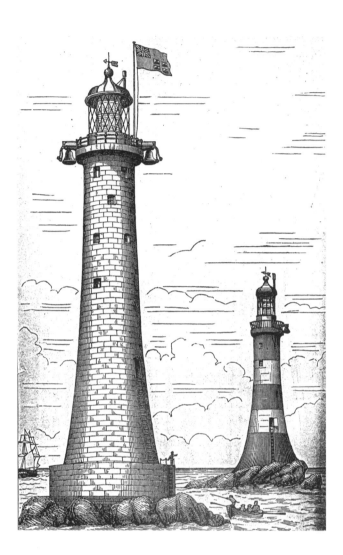

Placed on dangerous coastlines and visible land points, lighthouses shine characteristic lights which send clear messages to the on-board navigators. The lights are identifiable by their different colours, patterns and groupings, all of which are marked on the Admiralty charts and are well-known by sailors. Lighthouses also provide sound warnings in fog and at times of poor visibility.

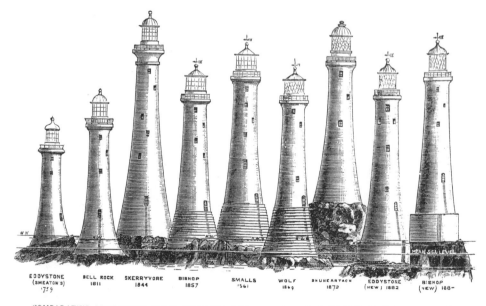

COMPARATIVE ELEVATIONS ABOVE MEAN SEA LEVEL OF PRINCIPAL BRITISH ROCK LIGHTHOUSES.

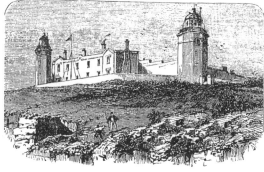
Lizard Point

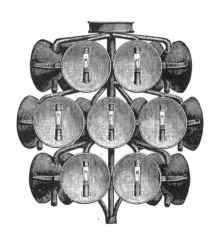

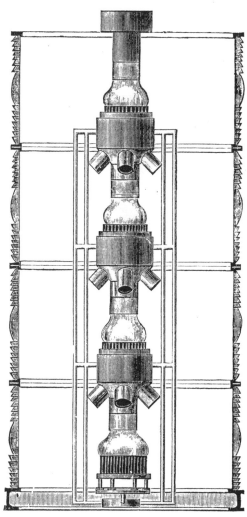
Quadriform gas burner

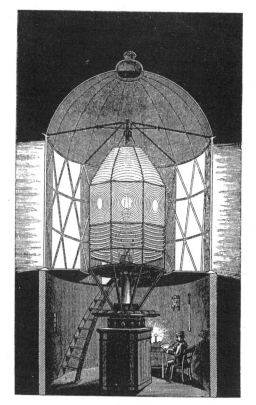
Interior of a lightroom

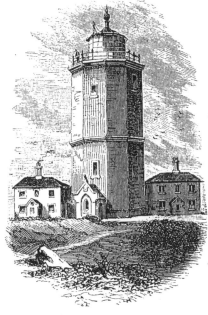
North Foreland lighthouse

Modern lighthouse of Alexandria

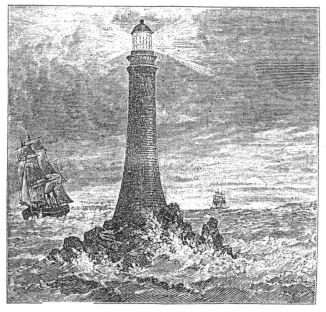
Bell Rock on the Firth of Forth

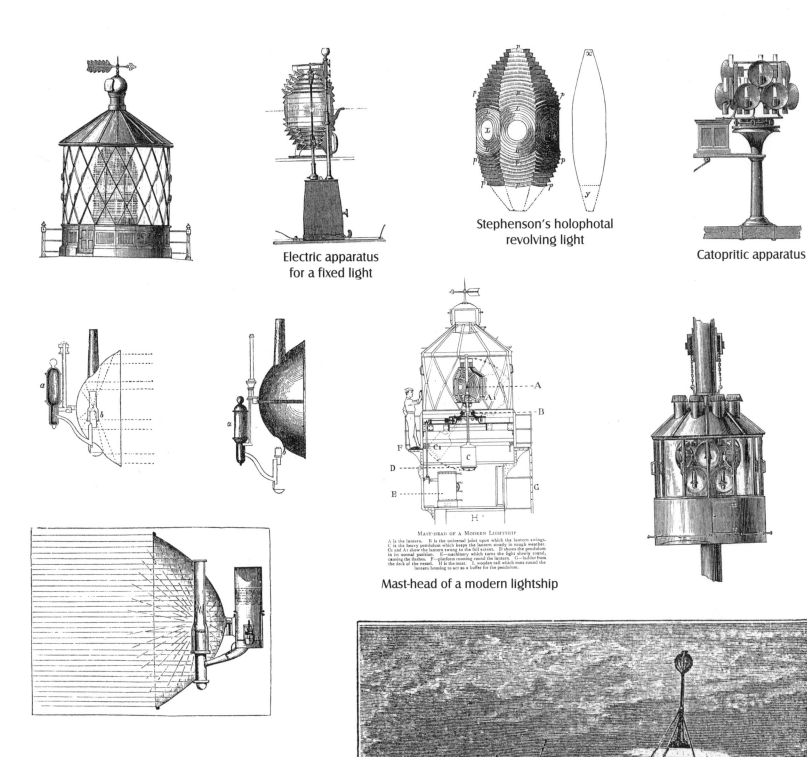

Electric apparatus
for a fixed light

Stephenson's holophotal
revolving light

Catopritic apparatus

MAST-HEAD OF A MODERN LIGHTSHIP

A is the lantern. B is the universal joint upon which the lantern swings.
C is the heavy pendulum which keeps the lantern steady in rough weather.
C₁ and A₁ show the lantern swung to the full extent. D shows the pendulum
in its normal position. E—machinery which turns the light slowly round,
causing the flashes. F—platform running round the lantern. G—ladder from
the deck of the vessel. H is the mast. I, wooden rail which runs round the
lantern housing to act as a buffer for the pendulum.

Mast-head of a modern lightship

Lightships are usually moored over banks on
expanses of open sea to aid navigation and safety.
Manned by three or four people, they use the same
characteristic lights and fog warnings as their land-
based counterparts, but also have additions of a
special mark to be used by day, submarine
signalling equipment and radar beacons. Gradually
lightships are being replaced by the Lanby Buoy
which is unmanned and can provide the same
service for up to six months without attention.

The lightship *Mouse*

Chapter 7

The New Worlds

The Renaissance was an era of discovery and invention. It also marked the beginning of the age of great sea exploration. Advances in mathematics, physics and astronomy saw the introduction of new instruments such as the magnetic compass, the astrolabe and the back-staff, all of which made sea navigation more accurate and precise. Improvements in shipbuilding also meant that voyages that once were long and fraught with danger now took less time and were much safer. These developments opened the way for daring sea explorers to journey into the unknown in search of new routes to India, and to discover the New Worlds of America, Australia, New Zealand, the Arctic and the Antarctic.

This had a massive impact on mapmaking. Explorers usually conducted detailed surveys of the new territories and waters, so enabling cartographers to produce more reliable charts, which in turn encouraged yet further exploration of land and seas.

Fame and fortune were driving forces for many sea explorers. Not only did a successful expedition often mean prestige and honours back home, but it could also make huge profits as well. The New Worlds were rich in treasures and exotic produce which would fetch a handsome price in Europe. They also provided new, untapped markets for the sale of European goods. As a result of trade, the major sea-faring countries of Europe – Britain, Portugal, Spain, France and the Dutch Republic – became the wealthiest and most powerful nations in the world. The sea exploration undertaken by famous explorers, and the subsequent opening of safe trade routes, created the vast merchant network that continues to thrive to the present day.

It is impossible to imagine how much of the globe still lay undiscovered only 600 years ago; it is thanks only to the persistence and courage of these adventurous explorers, who risked their lives and reputations on dreams and assumptions, that our knowledge of the world advanced.

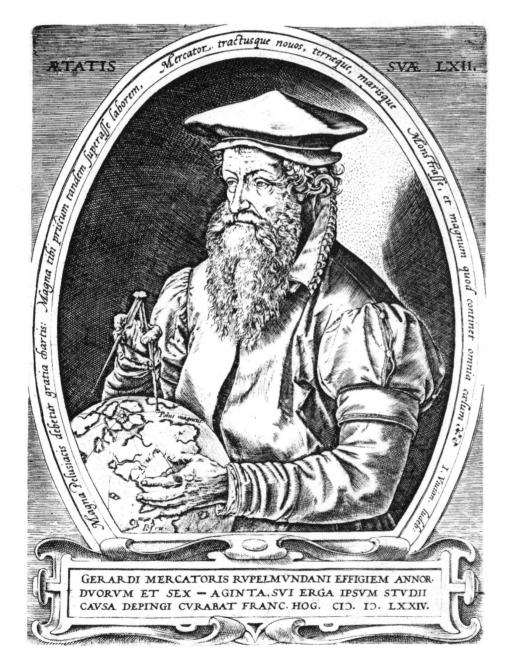

GERARDI MERCATORIS RVPELMVNDANI EFFIGIEM ANNOR·
DVORVM ET SEX — AGINTA, SVI ERGA IPSVM STVDII
CAVSA DEPINGI CVRABAT FRANC. HOG. CIƆ. IƆ. LXXIV.

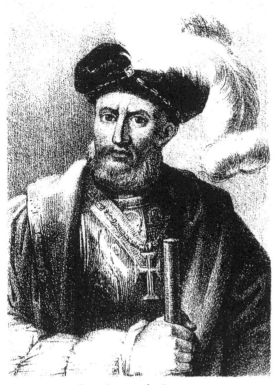

Dom Vasco da Gama

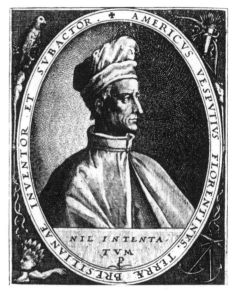

Christopher Columbus

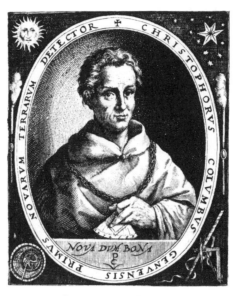

Amerigo Vespucci

Jacques Cartier

Martin Frobisher

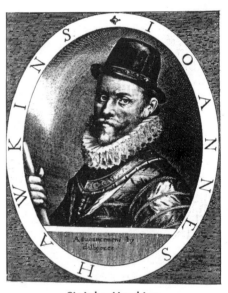

Sir John Hawkins

Each of the sea-faring nations of Europe had their own great explorers. Although originally from Italy, Columbus sailed for Spain on his famous voyage to America. Drake, Frobisher, Raleigh, Cavendish, and Hawkins all led expeditions from England to the New World, as did Cartier from France. The Portuguese Vasco da Gama was the first European to sail around the Cape of Good Hope, while the Dutchman Le Maire discovered Cape Horn.

Thomas Cavendish

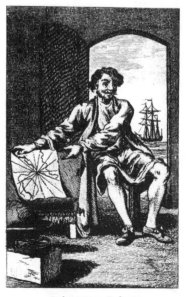

Sebastian Cabot

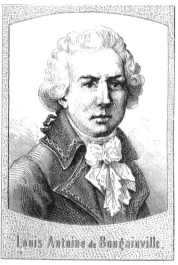
Louis Antoine de Bougainville

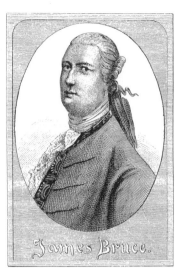
James Bruce

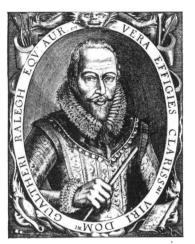
Sir Walter Raleigh

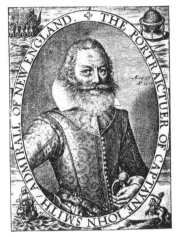
Captain John Smith

Martin Cortés

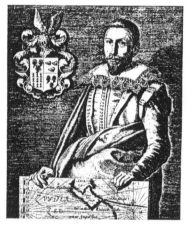
Jacob Le Maire

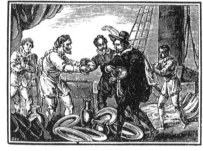
Captain Drake

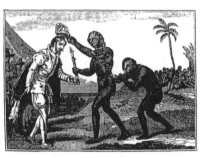
Drake made sovereign of California

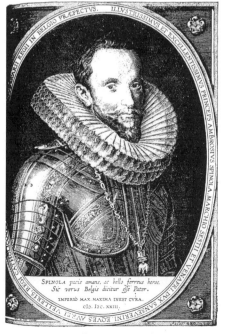
Ambrosia Spinola

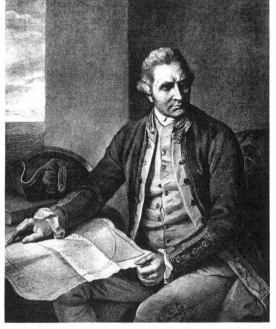
Captain James Cook

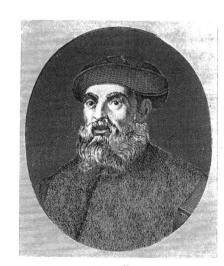
Magellan

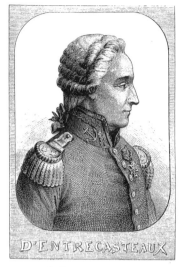

D'Entrecasteaux

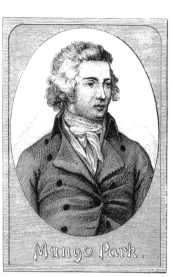

Mungo Park

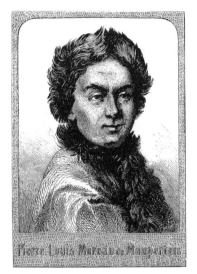

Pierre Louis
Moreau de Maupertuis

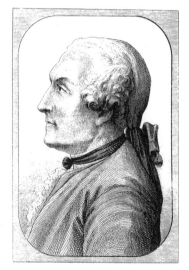

Condamine

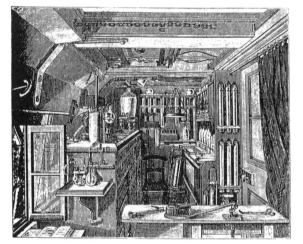

Laboratory on board the *Challenger*

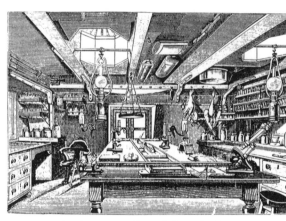

Workroom on board the *Challenger*

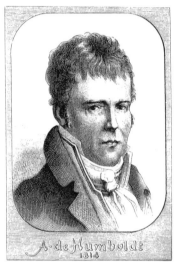

Alex de Humboldt

Expeditions to unknown lands provided plenty of material for scientists from a variety of fields, including physical geography, botany, geology, and anthropology, and ships often had working laboratories on board. On their travels, Condamine and Moreau de Maupertuis attempted to calculate the shape of the earth, while Humboldt and La Pérouse took samples of unfamiliar plants and rocks. Reports of encounters with strange peoples from Bougainville, Park, Bruce, and Byron helped to establish the eighteenth-century cult of the 'noble savage'. Sometimes, however, contact with natives could have tragic consequences, as Cook's violent end demonstrates.

Commander Byron in Patagonia

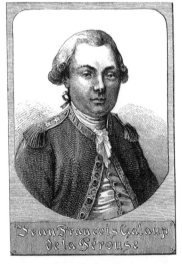

Jean Francois
Galoup de La Pérouse

Alexander Selkirk meets Captain Cook

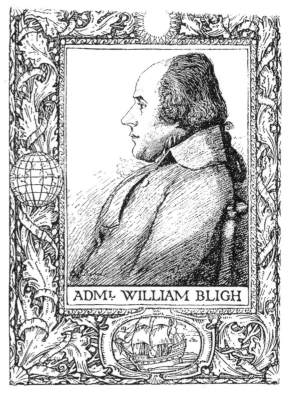

Admiral William Bligh

Captain Argall in Virginia, c.1614

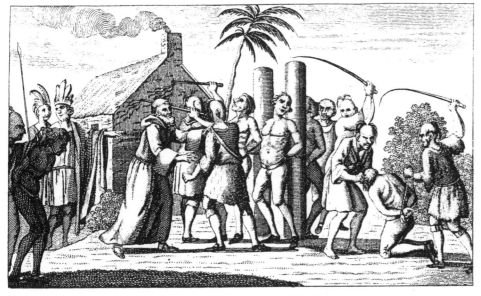

Mr Hatley and his crew whipped by the natives

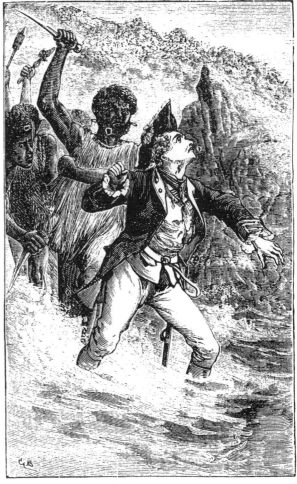

Death of Captain Cook

Death of Mauritius

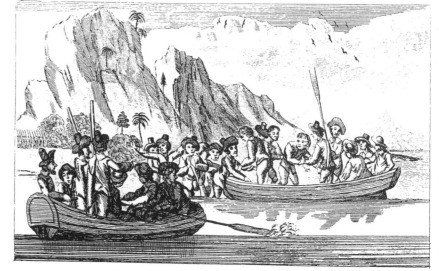

Captain Davis' men taken off the rock by comrades

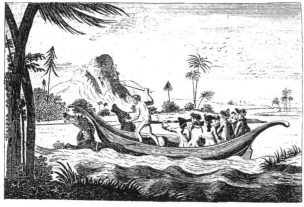

Bougainville crossing the St Lucia river

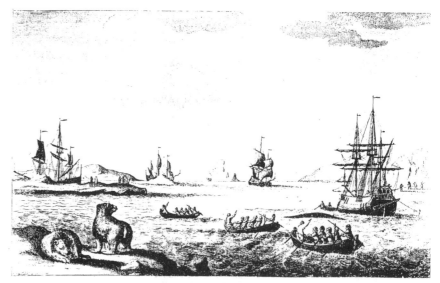

Sailing through the ice, 1760

Sixteenth-century Dutch Arctic exploration ship

European explorers have crossed every sea and ocean in their explorations for new lands and new sea routes. They have settled in the most extreme parts of the world, including the remote islands of St Helena in the Atlantic Ocean and the southern tip of South America, Tierra del Fuego. They have even tried to chart the frozen waters of the Arctic and the Antarctic, despite the perils of the expanses of treacherous, and sometimes deadly, ice.

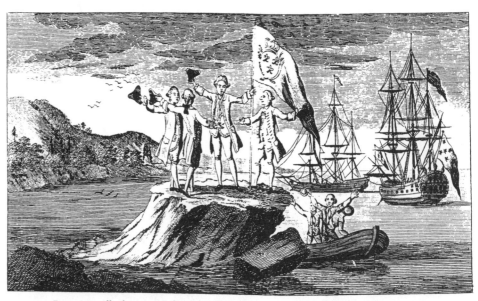

Bougainville hoisting the French colours near the Straits of Magellan

Ice islands in the Antarctic Ocean

The *Polaris*

Wintering in an Arctic hut
in the sixteenth century

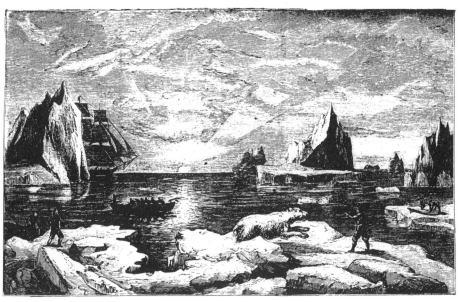

Arctic expeditions

Cavendish at St Helena

Cavendish off Guam

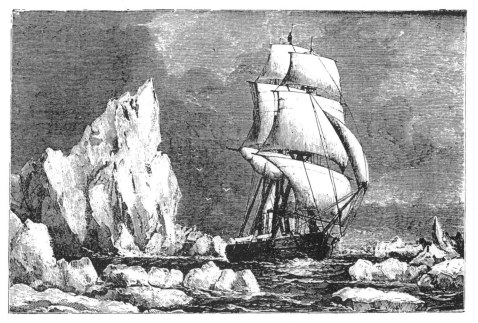

Steam and sail in Arctic ice

Vega passing the East Cape of India

Columbus and the Egg

Captain Carteret at English Cove

Captain Swan entertained
by the Raja Lout, uncle to the
King of Mandanao

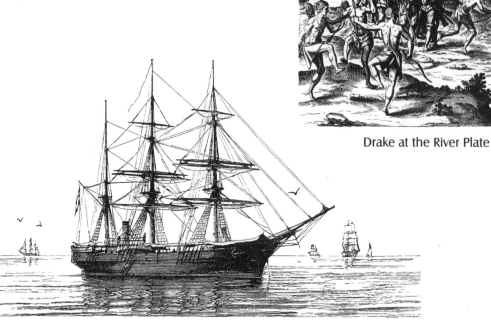

Drake at the River Plate

The *Vega*

Sir Walter Raleigh at Trinidad, 1595

In the eighteenth century, written accounts
of famous explorations, both past and present,
were very popular. The books were often
illustrated with engravings or drawings showing
the most important scenes of the expeditions.
Artists also accompanied explorers, including
Cook on his travels to the South Seas, to record
first-hand the journey's dramatic or unusual
moments. These often showed arrivals in new
lands, battles with an enemy or encounters with
natives, so providing an accurate report of the
voyage for the public back home.

J R Bellot

Sir Martin Frobisher passing Greenwich

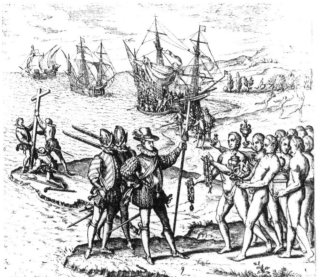

Columbus landing at Watling Island, 1492

Tracking HMS *Blossom* around Cape Smyth

Explorers at Duke of York Island

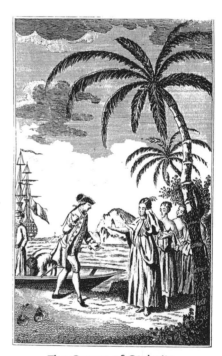

The Queen of Otaheite
taking leave of Captain Wallis

Drake going to sea on a raft

Endeavour under repair in Endeavour River

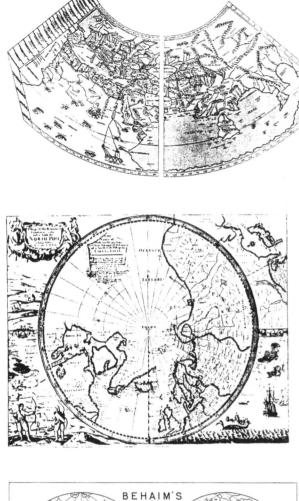

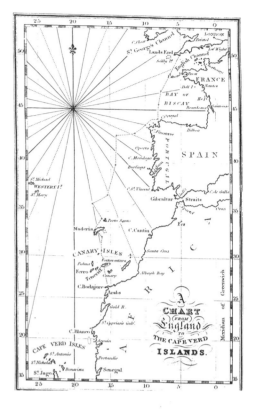

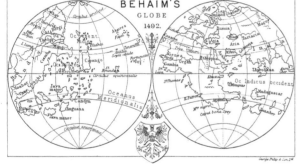

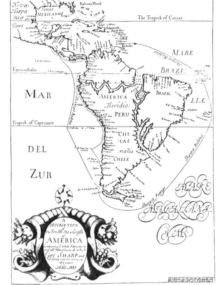

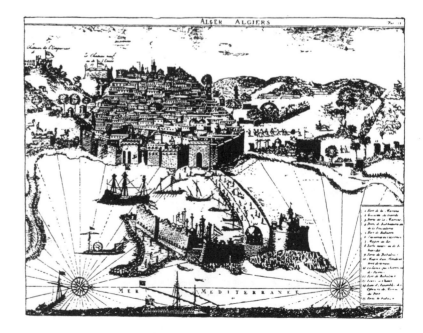

The development of printing in the fifteenth century made maps and charts increasingly common. Many of these, however, were crude designs based on the maps of Ptolemy, a Roman cartographer whose work had been rediscovered in 1400. In the sixteenth century, the discovery of the New World, and Mercator's breakthrough of showing the spherical globe on a flat surface, gave cartographers a better knowledge of the world and enabled them to produce ever more accurate maps.

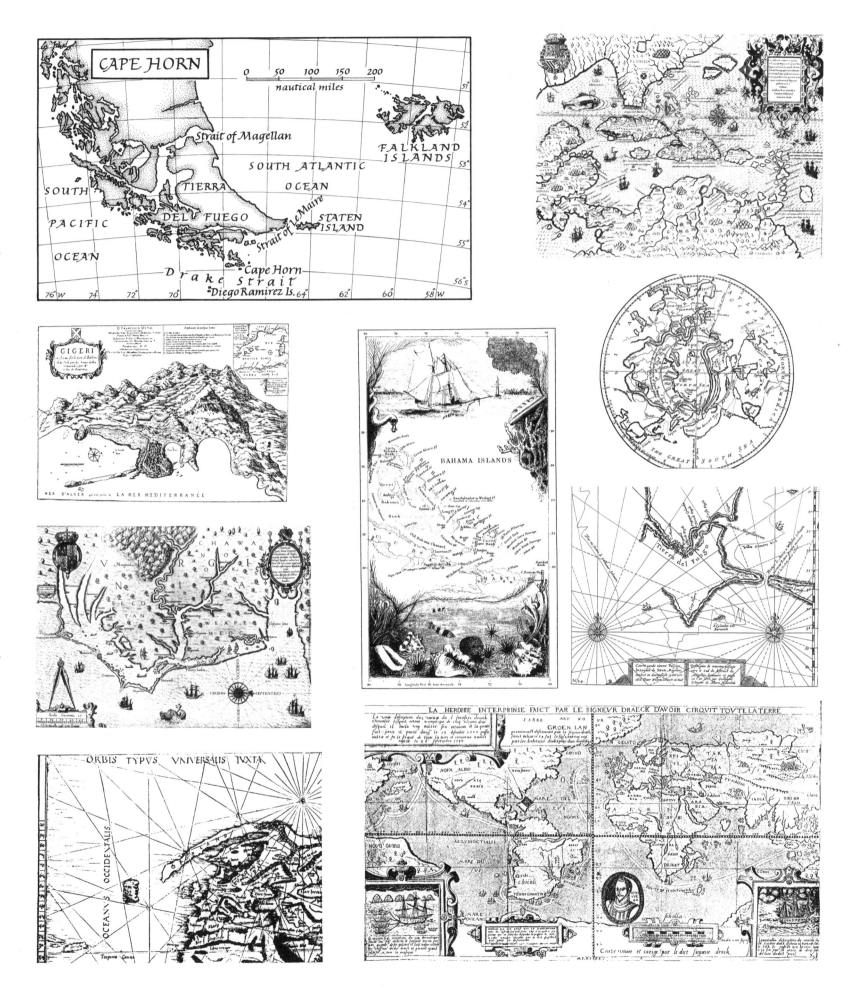

It quickly became apparent that it was also necessary to chart tidal currents, wind directions and whaling sites to find the safest possible routes through the seas, and so maps began to be created specifically for this purpose. Such charts are particularly important for merchant ships, which need to reach their destinations in the shortest time possible to keep profits high.

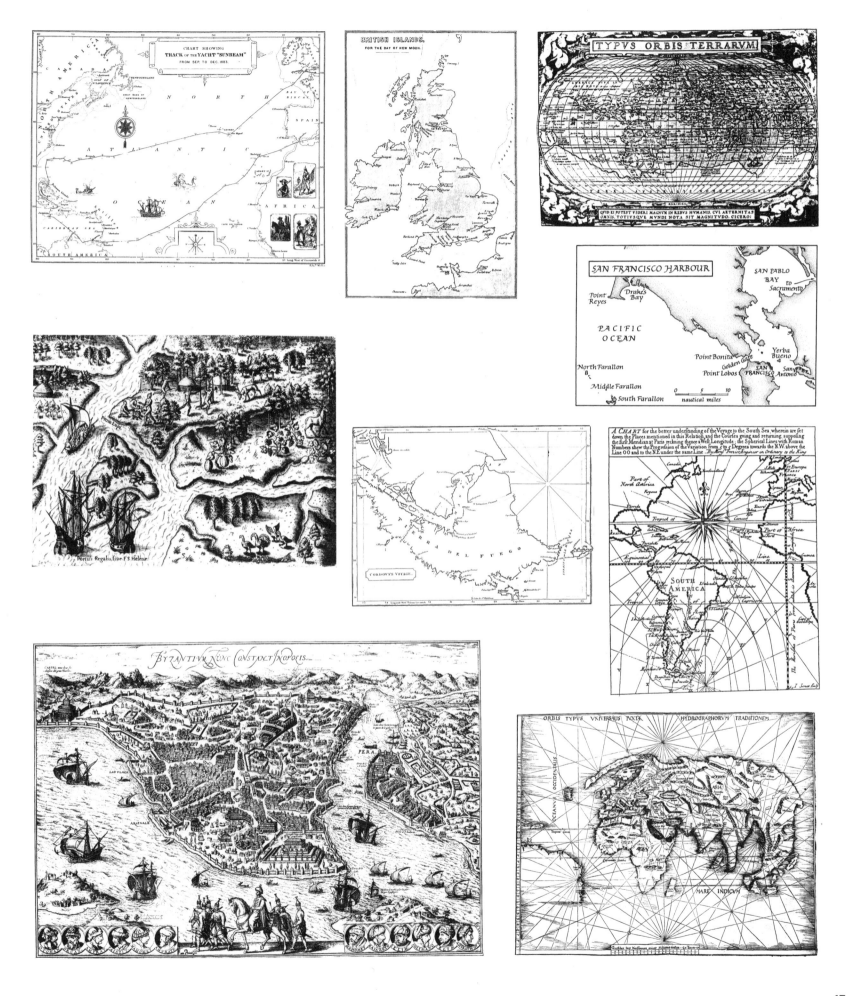

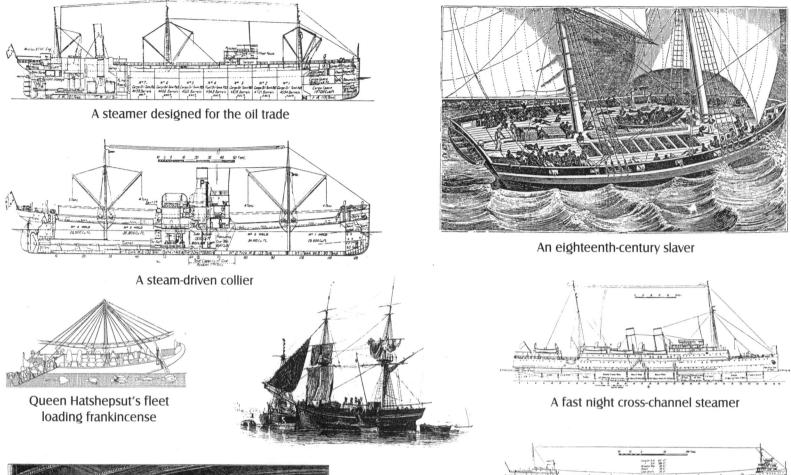

A steamer designed for the oil trade

A steam-driven collier

An eighteenth-century slaver

Queen Hatshepsut's fleet
loading frankincense

A fast night cross-channel steamer

A motorship designed to carry grain and ore on the
Great Lakes of North America

With the financial aspects of trade in mind,
shipwrights have always constructed vessels
specially designed to carry specific cargoes, from
tea clippers and colliers to whalers and oil
tankers. The huge profits on offer from the New
World led many unscrupulous European merchants
to send large numbers of Africans to America as
slaves. Conditions on slave ships were appalling:
hundreds of men, women and children would
often be cramped in the unlit hold. Even so, until
the nineteenth century, the slave trade was legal.

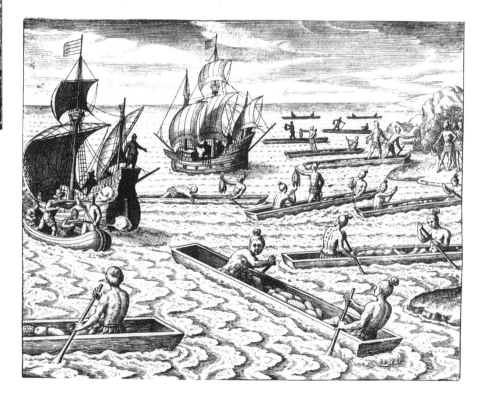

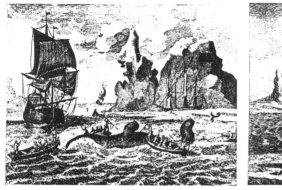

A successful Dutch whale hunt

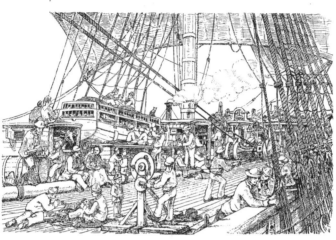

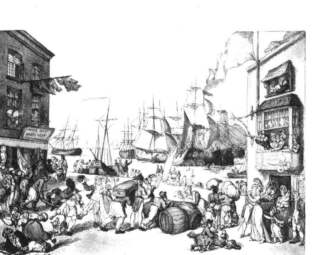

The hold of a slaveship

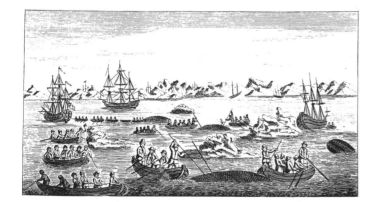

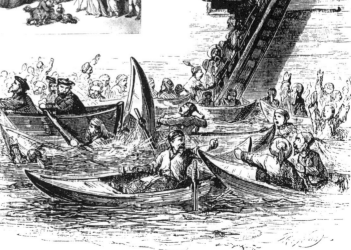

Method of securing tubs and stones for sinking

The *Rival*

A crop sunk

The 'industry' of Cowes

"Fire and be damned."

Transverse Section

b ... Lockers, t each side filled with tubs
C ... Wing-lockers do. do

The tubs were pushed into the lockers by means of greased planks

A rope (a) was first fixed to first Tub in each locker to dis charge by

Wing C.

Longitudinal Section

Placing of smuggled goods on the *Rambler*

1 CROWN PIECE

2 WAIST COAT.

3. BUSTLE.

4 THIGH PIECES.

How the Deal Boatmen used to sumggle tea ashore

Section at Fore Peak

a ... Sliding door in thwartship bulkhead
b ... Upperdeck beam
c ... Endview of tubs as stowed in trunks
d ... Iron and shingle ballast in hold
e ... Showing the scuttle to cover the ends of tubs made of inch board with wood lin ing and iron plate fitting in rabbit of bulkhead, with cloth nailed round edges. Fig 2
f ... Ropes used to draw tubs into Fore Peak
g ... Shifting bulkhead to form a locker (false)
I ... Locker under aft cabin for ballast
k ... Beam of lower deck

Plan of tubs stowed in trunks. 14 feet long. 12 tubs in each

Fore Peak

Concealment on board the *Ant*

A Section of vessel, showing false bottom on
cc Six timbers on each side, fastened to the keel and bilge, 1 ft above keel

a false bottom
b . kelson
c. divisions in concealment
d. main kelson
No 1 contained 22 flaggons
2. 3. 17 tubs
3. 2. 10.
4 1 19

Plan
Port side
54 tubs 28 flaggons

Starboard side
54 tubs 28 flaggons

Alterations on the *Emulation*

B Transverse section, showing false bottom (with tubs in position)
b nails through false timbers
c sheathing of ¾inch planking nailed to each timber, finely edged above, forward and aft; the tubs being built in and stowed fore - and aft in the chambers
N B The bottom was built on the ground in Barfleur, in two tides

Smugglers' stores on the *Charles and Hannah*

Smuggling, however, was not legal, and much time was spent trying to capture these most elusive of criminals. With the potential prospect of long imprisonment, torture and even death, smugglers devised various schemes to bring their contraband goods ashore without detection. They went as far as making their own amendments to the boat's structure and creating new under clothing.

Power of the Deep

For many centuries, shipwrecks were a regular occurrence in relatively uncharted waters, and crews were never certain whether a voyage would be completed without dramatic incident. Their need to explain unusual phenomena during their time at sea, and man's inability to control such a powerful element, resulted in the huge variety of legends and superstitions passed down the generations in verbal narrative and still prevalent in many cultures today. The global concern over the power of the devil, fuelled by the religious fervour of the maritime nations, developed these fantastical tales into believable horrors.

The introduction of accurate maps and charts, and continual developments in ship design during the twentieth century, mean that some of the original dangers have been somewhat lessened. There are, however, still strange occurrences, such as storms out of nowhere and freak winds and currents that can take control of a vessel within seconds and render its crew powerless. Reports of giant sea-creatures and unusual marine life still appear from time to time, but on-going research offers some explanation for many of these.

Developments in warfare, which initiated the arrival of the submarine, heralded a new age in deep sea research. Submersibles were created to explore great depths and salvage wreckage and information from the sea floor. These investigations confirmed that man would not be able to work in the pressure and density at that depth, and led to the creation of the computer-operated ROV vessels which follow routes set by marine biologists and can record on camera the life of the deep. Despite the importance of the sea for millennia, it is only in recent years that man has been able to begin exploring the depths to discover just how little we know about the extraordinary secrets of the oceans.

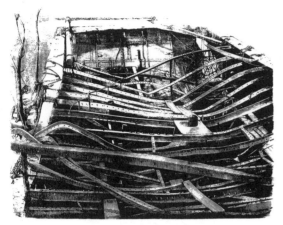

The *Sarah Sands* destroyed
by fire, November 1857

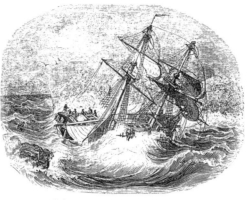

Loss of the *Commerce*, August 29 1815

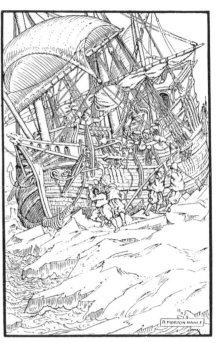

Frobisher's barque in the ice

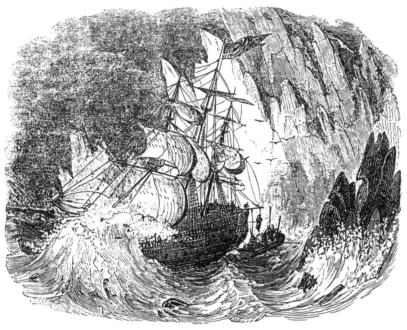

The *Lady Hobart* hits an island of ice, June 28 1803

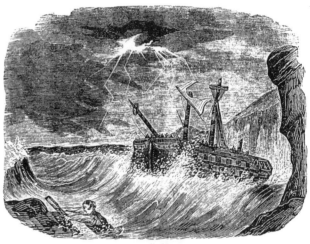

The 50-gun HMS *Litchfield*, wrecked off Africa

In the early days of trade and on-going
discovery, life at sea was ruled by uncontrollable
and inexplicable forces. The potentiality of disaster
lay waiting in every wave and subtle change of
current, or in the boilers and fires deep in the ship.
Once control had been lost, the ship and her crew
were open to the elements and the prospect of an
early grave.

Manilla on fire in Balaclava Roads, May 3 1853

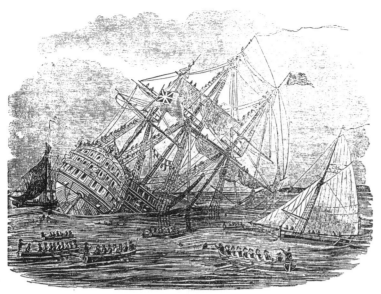

Loss of the *Royal George*, August 29 1782

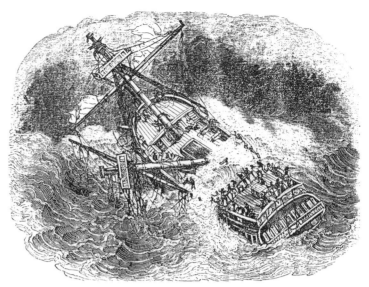

Loss of HMS *Phoenix*, August 1780

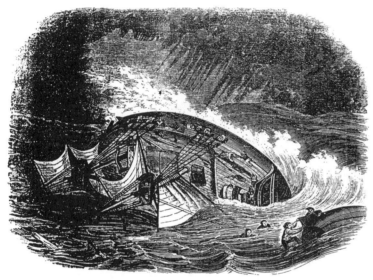

The brig *Tyrrel* overset in a gale, July 1 1759

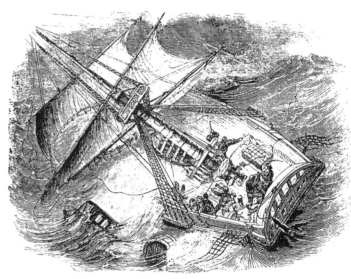

Misfortunes of Captain Norwood, 1649

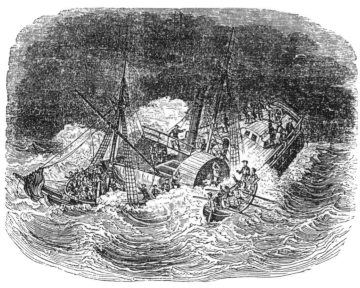

Shipwreck of the *Forfarshire Steamer*, September 7 1838

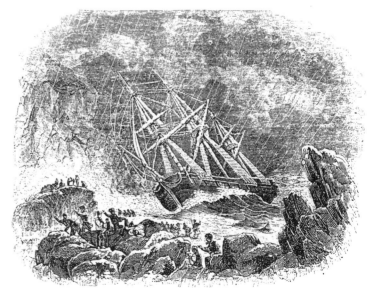

Wreck of the *Prosperpine*, February 1 1799

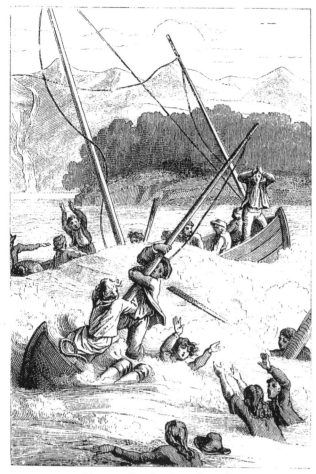

Disaster for the French at the
entrance to the Ports des Français

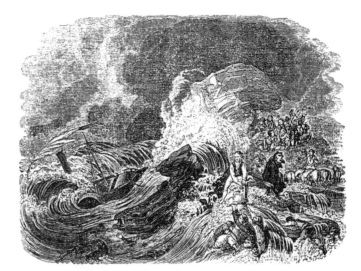

Marooned survivors of the *Killarney Steamer*, January 20 1838

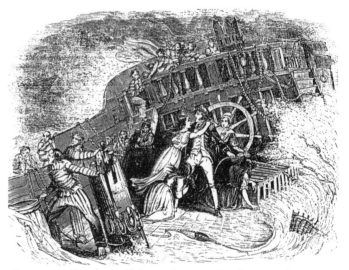

Troops on the deck of the sinking *Vryheid*, November 23 1802

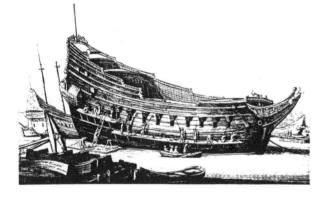

Those who survived the terrifying ordeal of being
shipwrecked or marooned on a deserted island
captured the imagination and inspired some of the
greatest works of literature. Alexander Selkirk (the
role-model for *Robinson Crusoe*) survived alone on
Juan Fernandez for over four years before the
privateers *Duke* and *Duchess*, commanded by
Woodes Rogers, rescued what had at first appeared
to be a demonic monster.

Alexander Selkirk rescued by Woodes Rodgers in 1709

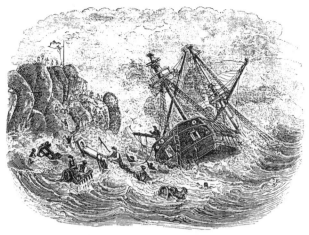

Loss of HMS *Nautilus*, January 5 1807

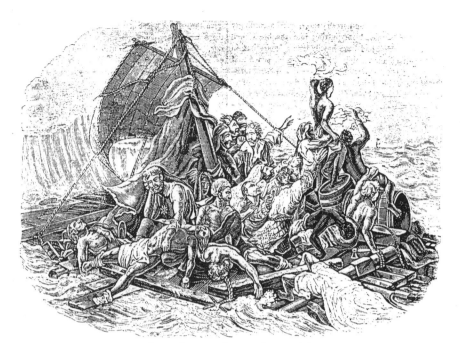

Survivors from the wreckage of *La Méduse*, 1816

Shipwrecked from the *Magpie*

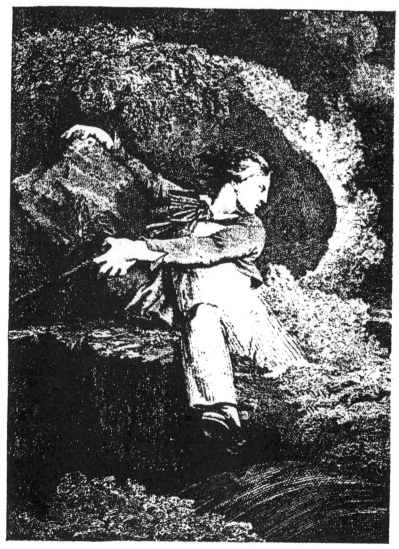

The shipwrecked sailor

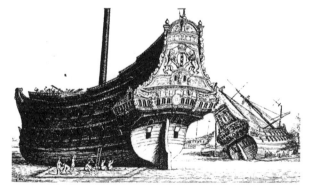

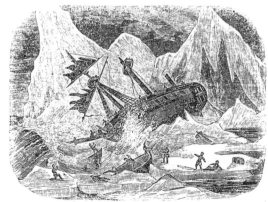

Loss of a Dutch Greenlandman, 1639

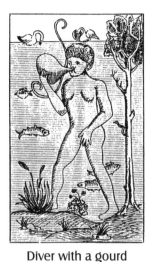

Diver with a gourd
of air, 1500s

Swimming jacket, 1300s

Diver's helmet, 1500s

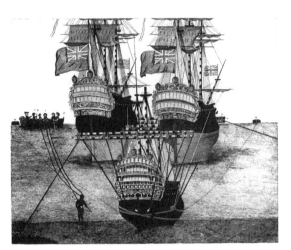

Raising the *Royal George*

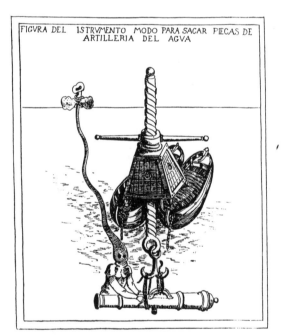

Diver salving a gun, 1600

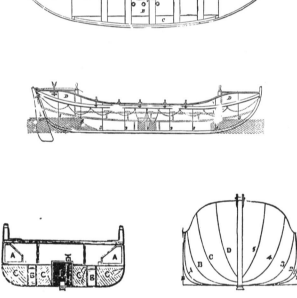

Diver's equipment,
1500s

Due to the sheer number of disasters occurring, the development of rescue and salvage equipment was imperative. The first lifeboat appeared in about 1760, but it was not until 1823 that the question of rescue at sea was discussed in parliament, resulting in the precursor to the RNLI. The evolution of diving tools from the first appearance of crude helmets and air gourds of the 1300s to 1500s opened up the oceans to more intensive study. They also offered the chance to salvage ships and their cargo, which was often of high value, from the sea bed.

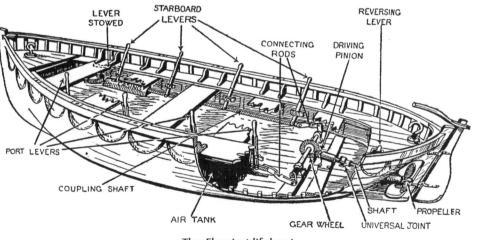

The Fleming lifeboat

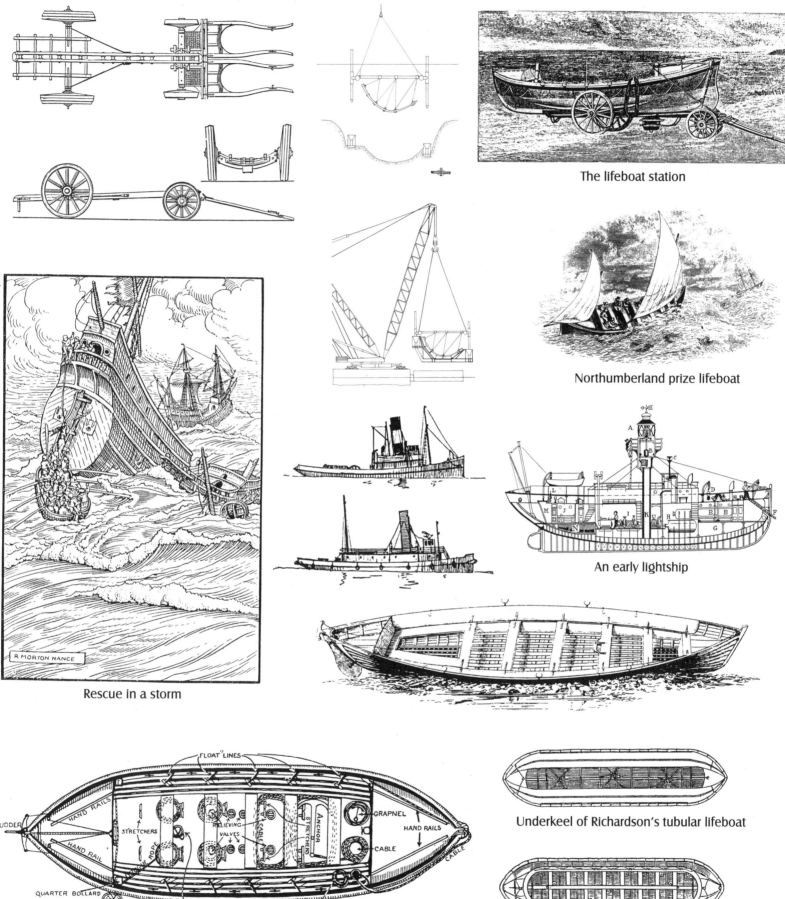

The lifeboat station

Northumberland prize lifeboat

An early lightship

Rescue in a storm

Self-righting lifeboat

Underkeel of Richardson's tubular lifeboat

Deck view of the tubular lifeboat

Doge of Venice wedding the Adriatic

The Echeneis or ship stopper

The Albatross, believed to be the
embodiment of dead sailors

Even with the arrival of underwater apparatus when
man could venture deeper into the oceans, the sea
was still believed to hold a mysterious power which
could decide man's destiny. Sea-farers prayed for
signs to indicate their future fortune and
interpreted many chance occurrences as good or
bad omens. St Elmo's lights, a shimmering on the
rigging, became a symbol of good fortune or
impending disaster depending on the sailors'
country of origin.

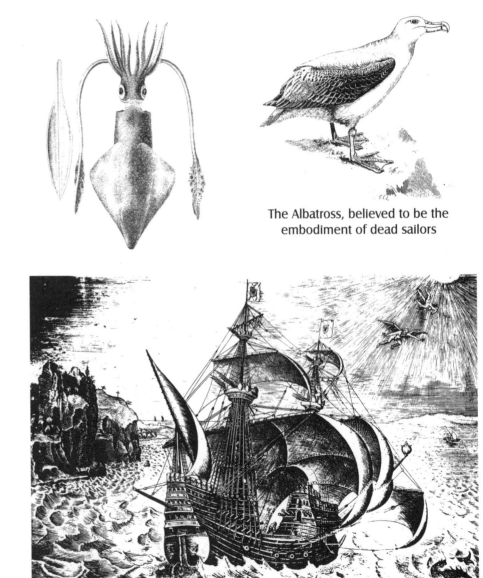

Demons or angels overlooking the voyage

Flying fish

The Cormorant

The giant sea-serpent

Whipping Christian slaves to
make them pray for fair winds

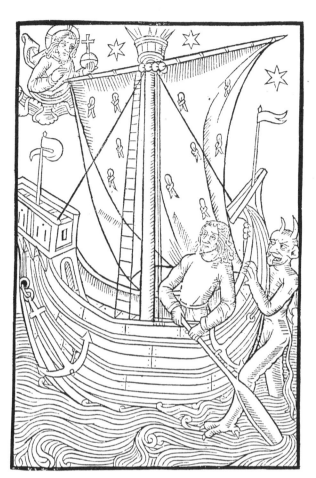

The demon of the sea

Saint Elmo's Fire

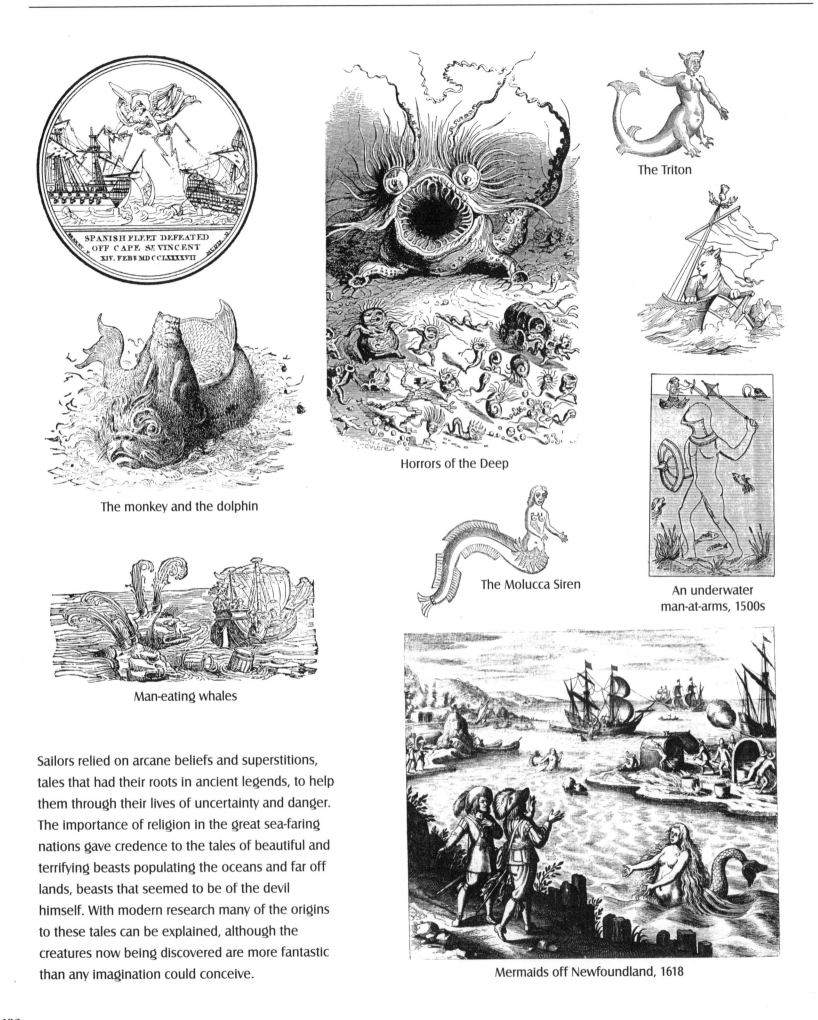

SPANISH FLEET DEFEATED OFF CAPE S₂ VINCENT XIV. FEB₃ MDCCLXXXXVII

The Triton

Horrors of the Deep

The monkey and the dolphin

The Molucca Siren

An underwater man-at-arms, 1500s

Man-eating whales

Sailors relied on arcane beliefs and superstitions, tales that had their roots in ancient legends, to help them through their lives of uncertainty and danger. The importance of religion in the great sea-faring nations gave credence to the tales of beautiful and terrifying beasts populating the oceans and far off lands, beasts that seemed to be of the devil himself. With modern research many of the origins to these tales can be explained, although the creatures now being discovered are more fantastic than any imagination could conceive.

Mermaids off Newfoundland, 1618